W9-BJG-574

AN ATLAS OF
ANIMAL ANATOMY
FOR ARTISTS

BY W. ELLENBERGER, H. BAUM AND H. DITTRICH

Second Revised and Expanded Edition

Edited by LEWIS S. BROWN, *Exhibition Department, American Museum of Natural History*

DOVER PUBLICATIONS, INC., NEW YORK

COPYRIGHT © 1949, 1956 BY DOVER PUBLICATIONS, INC.

All rights reserved under
Pan American and International Copyright Conventions.

An Atlas of Animal Anatomy for Artists, first published in 1949 by Dover Publications, Inc., is a new English translation by Helene Weinbaum of *Handbuch der Anatomie der Tiere für Kunstler*, originally published by Theodore Weicher, Leipzig, in 1901.

The second revised English edition, edited by Lewis S. Brown and first published in 1956 by Dover Publications, Inc., contains a new Preface, 25 additional plates and an enlarged bibliography.

International Standard Book Number: 0-486-20082-5

Library of Congress Catalog Card Number: 56-14001

Manufactured in the United States of America
Dover Publications, Inc.
31 East 2nd Street, Mineola, N.Y. 11501

The Contents

Preface to Second Revised American Edition

I have undertaken with a glad heart the preparation of this new edition of the incomparable Ellenberger, Baum, and Dittrich ATLAS OF ANIMAL ANATOMY FOR ARTISTS. When Dover Publications first approached me, they told me they intended to enrich the book by the addition of plates by George Stubbs and others, as well as a bibliography to suggest further study. I appreciate the freedom they have given me in my efforts to carry out those wishes.

Our first edition contained all of the plates from the original Ellenberger work, published in 1901 in five volumes. Only a part of the German text was omitted, most of it more technical than is generally warranted by the needs of artists. The real message is contained in the plates themselves. It is a larger message than may be apparent at first, including, as it does, the directive to compare the different forms as well as to study them separately. The choice of the horse, the dog, the cow, and the lioness was not an accident. Although all are of the class *Mammalia*, each is a member of a different order. The horse is of the order *Perissodactyla* (*perissos*—odd, *dactylos*—toe), an animal having an odd number of toes. It includes the zebra, the tapir, and the rhinoceros as well as the horse. The cow belongs to a larger order, *Artiodactyla* (*artios*—even, *dactylos*—toe). Other animals of this order are the pig, the camel, the antelope, the goat, the deer, the giraffe, and the hippopotamus, to mention a few. The lioness and the dog are of the order *Carnivora* (*carno*—flesh, *vorare*, to eat). The first two orders, you will notice, are based on the development of the legs while the third is based on the teeth.

In selecting material to expand this edition, I have kept in mind this comparative aspect. The quality of the Ellenberger plates is so fine that it has not been easy to find even a few more, strictly anatomical, studies from which could be made selections worthy to stand beside them. The engravings of the horse by George Stubbs are taken from his ANATOMY OF THE HORSE, published in 1776. George Stubbs has taken his place among England's great sporting artists. Although these anatomical studies were made under conditions that would be considered almost impossible today, his results speak for themselves. The ¾ view and the rear view form an excellent supplement to the Ellenberger plates on the horse. In the original work, numbered and lettered tracings accompany the anatomical plates to designate the names of the bones and muscles. The functions of the muscles were not understood in Stubbs' day as they are now, so

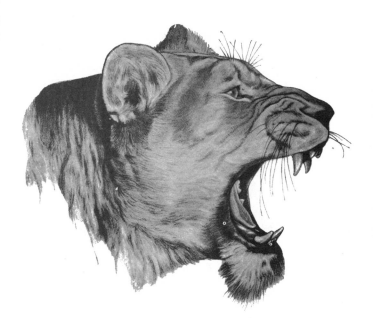

that much of the anatomical description does not agree with later (and present-day) descriptions as found in Ellenberger. To include them would probably be more confusing than helpful to the student.

The four plates on the anatomy of the cat are selected from the ANATOMIE DESCRIPTIVE ET COMPARATIVE DU CHAT by Hercole Straus - Durckheim, published in 1845. The same objection to the designations of the muscle names exists as in the case of Stubbs. Consequently, no names are given. The Cuvier plates are from ANATOMIE COMPARÉE by George Cuvier and M. Laurrillard, published in 1849. This is a giant volume which contains many more plates of equal merit, but the ones selected allow us to extend our study of comparisons to four more orders of mammals. The hare and the flying squirrel are of the order *Rodentia* (*rodere*—to gnaw); the rat kangaroo, of the order *Marsupialia* (*marsupium*—pouch); the bat, of the order *Chiroptera* (*chiro*—hand, *pteron*—wing). The monkey, like man, belongs to the order *Primates* (*primus*—first). Although the seal, because of its teeth, is classed with the carnivores, it is worth including because it is a mammal that has adapted itself to the sea. The flying squirrel is a link between the earth and the air while the bat, as much a mammal as the rest, has made itself entirely independent of the ground.

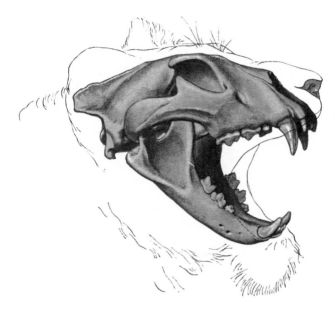

The amazing thing to me about all this is how much alike these animals are. The parts which they have in common far exceed those which each has alone. All are built around much the same skeletons. It is easy to locate a scapula, an elbow, a wrist on every one although the wrist on a monkey or man, may be called a knee on the horse or the cow. That is merely a confusion of terms, not a difference in structure. If one cared to look carefully enough, he would find that the attachments of the muscles in the different animals are the same. True, the sizes and shapes of the bones and muscles differ, and some of each have been discarded when no longer needed. The bones and muscles in the feet of horses are simpler and are easier to understand than those of most of the rest.

This leads us naturally into the subject of evolution. All the mammals shown in this book, or in any other for that matter, had a common ancestor which we are convinced lived in the closing ages of the huge reptilian dinosaurs. From it have arisen such different forms as the bat, the horse, the whale; a small animal that flies through the air, a large animal that runs across the land, and a huge animal that never leaves the water. Of all the animals included in this book, the rat kangaroo most resembles the common ancestor form.

Ernest Thomson Seton in his book, ANIMAL ANATOMY FOR ARTISTS, instructed his readers to consider the dog as the average mammal and to make it a first study from which to branch out into the study of other forms. This is a sensible suggestion as the dog is not as specialized as, for instance, the horse. However, for a number of reasons, I, myself, did my initial study of animal anatomy on the horse. It is, first of all, one of the simplest animals in structure. It is highly specialized with but a single toe on each foot and a fusion of bones in the legs. It has specialized joints which greatly limit the possible action. Secondly, there is a comparative wealth of easily accessible material on it. In addition, there are several

good comparisons of the horse form to the human form which allow the student readily to use what knowledge of human anatomy he may already possess to understand the quadripedal form. For these reasons, I have included more material in the appendix and in the bibliography on the horse than on any other animal.

Lastly, I have inserted a trifle on the sizes of the animals shown. I have added from the original edition those measurements by Ellenberger which pertain to horses of a kind to be found in this country at the present time. All the measurements are given in feet and inches.

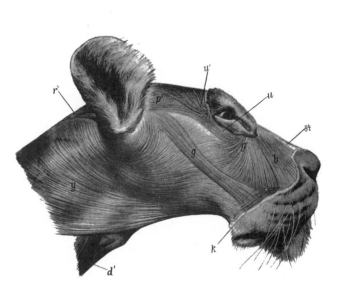

A NOTE ON STRUCTURE

All of the plates in this volume, designed primarily for the artist, deal only with the bones and muscles. In the Ellenberger, Baum, and Dittrich plates, a uniformity of part designations exists. For instance, the last muscle shown in the side view of the body of the horse, the dog, the lioness, the cow, the goat, the stag, and the roe is the *M. Semitendonosis*, and in each case designated by the small letter *r*. With few exceptions, numbers are used for the bones and letters for the muscles.

The animals shown have in common a skeleton framework comprised of a series of bones joined together and placed at certain definite angles to each other. At the joints, the bones are held together by ligaments. A ligament is a band of white fibrous tissue, pliant and flexible, to allow movement at the joint, but tough, strong, and inelastic. It does not contract as does a muscle. Between the bones at the joints is a padding or cushion of cartilage, a pearly white, gristly substance. It is also found in passages which must be kept open such as the nostrils and the ears.

The muscles are the motors of the body which cause movement. They are formed by bundles of reddish fibers endowed with the property of contractability. The muscles are connected to the bones, cartilage, or ligaments either directly or by tendons or aponeuroses. Tendons are white, glistening, fibrous cords varying in thickness and in length, sometimes round, sometimes long and flattened, of considerable strength and slight elasticity. Aponeuroses are fibrous membranes similar in structure to tendons. Tendons and aponeuroses are connected to the muscles at one end and to the movable bones, cartilage, and ligaments at the other.

Muscles act in pairs. For every muscle pulling in one direction, there must be a corresponding one pulling in the opposite direction. A muscle on the left side of the body is matched by a similar one on the right side.

In Plate 3 of the horse No. 1, the scapula, forms slightly more than a right angle with No. 4, the humerus, which joins it. If these two bones move toward each other, the angle decreases. The muscles causing this action are called flexors. If the scapula and humerus straighten, the muscles causing this would be called extensors. However, the same muscle which helped flex the scapula

and humerus might extend the humerus and radius. In one action it would be called a flexor, in the other, an extensor. This dual function of some muscles, with their several attachments, creates a difficulty in naming them and describing their functions. Adduction and abduction refer to the position of the bone or bones in relation to the center line of the body. Adduction means toward the center-line; abduction means away from the center-line.

LEWIS S. BROWN

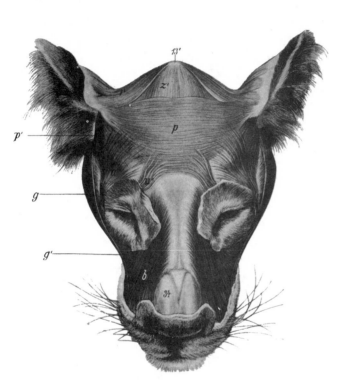

The Horse

THE HORSE - PLATES 1 2 3

FIGURES 1 2 3

a, a'—M. trapezius
c, c'—M. cleidomastoideus
d—M. sternomandibularis
e, e—M. deltoideus
f, f'—M. triceps brachii
g—Anterior portion of the M. pectoralis major
h—Posterior portion of the M. pectoralis minor
h'—Scapular portion of the M. pectoralis minor
i—Thoracic part of the M. serratus anterior
i'—Cervical part of the M. serratus anterior
k—M. latissimus dorsi
l, l'—M. obliquus abdominis externus
l''—Remainders of the abdominal subcutaneous
 muscle
m—M. serratus posterior
m'—Fascia
o—M. tensor fasciae latae
o'—Fascia lata
o''—M. gluteus maximus
p'—Fascia glutaea
q, q', q''—M. biceps femoris
r—M. semitendinosus
s, t—Short and long levators of the tail
u—Abductor of the tail
v—Cervical subcutaneous muscle (cervical
 panniculus)

w—M. splenius
x—A small part of the M. rhomboideus
y—Tendon of the M. longissimus capitis et
 atlantis
z, z'—M. supraspinatus
1 H—1st cervical vertebra (Atlas)
7 H—7th cervical vertebra
K—Sacrum
6 K—6th costal cartilage
1 L—1st lumbar vertebra
6 L—6th lumbar vertebra
1 R—1st thoracic (dorsal) vertebra
6 R—6th rib
17 R—17th thoracic (dorsal) vertebra
18 R—18th rib
1 S—1st caudal vertebra
16 S—16th caudal vertebra
*—Ala border of the atlas
1—Scapula
1'—Cartilago scapulae
2—Spina scapulae
4—Humerus
4'—External epicondyle
5—External tuberosity
6—Rotator
7—Ulna

8—Olecranon
9—Radius
10—Carpus
11—Os pisiforme
12—Metacarpus
13—Phalanges manus
14—Sternum
14''—Cartilago xiphoidea
15—Ossa pelvis
16—Tuber coxae
16'—Tuber sacrale
17—Tuber ischiadicum
18—Os femoris
19—Trochanter major
20—Patella
21—Tibia
21'—External condyle
22—Tarsus
23—Fibula
24—Tuber calcanei
25—Metatarsus
26—Phalanges pedis
27—Trochanter minor
28—Trochanter tertius

[2]

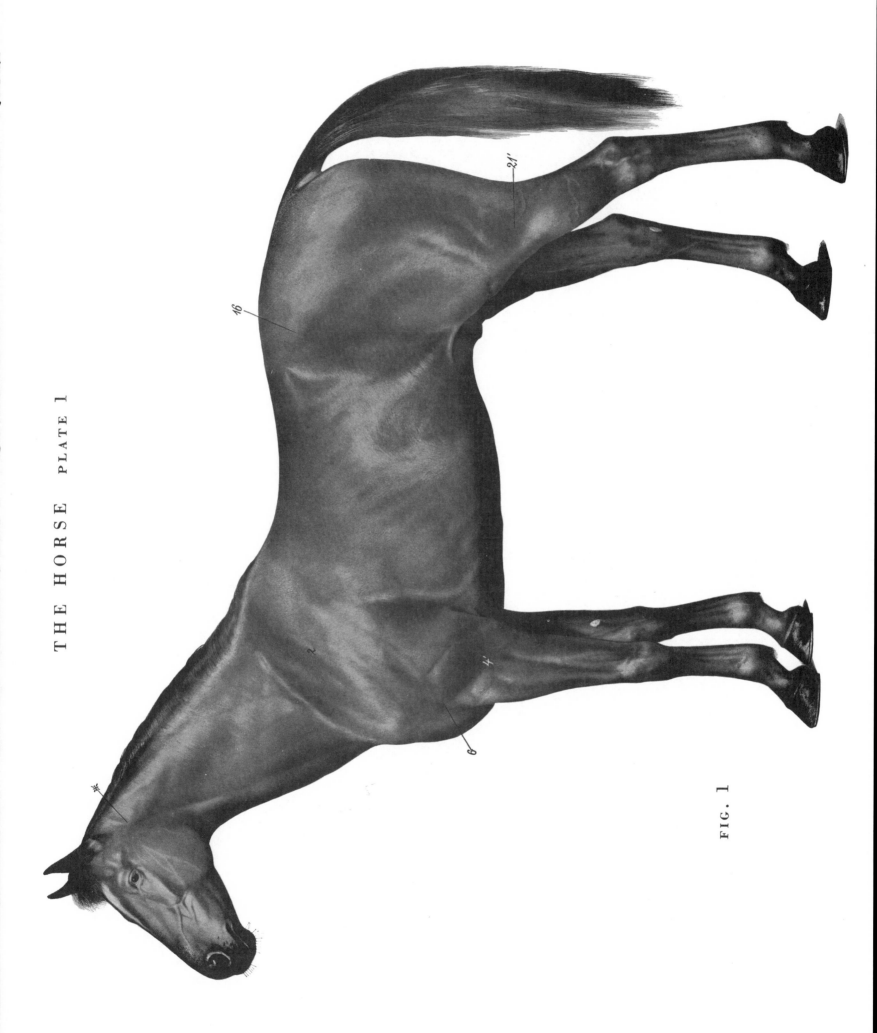

FIG. 1

THE HORSE PLATE 2

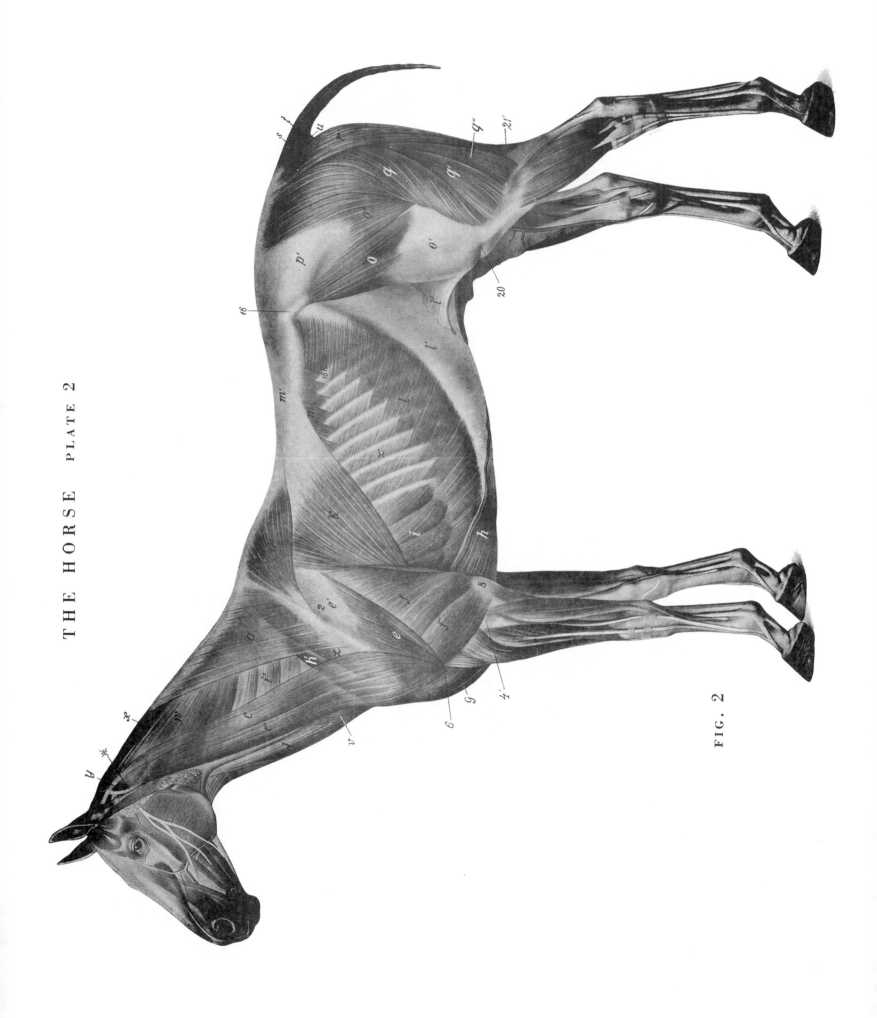

FIG. 2

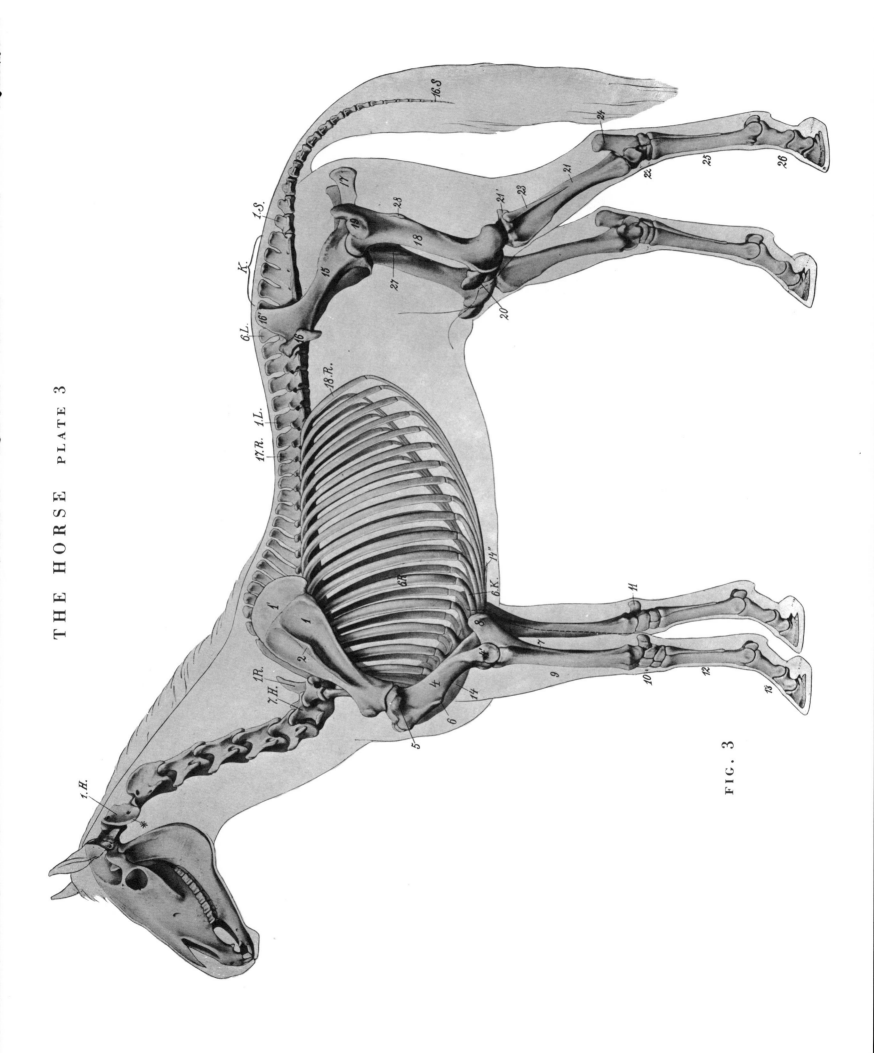

FIG. 3

THE HORSE · PLATE 4

FIGURES 4 5 6

a—M. trapezius
c, c'—M. cleidomastoideus
d—M. sternomandibularis
f, f'—Caput longum et laterale tricipitis brachii
g—Clavicular part of M. pectoralis major
g'—Sternal part of M. pectoralis major
h'—Scapular part of M. pectoralis minor
v—Cervical subcutaneous muscle (cervical
 panniculus)
z—M. supraspinatus

1R—1st rib
1—Scapula
1'—Cartilago scapulae
2—Spina scapulae
4—Humerus
4'—External epicondyle of humerus
5—External tuberosity of humerus
6—Deltoid tuberosity of humerus (Rotator)
9—Radius
10—Carpus

12—Metacarpus
13—Phalanges of anterior digit
14—Sternum
14'—Cariniform cartilage
29—M. omoyoideus
30—M. sternohyoideus
31—V. jugularis
32—Cutaneous vein

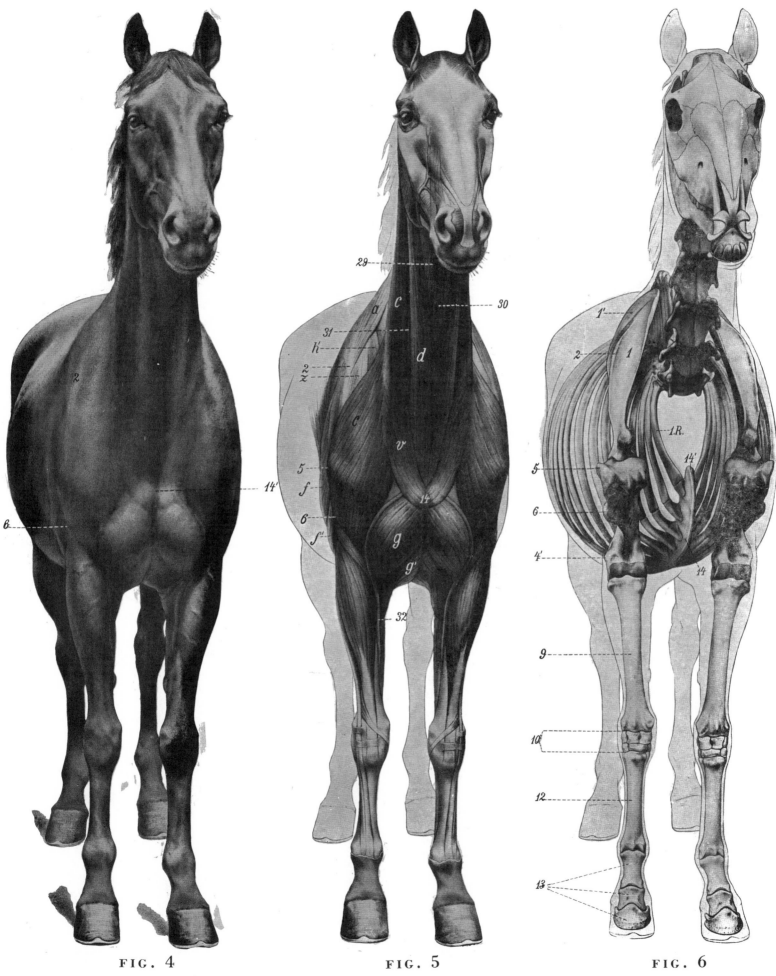

FIG. 4 FIG. 5 FIG. 6

THE HORSE · PLATE 5

FIGURES 7 8 9

a—Inner terminal tendon of M. tibialis anterior
d—M. extensor digitorum pedis lateralis
e—M. flexor digitorum profundus
e'—Deep flexor tendon
e''—M. tibialis posterior
f—Terminal part of the united Mm. gastro-
 cnemii
f'—Tendo achillis
f''—M. soleus
g—Superficial flexor tendon
h—M. interosseus medius
m—M. flexor digitorum pedis longus
o—M. tensor fasciae latae
o''—M. glutaeus maximus
p'—Fascia glutaea
q, q', q''—M. biceps femoris
r—M. semitendinosus

s, t—Muscles of the tail
v—M. semimembranosus
w—M. gracilis
K—Sacrum
1 S—1st caudal vertebra
16 S—16th caudal vertebra
15—Ossa pelvis
16—Tuber coxae
16'—Tuber sacrale
17—Tuber ischii
18—Femur
18'—External condyle of the femur
19—Trochanter major of the femur
20—Patella
21—Tibia
21'—External condyle of the tibia
22—Tarsus

23—Fibula
24—Tuber calcanei
25—Large cannon bone (3rd metatarsal bone)
25'—External small cannon or splint bone
 (4th metatarsal bone)
25''—Capitulum
27—Internal trochanter of the femur
28—External trochanter of the femur
29—Sesamoid bones of the 1st digital joint
30—Phalanx prima
31—Phalanx secunda
32—Phalanx tertia
33—Sesamoid bone of the 3rd digital joint
34—Anus
35—Vulva

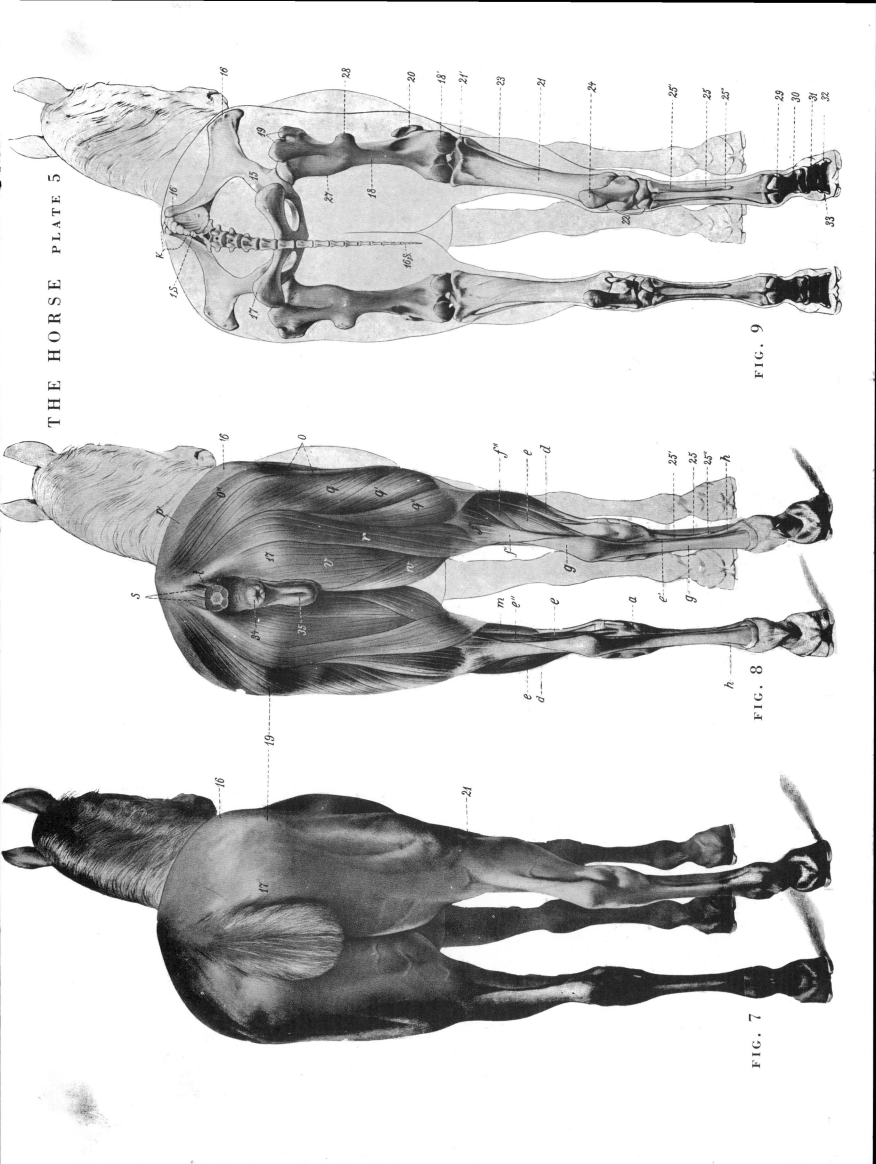

FIG. 9

FIG. 8

FIG. 7

THE HORSE · PLATE 6

FIGURES 10 11 12

[10]

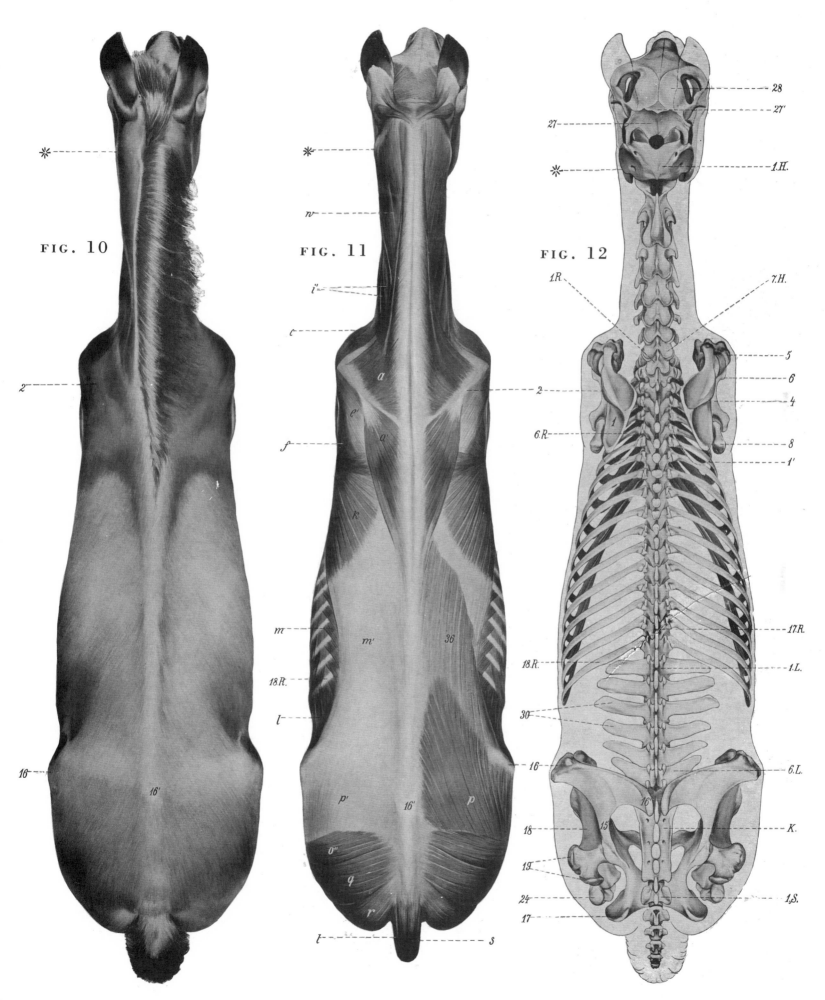

FIG. 10

FIG. 11

FIG. 12

THE HORSE - PLATE 7

FIGURES 13 14 15

d—M. sternomandibularis
f, f'—M. triceps brachii
g—Anterior portion of the M. pectoralis major
h—Posterior portions of the M. pectoralis minor
h'—Scapular portion of the M. pectoralis minor
i—Thoracic portion of the M. serratus anterior
i'—Cervical portion of the M. serratus magnus
l—Part of the M. obliquus abdominis externus
l'—Tendon of the M. obliquus abdominis externus
m—M. serratus posterior
p—M. glutaeus medius
r—M. semitendinosus
s, t—Short and long levators of the tail
u—Abductor muscle of the tail
v'—M. biceps brachii
x—M. rhomboideus
y—M. longissimus capitis
y'—M. longissimus atlantis
z—M. supraspinatus
z', z''—M. infraspinatus
18 R —18th rib

*—Border of the atlas
1—Scapula
1'—Cartilago scapulae
2—Spina scapulae
4—Humerus
4''—External lateral ligament of the elbow joint
5—External tuberosity of the humerus
6—Deltoid tuberosity of the humerus
7—Ulna
8—Olecranon
9—Radius
16—Tuber coxae
19—Trochanter major of the femur
20—Depression over the lower part of the patella
21'—External condyle of the tibia
26—Articular processes of the cervical vertebrae
27—Depressor muscle of the auricle
28, 28'—M. quadriceps femoris
28''—Trochanter tertius femoris
29—A part of the M. semimembranosus
30—Mm. gastrocnemii
31—Posterior part of the sacro-sciatic ligament

32—M. omohyoideus
33—M. complexus
34—M. longus capitis
35—M. spinalis et semispinalis dorsi et cervicis
36—M. longissimus dorsi
37—M. iliocostalis
38—M. teres minor
39—M. brachialis internus
40—M. intercostalis
41—M. obliquus abdominis internus
42—M. iliacus
43—M. transversus abdominis
44—Dotted line indicating the distance between the two external angles of the ilium, upper view of the pelvis of a stallion
45—Dotted line indicating the distances between the two hip joints, upper view of the pelvis of a stallion
46—Dotted line indicating the distance between the tuberosities of the ischia, upper view of the pelvis of a stallion
47—Cervical ligament cord

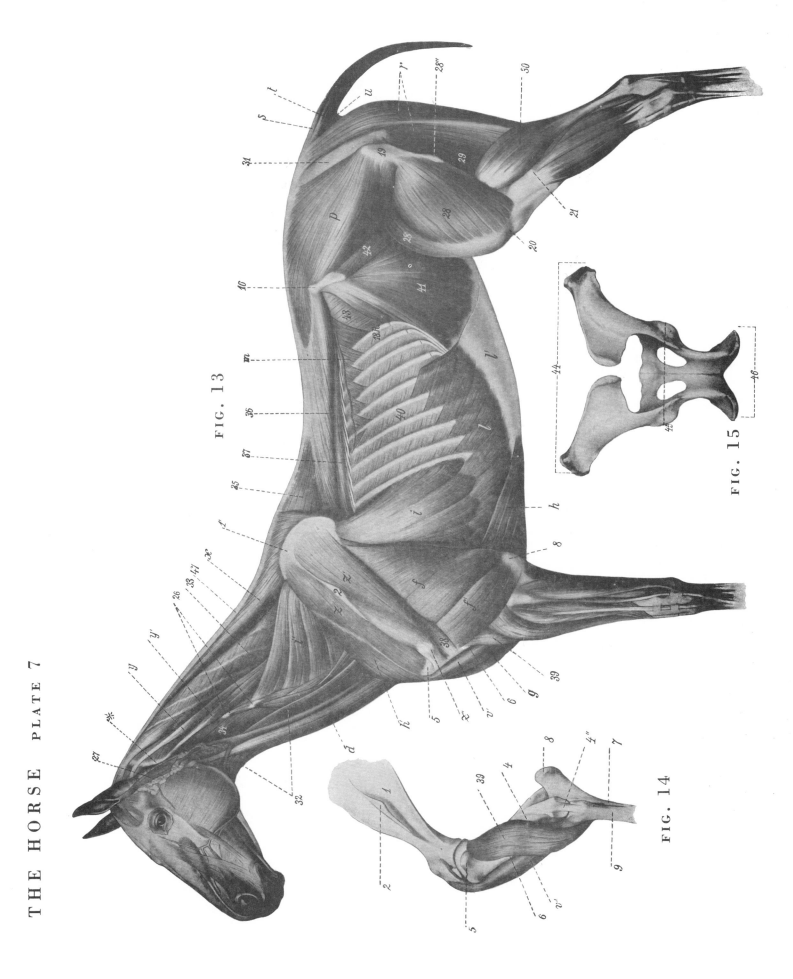

FIG. 13

FIG. 14

FIG. 15

THE HORSE · PLATE 8

FIGURES 16 17 18 19

c—Lower marginal part of the M. mastoido-humeralis
d—M. sternomandibularis s. sternocephalicus
g—Anterior portion of the M. pectoralis major
g'—Posterior portion of the M. pectoralis major
h—Posterior part of the M. pectoralis minor
i—Teeth of origin of the M. serratus magnus
k—Marginal part of the M. latissimus dorsi
l—M. obliquus abdominis externus
l'—Aponeurosis of the M. obliquus abdominis externus
l''—The fold of the groin caused by the M. panniculus carnosus
r—End of the M. semitendinosus
s'—Flexor muscles of the tail
t—M. pectineus
u—End of the M. iliopsoas
v—End of the M. semimembranosus
v'—Cervical subcutaneus muscle (cervical panniculus)
w—M. gracilis
x—M. sartorius
y, y'—M. quadriceps femoris
z, z'—Mm. adductores femoris
1 H—1st cervical vertebra
7 H—7th cervical vertebra
1 R—1st thoracic (dorsal) vertebra
*—Edge of the atlas
1—Scapula
1'—Cartilago scapulae
2—Junicular part of the ligamentum nuchae
3—Wide section of the ligamentum nuchae
4—Lamellar part of the ligamentum nuchae
8—Olecranon
9—Zygomatic arch
10—Supraorbital depression (temporal fossa)
12—Orbital arch
14—Lower edge of the sternum
14'—Manubrium streni
19—Orbital cavity
20—Patella
27—Zygomatic or facial crest
29—End of the M. omohyoideus
30—End of the M. sternohyoideus
51—Upper eyelid with its eyelashes
51'—Lower eyelid
52—Cartilago nictians
53—Caruncula lacrimalis
54—Lacus lacrimalis
55, 55'—Eyeball
56—Pupil
56'—Corpora nigra
57—Pigmented marginal band along the junction of the sclera with the cornea

[14]

THE HORSE PLATE 8

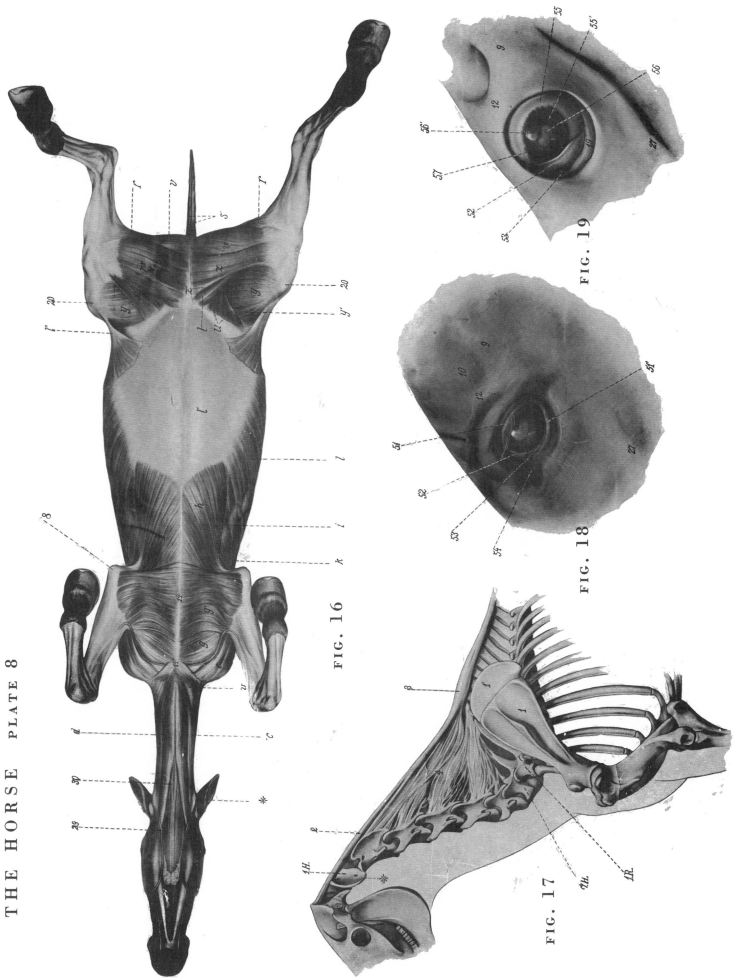

FIG. 16

FIG. 17

FIG. 18

FIG. 19

THE HORSE - PLATES 9 10

FIGURES 20 21 22 23 24 25 26 27 28 29

a—M. levator labii sup. propius
a'—Uniting tendon
b—M. levator labii sup. alaeque nasi
c—Origin of the M. sterno-cleidomastoideus
d—End of the M. sterno-mandibularis
d'—Tendon at the end of M. sterno-mandibularis
e—Terminal parts of the combined Mm. omo-
　　hyoidei et sterno-hyoidei
f—M. caninus s. pyramidalis nasi
g—M. zygomaticus major
h—M. buccinator
i—M. quadratus labii inferioris
k—M. orbicularis oris
l—M. dilatator nasi
m—M. masseter
n—Depressor of the auricle
o—External adductor of the auricle
o'—Inferior adductor of the auricle
o''—Superior adductor of the auricle
p, p'—M. scutularis
q—Abductor of the auricle
r—Levator of the auricle
s—M. obliquus capitis superior
t—M. splenius
u—M. corrugator supercilii
v—M. biventer maxillae; M. digastricus
x—M. transversus nasi
y—Tendon of the M. longissimus capitis et
　　atlantis

*—Ala border of atlas
1—Auricula or cartilage of the ear
2—External or posterior edge of auricle
3—Internal or anterior edge of auricle
4—Incisura intertragica
5—Base of auricle
6—Styloid process of auricle
7—Cartilago annularis
8—Scutellum
9—Arcus zycomaticus
10—Temporal fossa
11—Proc. coronoideus of the lower jawbone
12—Orbital arch
13—Os occipitale
13'—Crest of os occipitale
13''—Jugular process of os occipitale
13'''—Condyle of the os occipitale
14—Os parietale
14'—Crest of the os parietale
15—Os frontale
15'—Frontal crests
16—Os temporale
17—Meatus acusticus externus
18—Temporo-maxillary joint
19—Orbita
20—Os jugale
21—Os lacrimale
22—Os nasale
23—Os intermaxillare s. incisivum

24—Upper incisor teeth
25—Upper canine tooth
26—Os maxillare sup.
27—Zygomatic or facial crest
28—Body of the lower jawbone
29—Lower canine tooth, exposed from the alveo-
　　lus
29'—Incisor tooth, exposed from the alveolus
30—Branch of the lower jaw
30'—Angle of the lower jaw
31—Condyle process of the lower jaw
32—1st cervical vertebra (Atlas)
33—2nd cervical vertebra
34—Lateral cartilage of the nose
35, 35'—The X shaped or alar cartilage of the
　　nose
37—V. maxillaris externa
38—V. jugularis
39—V. facialis
40—Ductus parotideus
41—Transverse facial vein
42—Masseteric vein
43—Facial nerve
44—Glandula parotis
45—Chin
46—Enamel ridge of the incisor tooth as seen
　　from the masticatory surface
47—Mark or cup characteristic of the incisor
　　tooth

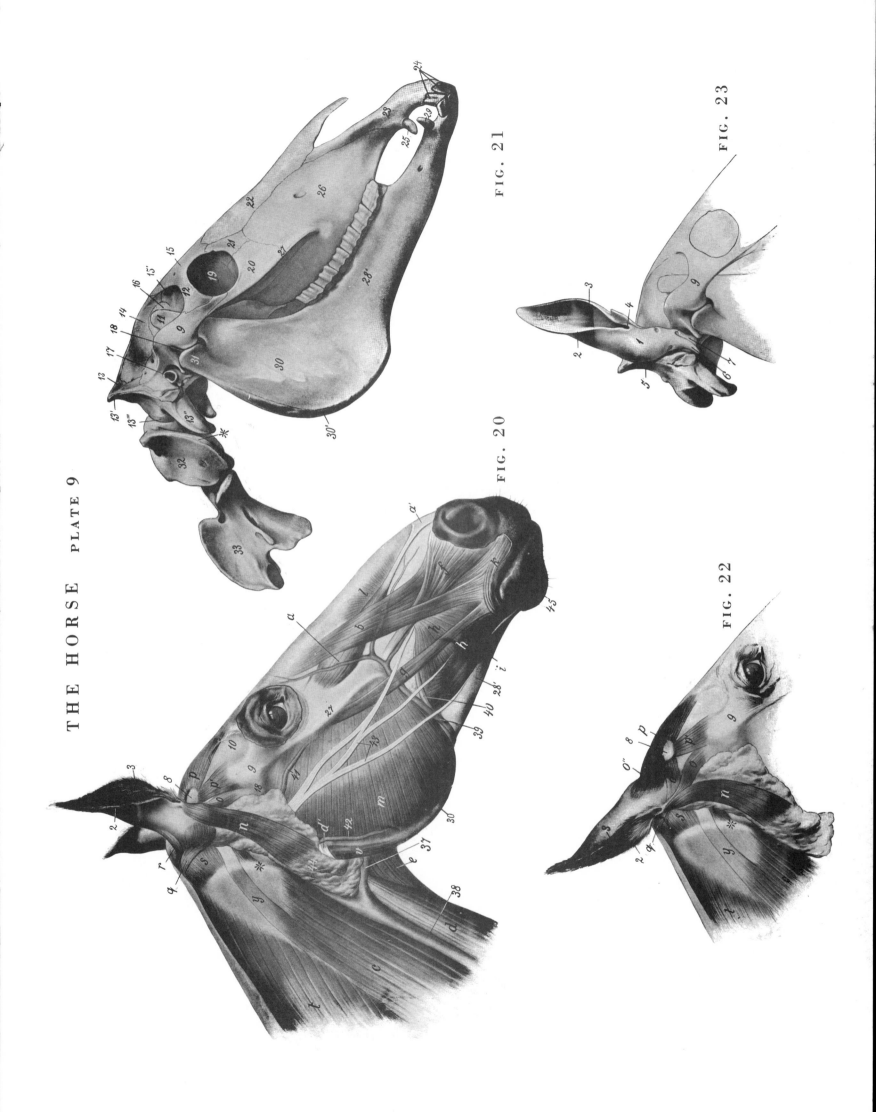

THE HORSE PLATE 9

FIG. 21

FIG. 23

FIG. 20

FIG. 22

THE HORSE PLATE 10

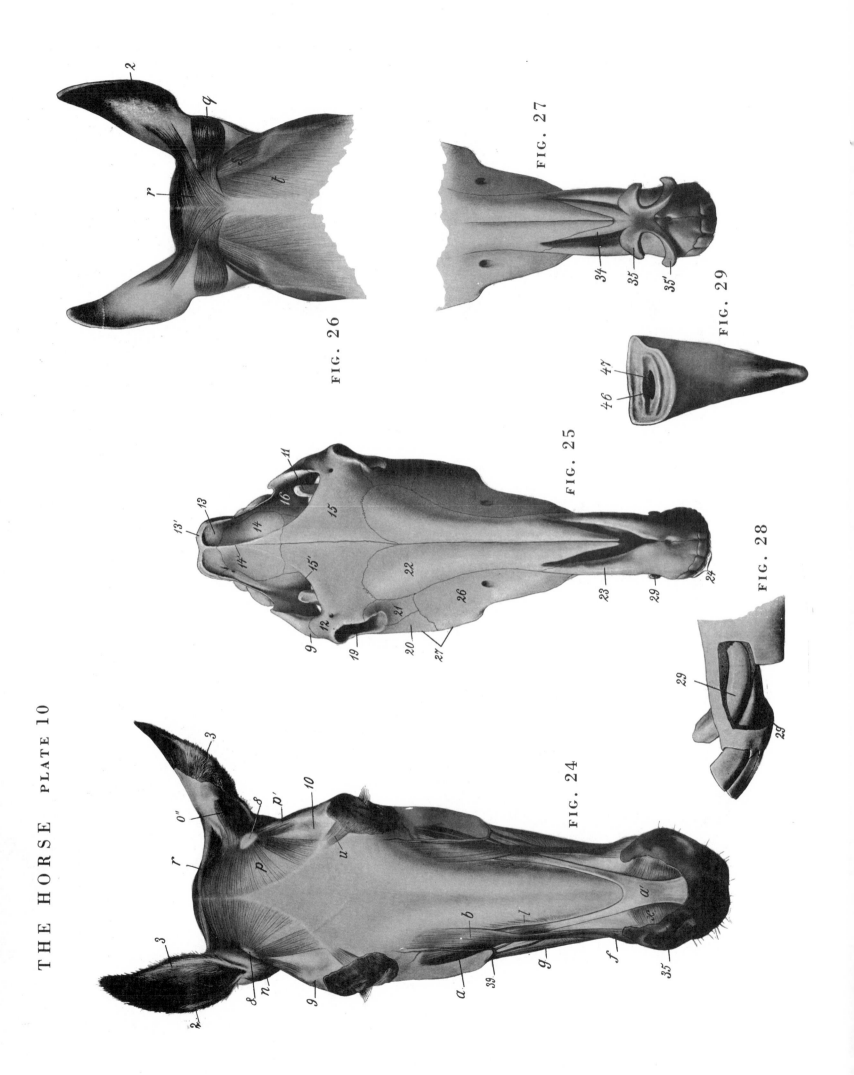

FIG. 24

FIG. 25

FIG. 26

FIG. 27

FIG. 28

FIG. 29

THE HORSE - PLATES 11 12

FIGURES 30 31 32 33 34 35 36 37 38 39 40 41

a—M. extensor carpi radialis
c—M. extensor digitorum communis
d, d'—M. extensor digiti minimi
e, e'—M. extensor carpi ulnaris
f—M. abductor pollicis longus
f''—Ulnar head of the deep flexor of the digit
g—End of the M. brachialis internus
g'—End of the M. pectoralis major
g''—Same muscle of the left side
h—M. interosseus medius
h'—Tendinous band to the tendon of the digito-
　　rum communis
i—Flexor tendons

i'—Check ligament
k—M. flexor carpi radialis
l—M. extensor carpi ulnaris
n—Lateral cartilage
o—M. flexor digitorium profundus
p—Great subcutaneous vein
q—Annular ligament
4—Humerus
4'—External or extensor condyle of the humerus
7—Ulna
8—Olecranon
9—Radius
9'—External tuberosity of the radius

10—Bones of the carpus
11—Os pisiforme
12—Large metacarpal bone
12'—Tuberosity of large metacarpal bone
14—External small metacarpal bone
14'—Internal small metacarpal bone
15—Sesamoid bones of the 1st digital joint
16—Phalanx prima
17—Phalanx secunda
18—Phalanx tertia
19—Sesamoid bones of the 3rd digital joint

THE HORSE PLATE 11

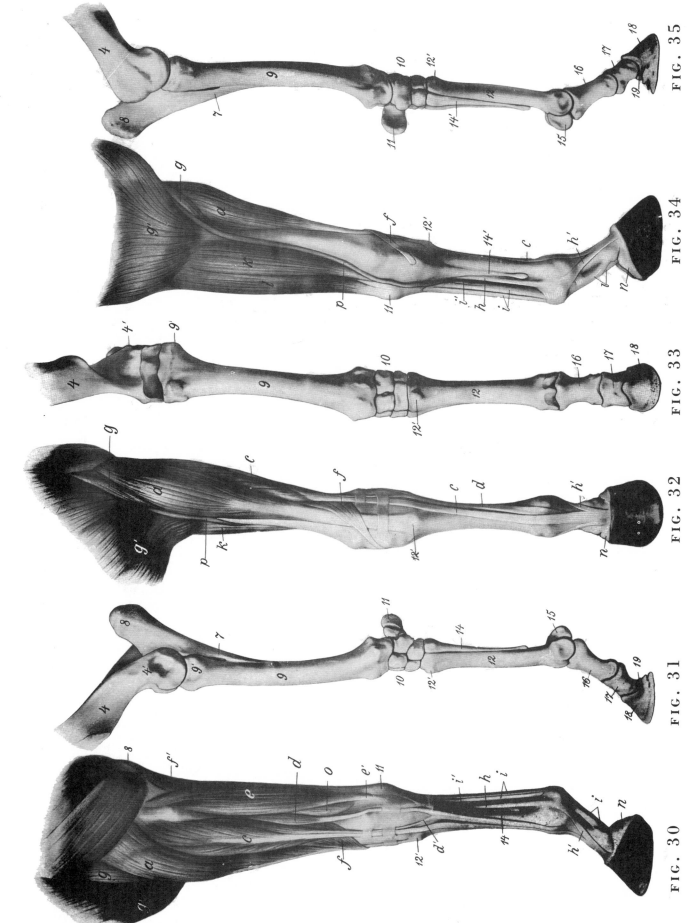

FIG. 30

FIG. 31

FIG. 32

FIG. 33

FIG. 34

FIG. 35

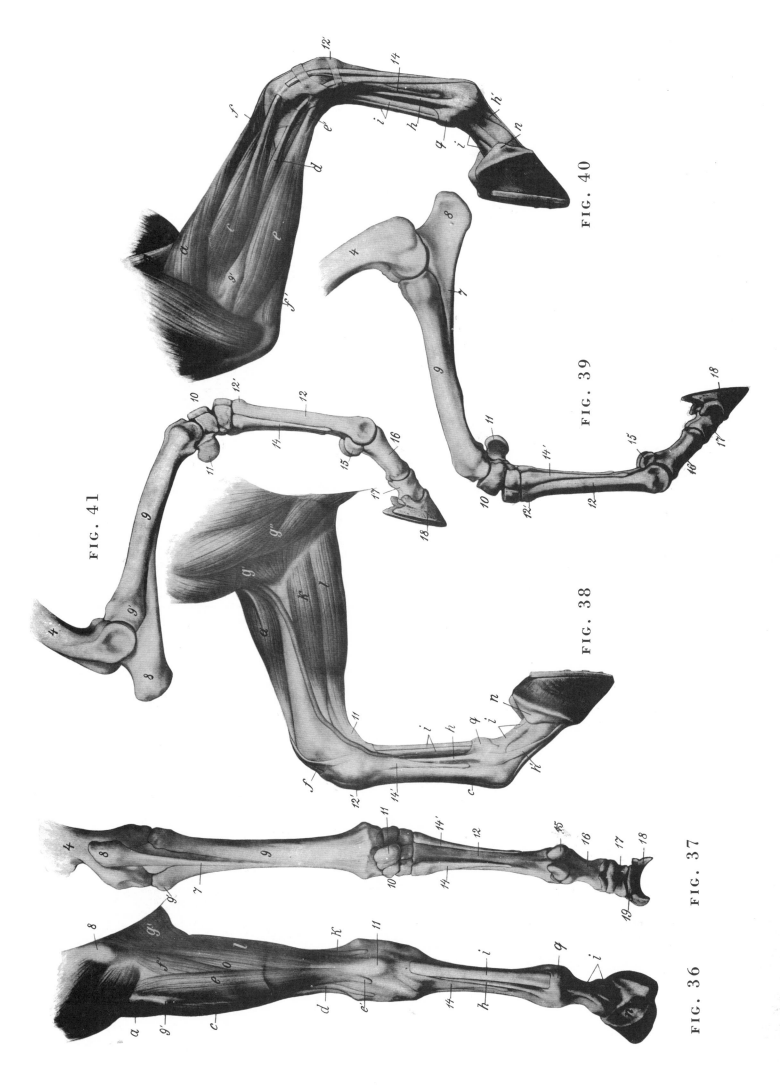

THE HORSE PLATE 12

FIG. 36 FIG. 37

FIG. 38

FIG. 39

FIG. 40

FIG. 41

THE HORSE · PLATES 13 14 15

FIGURES 42 43 44 45 46 47 48 49. 50 51 52 53 54 55 56 57 58 59

a—M. tibialis anterior
a'—Inner branch of M. tibialis anterior
a''—Outer branch of M. tibialis anterior
a'''—M. peronaeus tertius
b, b'—M. extensor digitorum longus
d, d'—M. extensor digitorum pedis lateralis
e—M. flexor hallucis longus
e'—Fusion of tendon and M. flexor hallucis longus
e''—M. tibialis posterior
f—Mm. gastrocnemii
f'—Tendo Achillis
f''—M. soleus
g—Superficial flexor tendon
h—M. interosseus medius
i, i', i''—Annular ligaments
l—Tendinous band from the interosseus medius to the common extensor tendon
m—Mm. flexor digitorum pedis longus
m'—Tendon of M. flexor digitorum pedis longus
o—M. popliteus
o'—Fascia covering the M. quadriceps femoris
q, q', q''—End of the M. biceps femoris
q'''—Tendinous band from M. biceps femoris to fascia of leg

r—End of the M. semitendinosus
r'—Tendon of M. semitendinosus
w—End of the M. gracilis
x—End of the M. sartorius
y—End of the M. quadriceps femoris
18—Lower end of femur
20—Patella
21—Tibia
21'—External condyle of tibia
21''—External malleolus of tibia
21'''—Internal malleolus of tibia
22—Tarsus
22'—Os tarsi tibiale
23—Fibula
24—Tuber calcanei
25—Large metatarsal bone
25'—Inner small metatarsal bone
25''—Nodular enlarged end of inner small metatarsal bone
29—Sesamoid bone of 1st digital joint
30—Phalanx prima
31—Phalanx secunda
32—Phalanx tertia
36—Crista tibiae

37—External long lateral ligament of the hock joint
37'—Inner edge of the lower surface of the sole, right fore hoof
38—External short lateral ligament of the hock joint
38'—Outer edge of the lower surface of the sole, right fore hoof
39—Plantar ligament of the hock joint
39'—Bearing edge, right fore hoof, unshod
40—Oblique ligament of the hock joint
40'—So-called white line, right fore hoof
41—Internal long lateral ligament of the hock joint
41'—Sole, right fore hoof
42—Internal short lateral ligament of the hock joint
42'—Apex of frog, right fore hoof
43—Branch of frog, right fore hoof
44—Median furrow of frog, right fore hoof
45—Lateral furrow of frog, right fore hoof
46—Bar, right fore hoof
47—Left fore hoof, shod
48—Left hind hoof, shod

THE HORSE PLATE 13

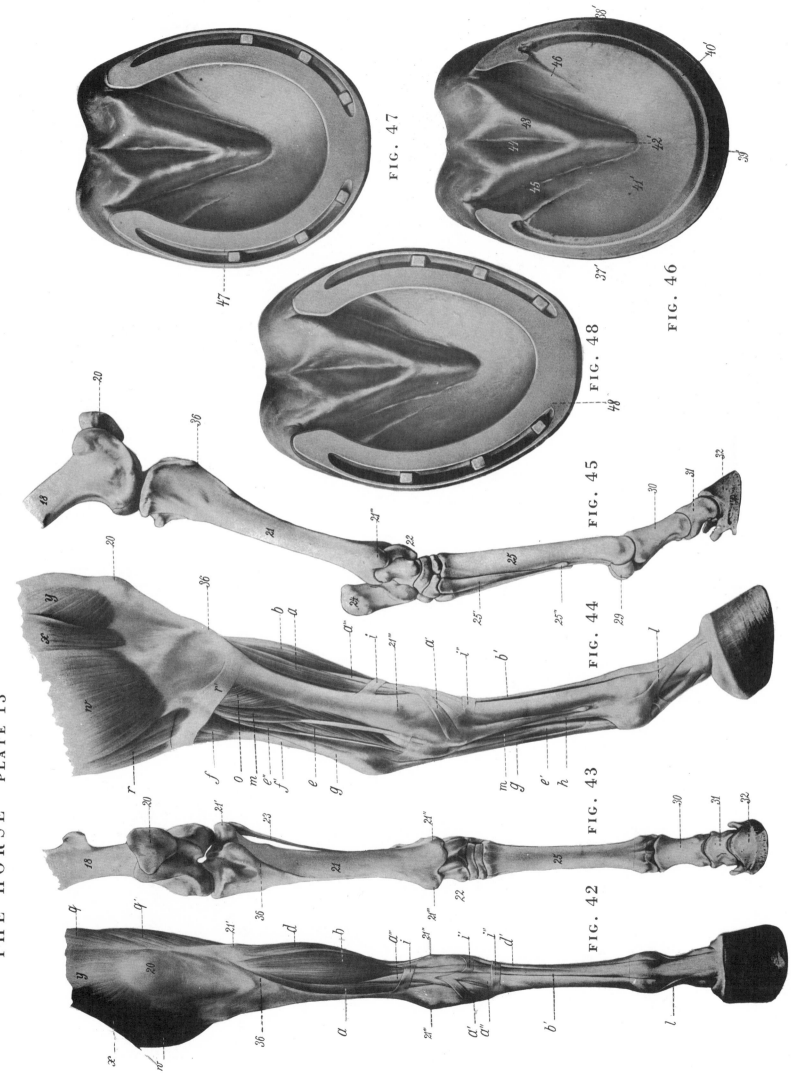

FIG. 42
FIG. 43
FIG. 44
FIG. 45
FIG. 46
FIG. 47
FIG. 48

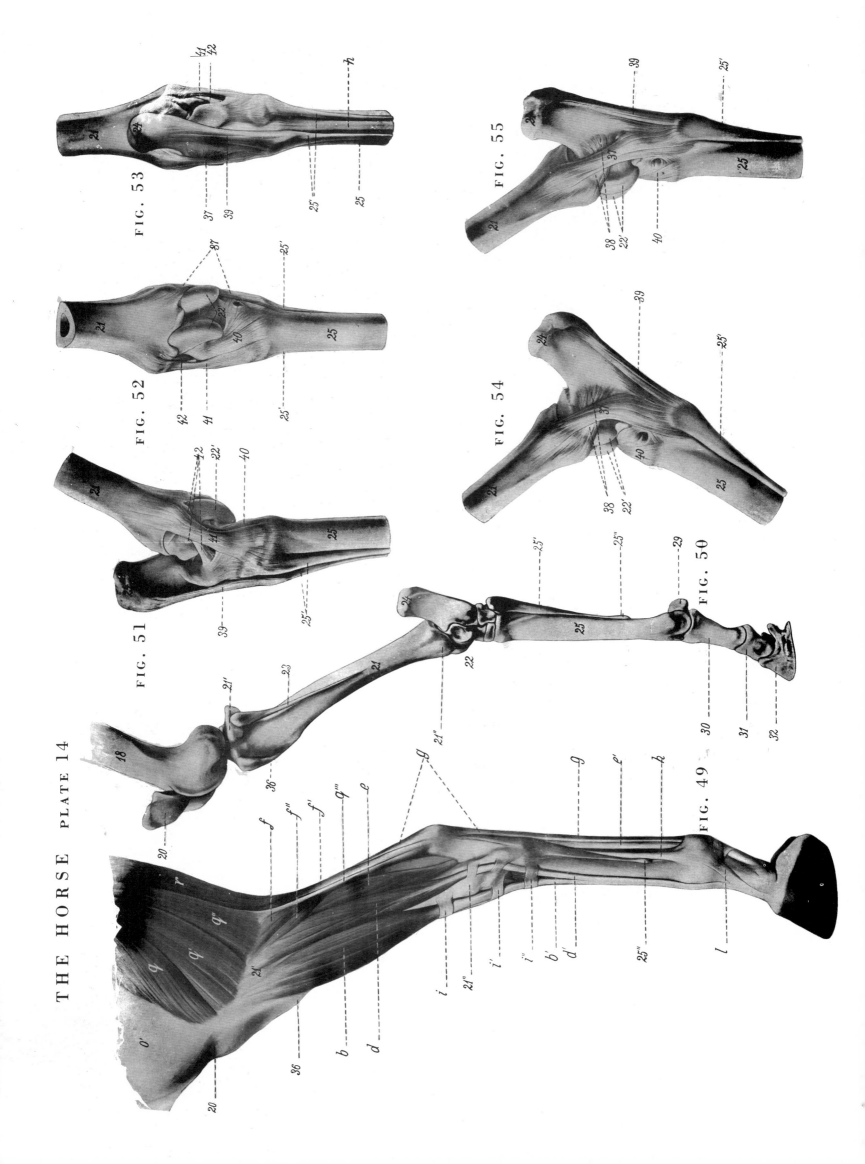

THE HORSE PLATE 14

FIG. 49

FIG. 50

FIG. 51

FIG. 52

FIG. 53

FIG. 54

FIG. 55

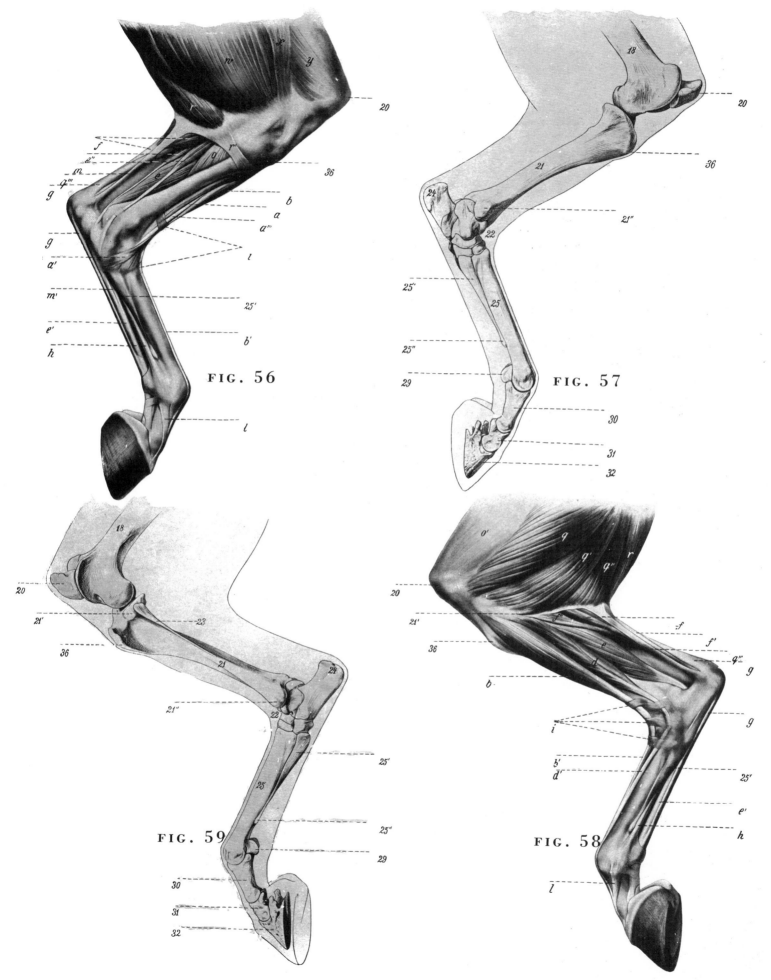

FIG. 56

FIG. 57

FIG. 59

FIG. 58

THE HORSE · PLATE 16

FIGURES 60 61 62 63 64 65 66 67

a, a', a''—Straight patellar ligaments
b, b'—Lateral patellar ligaments
c—External lateral ligements of the stifle (or femoro-tibial) joint
c'—Internal lateral ligaments of the stifle (or femoro-tibial) joint
d—Menisci
e—External lateral ligament of the carpal joint
e'—Internal lateral ligament of the carpal joint

f—Lig. pisometacarpeum
9—Lower end of the radius
9''—External tuberosity of the radius
9'''—Internal tuberosity of the radius
11—Os pisiforme
12—Large metacarpal bone
12'—Tuberosity of large metacarpal bone
14—External small metacarpal bone
14'—Internal small metacarpal bone

18—Lower end of the femur
18'—Inner ridge of the trochlea of the femur
20—Patella
20'—Cartilage serving to complete the patella
21—Tibia
21'—External condyle of tibia
23—Fibula
36—Crista tibiae

THE HORSE PLATE 16

FIG. 60

FIG. 61

FIG. 62

FIG. 63

FIG. 64

FIG. 65

FIG. 66

FIG. 67

THE HORSE - PLATE 17

FIGURES 68 69 70 71 72 73

1—Large metacarpal bone
2—Lower nodular end of the external small metacarpal bone
3—1st digital or fetlock joint
4—Sesamoid bone
5—First phalanx or large pastern bone
6—Second digital or pastern joint
7—Second phalanx or small pastern bone
8—Third digital or coffin joint
9—Third phalanx of coffin bone
10—Sesamoid bone of the 3rd digital joint
11, 11'—Lateral cartilage
12—M. interosseus medius
13—Tendinous band extending from the suspensory ligament to the extensor tendon

14, 14'—Deep flexor tendon
15—Superficial flexor tendon
15'—Terminal branches of the flexor tendon
16—Annular ligament of the fetlock
17—Vaginal ligament
18—Reinforcing sheath of the deep flexor tendon
19—Lateral ligament of the coffin joint
20—Straight sesamoidean ligament
21—Tendon of the common digital extensor muscle
22—Tendon of the lateral digital extensor muscle
23, 23'—Lateral digital vein
24—Plantar cushion
25—Coronet
26—Bulb

27—Interbulbar furrow
28—Toe of the wall of the hoof
28'—Quarter of the wall of the hoof
28''—Heel of the wall of the hoof
29—Sole of the hoof
30—Frog of the hoof
31—Clip of the shoe
32—Clinches of the horseshoe nails
33—Fetlock (tuft)
34—A small depression occurring under the nodular enlarged end of the small cannon bone

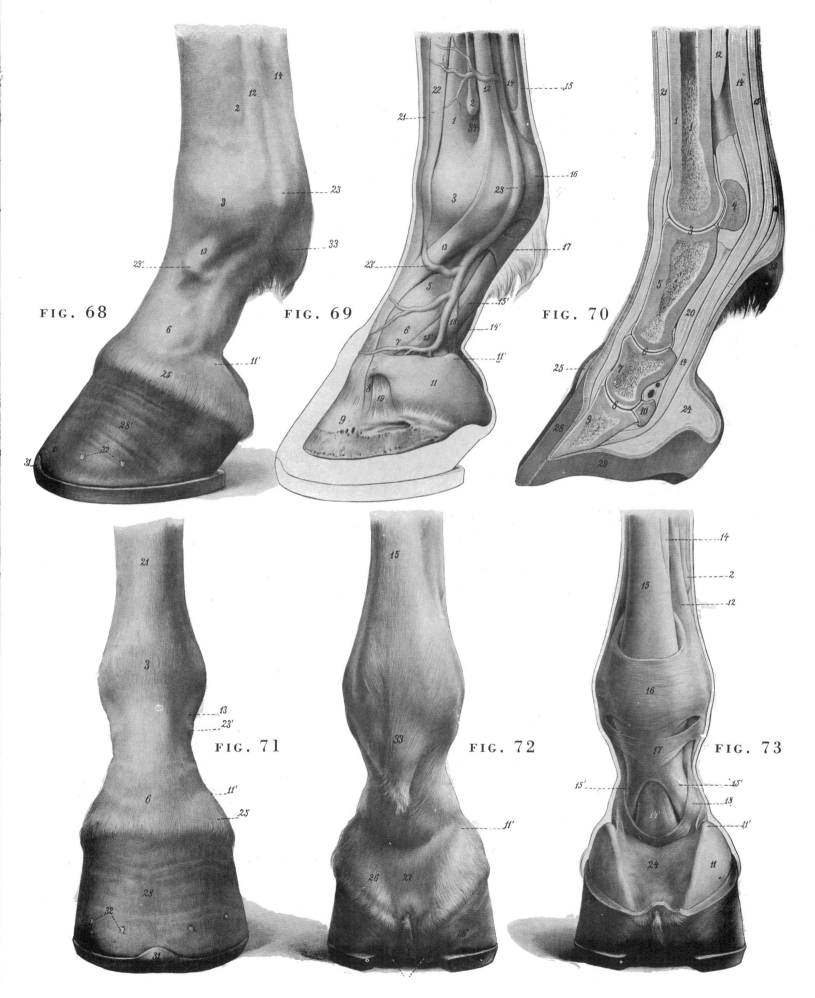

FIG. 68 FIG. 69 FIG. 70

FIG. 71 FIG. 72 FIG. 73

THE HORSE · PLATE 18

FIGURES 74 75 76 77 78 79 80 81 82 83

1—Plane of the cross section of the head shown
 in Fig. 81 on Plate 18
2—Plane of the cross section of the head shown
 in Fig. 82 on Plate 19
3—Plane of the cross section of the head shown
 in Fig. 83 on Plate 18
4—Plane of the cross section of the neck shown
 in Fig. 79 on Plate 18
5—Plane of the cross section of the chest shown
 in Fig. 80 on Plate 18
6—Plane of the cross section of the fore-arm
 shown in Fig. 77 on Plate 18
7—Plane of the cross section of the fore-cannon
 shown in Fig. 75 on Plate 18
8—Plane of the cross section of the leg shown
 in Fig. 78 on Plate 18
9—Plane of the cross section of the hind-cannon
 shown in Fig. 76 on Plate 18
10—Outer skin
11—Nuchal fat
12—M. rhomboideus
13—M. splenius
14—Cervical part of M. serratus magnus
15—M. mastoido-humeralis
16—M. sterno-cephalicus
17—Trachea
18—Oesophagus
19—V. jugularis
20—5th cervical vertebra
21—M. trapezius
22—Ligamentum nuchae
23—Thoracic vertebra
24—Rib sections
24'—Xiphoid cartilage
25—Thoracic cavity
26—M. pectoralis minor
27—M. rectus abdominis
28—M. obliquus abdominis externus
29—Thoracic part of the M. serratus magnus
30—M. latissimus dorsi
31—Panniculus carnosus of the abdomen
32—Dorsal part of the M. trapezius
33—M. longissimus dorsi
34—Radius
35—M. extensor carpi radialis
36—M. extensor digitorum communis
37—M. extensor digiti lateralis
38—M. extensor carpi ulnaris
39—M. flexor carpi ulnaris
40—M. flexor carpi radialis
41—M. flexor digiti sulimis
42, 43—M. flexor digiti profundus
44—Greater subcutaneous vein
45—Tendon of the common extensor of the digit
46—Tendon of the lateral extensor of the digit
47—Large metacarpal bone
48, 48'—Outer and inner small metacarpal bones
49—Superficial flexor tendon
50—Deep flexor tendon
50'—Reinforcing ligament of the flexor tendon
51—M. interosseus medius
52—Large veins
53—Tibia
54—Fibula

55—Long or common extensor of the digit
56—M. peronaeus tertius
57—M. tibialis anterior
58—Tendo Achillis
59—Superficial flexor tendon
60—Deep flexor of the digit
60'—M. tibialis posterior
60''—M. flexor dig. longus
61—M. extensor dig. lateralis
62—Internal subcutaneous vein
63—Tendinous tissue
64—Larte metatarsal bone
65, 65'—Outer and inner small metatarsal bones
66—Tendon of the long or common digital ex-
 tensor
67—Superficial flexor tendon
68—Deep flexor tendon
69—M. interosseus medius
70—Large veins
71—Mandible
72—Maxilla
72'—Zygomatic or facial crest
73—M. levator labii sup. propius
74—M. levator labii sup. alaeque nasi
75—M. caninus s. pyramidalis nasi
76—M. zygomaticus major
77—M. buccinator
78—M. quadratus labii inferioris
80—M. masseter
81—Frontal bone
82—Maxillary sinus

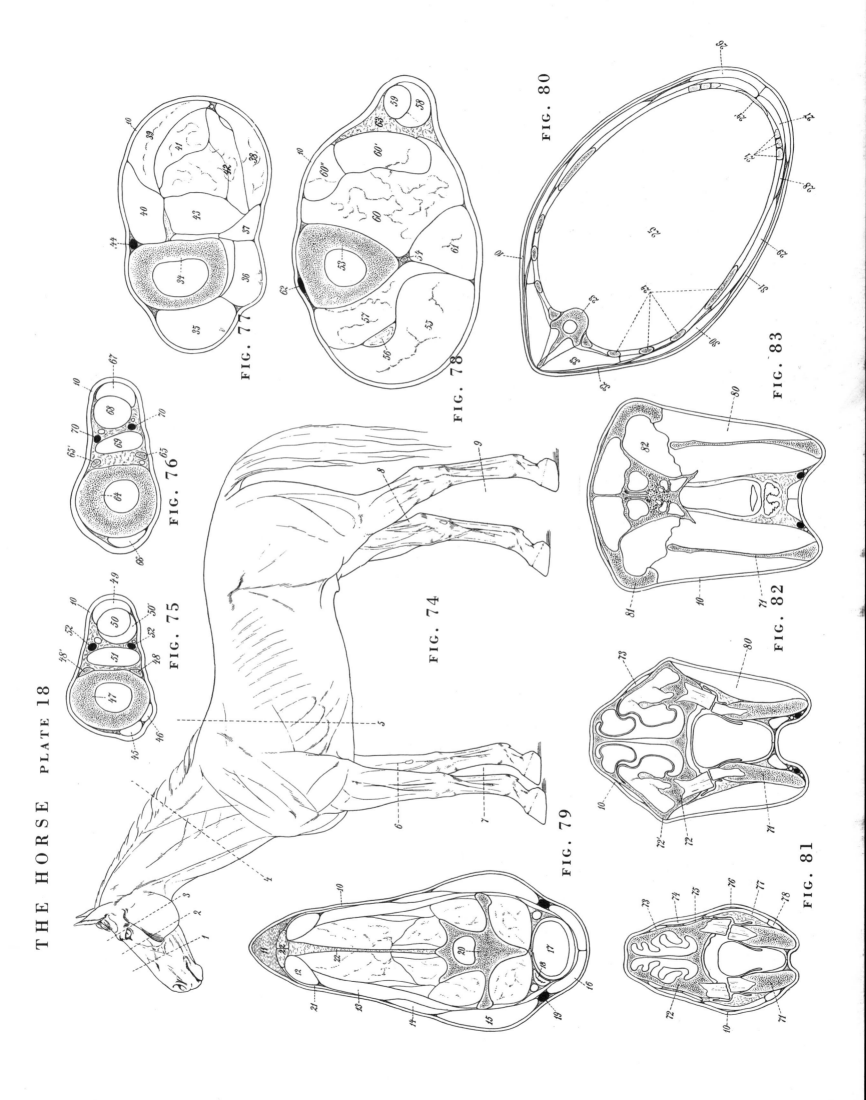

THE HORSE PLATE 18

FIG. 74

FIG. 75

FIG. 76

FIG. 77

FIG. 78

FIG. 79

FIG. 80

FIG. 81

FIG. 82

FIG. 83

[32]

THE HORSE · PLATES 19 20

FIGURES 84 85 86 87 88

1—Height of withers
2—Height of buttocks
3—Length of the trunk
4—Length (breadth) of the shoulder-arm vicinity
5—Length of buttocks
6—Length of the trunk
7—Height of the trunk
8—Height of the trunk
9—Height of the trunk
10—Transverse diameter of the trunk
11—Transverse diameter of the trunk
12—Transverse diameter of the trunk
13—Transverse diameter of the trunk
14—Distance between the two tuberosities of hips
15—Length of the neck
16—Height (breadth) of the insertion of the neck
17—Height (breadth) of the neck
18—Transverse diameter of the neck
19—Transverse diameter of the neck
20—Length of the head
21—Distance between the outer canthus and fore-
 most ridge of the upper lip
22—Distance between the foremost end of the
 zygomatic bone and the foremost ridge
 of the upper lip
23—Height of the head
24—Breadth or transversal diameter of the head
25—Breadth of the head
26—Vertical distance of the nether chest-margin
 from the ground

27—Distance of the olecranon from the ground
28—Measurement of length from the elbow-joint
 to the nether end (condyle) of the
 styloid-bone
29—Measurement of the length from the ole-
 cranon to the most prominent point of
 the pisiform bone
30—Distance of the most prominent point of the
 pisiform bone from the middle of the
 pastern joint
31—Length of the fetlock
32—Length of the toe-joints
33—Diameter of the depth of the forearm
34—Diameter of the depth of the carpus
35—Diameter of the depth of the meta-tarsus
36—Diameter of the depth of the pastern joint.
37—Diameter of the depth in the middle of the
 fetlock
38—Transverse diameter or breadth of the fore-
 arm
39—Diameter of breadth or transverse diameter
 of the forearm just above the carpus
40—Greatest breadth of the carpus
41—Breadth, transverse diameter of the middle
 of the metacarpus
42—Breadth of the fetlock joint
43—Breadth of the middle of the fetlock
44—Greatest breadth of the coronet ridge of the
 hoof

45—Greatest breadth of the hoof at the bearing
 ridge of the wall of the hoof
46—Vertical distance of the patella from the
 ground
47—Distance of the patella from the inner con-
 dyle of the tibia
48—Vertical distance of the tuber calcanei from
 the ground
49—Length of the fetlock
50—Length of the toe part of the wall of the hoof
51—Diameter of the depth of the leg
52—Diameter of the depth of the lower leg
53—Greatest depth diameter of the tarsus
54—Diameter of the depth of the middle of the
 cannon
55—Diameter of the depth of the fetlock joint
56—Diameter of the depth of the middle of the
 fetlock
57—Transverse diameter of the most prominent
 parts of both upper thighs
58—Breadth, transverse diameter of the lower leg
59—Breadth, transverse diameter of the lower leg
60—Breadth of the tarsus
61—Middle breadth of the hind meta-tarsus
62—Breadth of the hind fetlock joint
63—Middle breadth of the hind fetlock
64—Breadth of the upper coronet ridge of the
 hind hoof
65—Breadth of the bearing edge of the hind foot

Directions of the hair tracts

FIG. 84

FIG. 85

FIG. 86

FIG. 87

THE HORSE PLATE 20

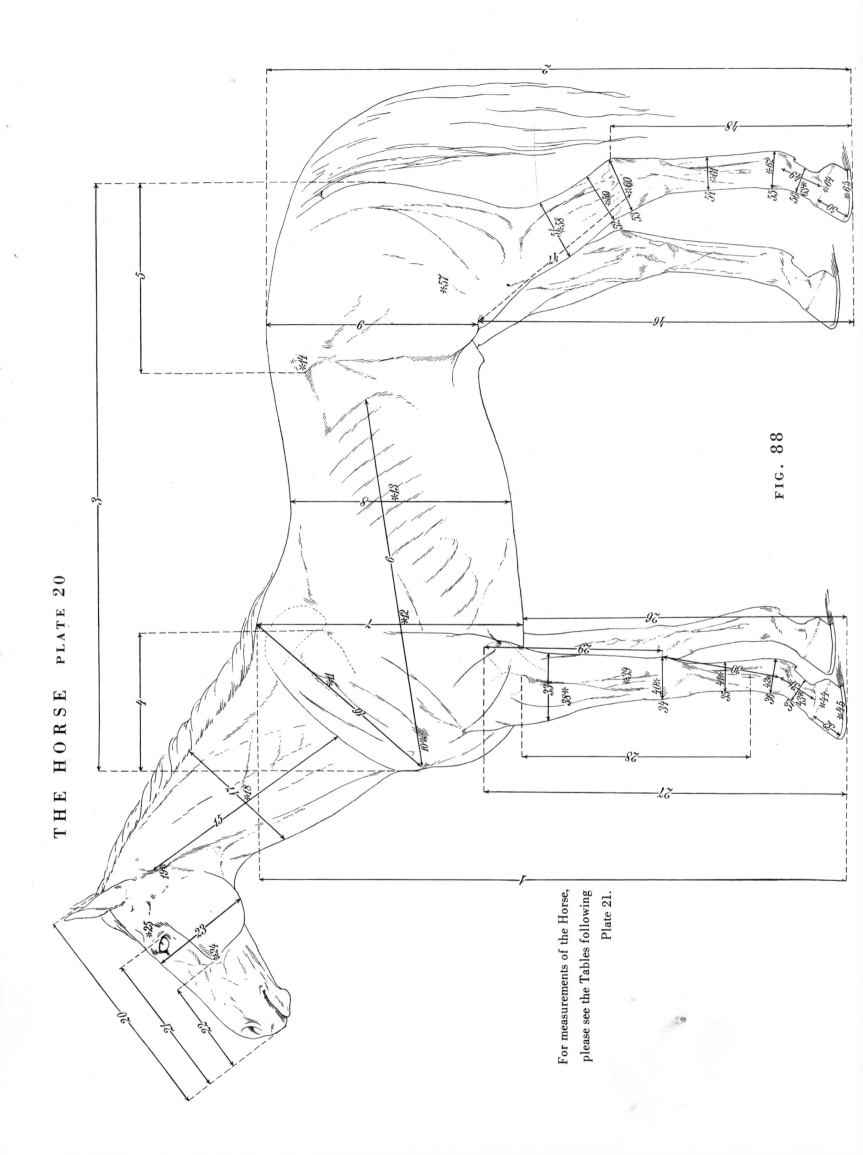

FIG. 88

For measurements of the Horse,
please see the Tables following
Plate 21.

THE HORSE PLATE 21

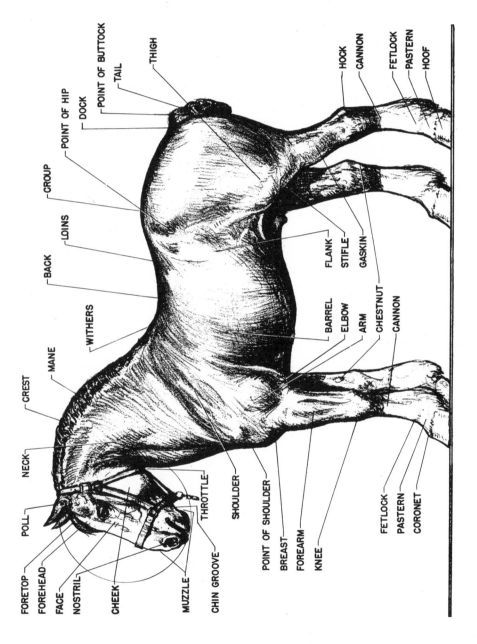

FORETOP
FOREHEAD
FACE
NOSTRIL
CHEEK
MUZZLE
CHIN GROOVE

POLL
NECK
CREST
MANE
WITHERS
BACK
LOINS
CROUP
POINT OF HIP
DOCK
POINT OF BUTTOCK
TAIL
THIGH

THROTTLE
SHOULDER
POINT OF SHOULDER
BREAST
FOREARM
KNEE

BARREL
ELBOW
ARM
CHESTNUT
CANNON

FLANK
STIFLE
GASKIN

FETLOCK
PASTERN
CORONET

HOCK
CANNON
FETLOCK
PASTERN
HOOF

The Points of the Horse. This is a 17 hand (68 inch) Clydesdale stallion. His head is 28 inches long.

These Tables refer to Plate 20.

Table 1 — column groups: Measures of height (1–2); Measures of lengths of trunk (3–6); Measures of height of trunk (7–9); Transverse diameter of the trunk (10–14); Length of neck (15); Height of neck (16–17).

	1	2	3	4	5	6	7	8	9	10	11	12	13	14	15	16	17
English riding horse 12 year old gelding	63 11/16	61 1/2	67 13/16	15	21 7/16	42 7/8	29 3/8	25 3/4	24	17 7/8	12 9/16	18 1/8	24 9/16	19 4/16	26	26	15 15/16
English half-bred inclination to thoroughbred	62 1/2	61 3/4	63 5/16	13 3/8	19 1/2	37 15/16	29 1/2	25 3/4	22 7/16	15	10 1/4	14 3/8	21 1/16	18 1/2	24 3/4	24 3/4	12 3/4
English thoroughbred stallion 10 year old race horse	62 1/2	62 3/4	62 15/16	15 3/8	19 1/4	38 1/8	27 3/16	23 13/16	21 7/8	17 5/16	11 7/16	15 15/16	21 1/16	17 11/16	24 3/8	22 13/16	14
English thoroughbred mare 9 year old race horse	63 3/8	63 1/8	64 3/8	13 9/16	20 1/16	40 1/8	30 1/8	26	22 7/16	15 3/16	10 1/4	14 9/16	20 7/8	17 11/16	26	25 3/16	12 3/4
English Shire stallion	63 5/16	62 5/16	68 13/16	17 7/8	21 7/16	43 3/16	31 7/8	28 15/16	23 13/16	20 7/8	16 1/8	22 7/16	27 3/4	20 7/8	23 5/8	28 5/16	18 11/16
Belgian mare—5 years	63 14/16	63 11/16	66 7/16	16 1/2	18 11/16	41 5/16	32 7/8	28 5/16	24	21 7/16	14 3/16	20 7/8	26 3/4	21 1/4	23 3/16	26	18 1/2
Belgian gelding—5 years	62 1/2	63 5/16	66 7/16	16 1/2	20 1/2	37 3/4	31 4/16	26 3/8	23 5/8	19 1/4	14	18 5/16	25 9/16	20 7/8	23 3/16	24 9/16	16 3/4

Table 2 — column groups: Transverse diameter of neck (18–19); Head lengths (20–22); Head height (23); Breadth diameters (24–25); Measures of length of fore limb (26–32).

	18	19	20	21	22	23	24	25	26	27	28	29	30	31	32
English riding horse 12 year old gelding	7 5/16	7 7/8	26	16 1/8	9 7/8	11 13/16	7 1/8	9 1/4	34 5/8	39 15/16	23 13/16	19 7/8	12 9/16	4 9/16	3 15/16
English half-bred inclination to thoroughbred	5 15/16	6 9/16	25 3/8	16 1/2	10 1/4	11	6 7/8	8 11/16	33 1/16	38 9/16	24 3/8	20 7/16	12 3/8	4 9/16	4 9/16
English thoroughbred stallion 10 year old race horse	7 7/8	6 11/16	24 9/16	15 3/4	9 7/8	11	6 11/16	8 7/8	35 3/8	38 15/16	24 3/4	19 3/4	13 3/8	5 1/8	4 1/8
English thoroughbred mare 9 year old race horse	5 15/16	6 11/16	25 9/16	16 15/16	10 1/4	11 5/8	6 7/8	8 7/8	33 1/16	38 15/16	24	20 1/16	12 9/16	5 1/8	4 3/4
English Shire stallion	8 3/8	8 1/16	27 9/16	17 11/16	11	13	7 1/2	9 7/8	31 1/2	37 3/4	23 1/16	18 1/2	11 7/16	3 15/16	5 1/2
Belgian mare—5 years	7 7/8	6 11/16	28 3/4	18 1/8	11 7/16	13 3/8	8	10 3/8	31 1/16	39 3/8	23 9/16	18 1/8	12 9/16	3 3/4	4 15/16
Belgian gelding—5 years	7 7/8	7 7/8	28 5/16	17 11/16	11	13 3/16	7 7/8	9 5/8	31 1/2	39 3/4	23 9/16	19 11/16	12 9/16	3 3/4	5 1/2

Measures of length of the hind limb | **Transverse diameters or thickness through leg at starred point** | **Diameters of fore limb**

| | Diameters of fore limb | | | | | Transverse diameters or thickness through leg at starred point | | | | | | | | Measures of length of the hind limb | | | | |
|---|
| | 33 | 34 | 35 | 36 | 37 | 38 | 39 | 40 | 41 | 42 | 43 | 44 | 45 | 46 | 47 | 48 | 49 | 50 |
| English riding horse 12 year old gelding | 7½ | 4¾ | 3¼ | 3⅞ | 2¾ | 4⅝ | 2¾ | 4⁵/₁₆ | 2 | 3⅛ | 2⅜ | 4⁵/₁₆ | 5½ | 39⁹/₁₆ | 20½ | 25 | 4⁵/₁₆ | 4⅛ |
| English half-bred inclination to thoroughbred | 5¹⁵/₁₆ | 4⅛ | 2¾ | 2¾ | 2³/₁₆ | 3¹⁵/₁₆ | 2⅜ | 3¹⁵/₁₆ | 1⁹/₁₆ | 2¾ | 2 | 4⅛ | 4¹⁵/₁₆ | 38⁹/₁₆ | 20½ | 24³/₁₆ | 5⅛ | 4¾ |
| English thoroughbred stallion 10 year old race horse | 6¹¹/₁₆ | 4¼ | 2¹³/₁₆ | 3⁹/₁₆ | 2⅜ | 3¹⁵/₁₆ | 2⅜ | 4⅛ | 1⁹/₁₆ | 2¾ | 2 | 3¾ | 4⅛ | 40½ | 20½ | 25⁹/₁₆ | 4¾ | 4¾ |
| English thoroughbred mare 9 year old race horse | 6⁵/₁₆ | 4⅛ | 2¹⁵/₁₆ | 3⅜ | 2⁵/₁₆ | 3¾ | 2⅜ | 3¾ | 1⁹/₁₆ | 2¾ | 1⅞ | 3¹⁵/₁₆ | 4⁵/₁₆ | 40½ | 20¼ | 25³/₁₆ | 5⅛ | 4¾ |
| English Shire stallion | 8⅛ | 5½ | 3⁹/₁₆ | 4⅛ | 3³/₁₆ | 4⁵/₁₆ | 3¾ | 5⅛ | 2⅜ | 3⁹/₁₆ | 2¾ | 5⅛ | 6⁵/₁₆ | 37⅞ | 18⅞ | 25⁹/₁₆ | 4 | 4¾ |
| Belgian mare—5 years | 7⅞ | 4¾ | 3⅜ | 3¹⁵/₁₆ | 2¹⁵/₁₆ | 4⁵/₁₆ | 3⅜ | 4¾ | 2⅜ | 3⅜ | 2¾ | 5⅛ | 6⁵/₁₆ | 38⁹/₁₆ | 18⅞ | 24¹³/₁₆ | 3¹⁵/₁₆ | 4¾ |
| Belgian gelding—5 years | 7⅞ | 4¹⁵/₁₆ | 3⁹/₁₆ | 3¾ | 2¾ | 4⅛ | 3⁹/₁₆ | 4¾ | 2³/₁₆ | 3½ | 2⅜ | 4¾ | 6⁵/₁₆ | 38¹⁵/₁₆ | 19¼ | 25⁹/₁₆ | 3¹⁵/₁₆ | 4¾ |

Transverse diameters or thickness through hind leg at starred points | **Width diameters of hind leg**

	Width diameters of hind leg					Transverse diameters or thickness through hind leg at starred points									
	51	52	53	54	55	56	57	58	59	60	61	62	63	64	65
English riding horse 12 year old gelding	6½	5¹³/₁₆	6⁵/₁₆	3¾	3¹⁵/₁₆	2¾	23	4¹³/₁₆	3³/₁₆	4½	1¾	3¼	2½	4¾	5⅜
English half-bred inclination to thoroughbred	5¹¹/₁₆	5⅛	5½	3³/₁₆	3⁹/₁₆	3⅜	20¹/₁₆	3¹⁵/₁₆	2¾	3¾	1⁹/₁₆	2¾	2	4⅛	4⁵/₁₆
English thoroughbred stallion 10 year old race horse	6½	5¹¹/₁₆	5⅝	3⁹/₁₆	3¾	2⁹/₁₆	21⁷/₁₆	4⁵/₁₆	2¾	3¹⁵/₁₆	1⁹/₁₆	2¹⁵/₁₆	2	3¾	4⅛
English thoroughbred mare 9 year old race horse	6⅛	5½	5¹¹/₁₆	3¾	3¹⁵/₁₆	2¹⁵/₁₆	20⁹/₁₆	4⅛	2¾	3¹⁵/₁₆	1⁹/₁₆	2¹⁵/₁₆	2³/₁₆	4	4
English Shire stallion	7½	6¹¹/₁₆	7⁷/₁₆	4⁵/₁₆	5⅛	3½	24¾	5½	3¹⁵/₁₆	5½	2⅜	4⅛	3⅜	5⅛	6½
Belgian mare—5 years	6⅞	6⁵/₁₆	6¹¹/₁₆	3¹⁵/₁₆	3¹⁵/₁₆	3³/₁₆	24⁹/₁₆	5½	3⁹/₁₆	4¾	2⅜	3¾	2⅜	5⁵/₁₆	6⁵/₁₆
Belgian gelding—5 years	6¹¹/₁₆	6⁵/₁₆	6¹¹/₁₆	3¹⁵/₁₆	3¹⁵/₁₆	2¾	22¹/₁₆	4¹⁵/₁₆	3⁹/₁₆	4¹³/₁₆	2³/₁₆	3¾	2⅜	5	6½

The Dog

THE DOG · PLATES · 1 2 3 4 5 6 7 8

FIGURES 1 2 3 4 5 6 7 8 9 10 11 12 13

a, a'—M. trapezius
b—Inferior M. levator anguli scapulae
c, c''—M. brachiocephalicus s. cleidomastoideus
c'—Mastoid portion of the sterno-cleid-mastoid muscle
c'''—Tendinous band
d—M. sternomastoideus
e, e'—M. deltoideus
f, f'—M. triceps brachii. ƒ caput longum, f' caput laterale
g, g'—M. pectoralis major s. superficialis
h—M. pectoralis minor s. profundus
i—Thoracic portion of M. serratus anterior
i'—Cervical portion of M. serratus anterior
k—M. latissimus dorsi
l—M. obliquus abdominis externus
l'—Aponeurosis
m—Posterior part of M. serratus posterior
m'—Lumbo-dorsal fascia
m''—Anterior part of M. serratus posterior
n—A small part of origin of M. obliquus abdominis internus
o—M. tensor fasciae latae
o'—Surface of thigh
o''—M. glutaeus maximus s. superficialis
p—M. glutaeus medius
q—M. biceps femoris
r—M. semitendinosus
s, t—Levators of the tail

u—Abductor of the tail
v—M. semimembranosus
w—M. gracilis
x—Levator of the auricle
x'—M. occipitalis
y—M. obturator internus
z—M. supraspinatus
z'—A small part of the M. infraspinatus
1H—1st cervical vertebra (Atlas)
7H—Last (7th) cervical vertebra
1R—1st rib
1R'—1st thoracic (dorsal) vertebra
6R—6th rib
12R—12th thoracic (dorsal) vertebra
13R—13th rib
1L—1st lumbar vertebra
7L—7th lumbar vertebra
K—Sacrum
1S—1st caudal vertebra
*—Ala of the atlas
1—Scapula
2—Spina scapulae
3—Acromion
4—Humerus
4'—Epicondyle
5—Tuberculum majus
6—Rotator
7—Ulna
8—Olecranon

9—Radius
10—Carpus
11—Os pisiforme
12—Metacarpus
13—Phalanges manus
14—Sternum
14'—Manubrium sterni
15—Ossa pelvis
16—Tuber coxae
17—Tuber sacrale
18—Os femoris
19—Trochanter major
20—Patella
21—Tibia
21'—External condyle of the tibia
22—Tarsus
23—Fibula
24—Tuber calcanei
25—Metatarsus
26—Phalanges pedis
27—Os parietale
27'—Cervical crest of os occipitale
28, 28'—M. quadriceps femoris
29—M. semimembranosus
30—Mm. gastrocnemii
31—M. sterno-hyoideus
32—V. jugularis
33—Head part of M. rhomboideus
34—M. rhomboideus

35—M. spinalis et semispinalis dorsi
36—M. longissimus dorsi
37—M. iliocostalis
38—Part of origin of M. teres major
39—M. splenius

40—M. intercostalis
41—Lig. tuberoso- et spinosacrum
42—Popliteal lymphatic gland
43—M. transversus abdominis

44—M. rectus abdominis
45—Depressor of the tail
46—Anterior part of M. sartorius
48—A part of M. scalenus

THE DOG PLATE 1

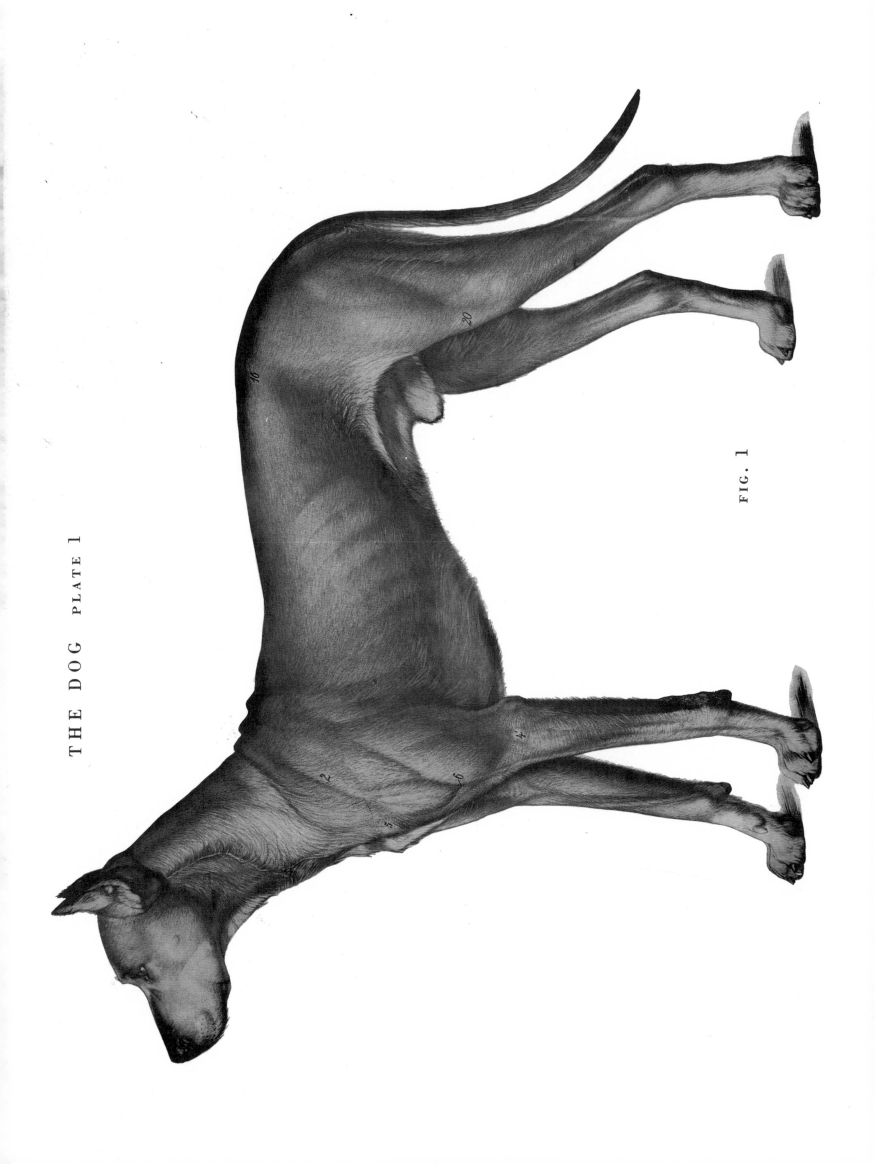

FIG. 1

THE DOG PLATE 2

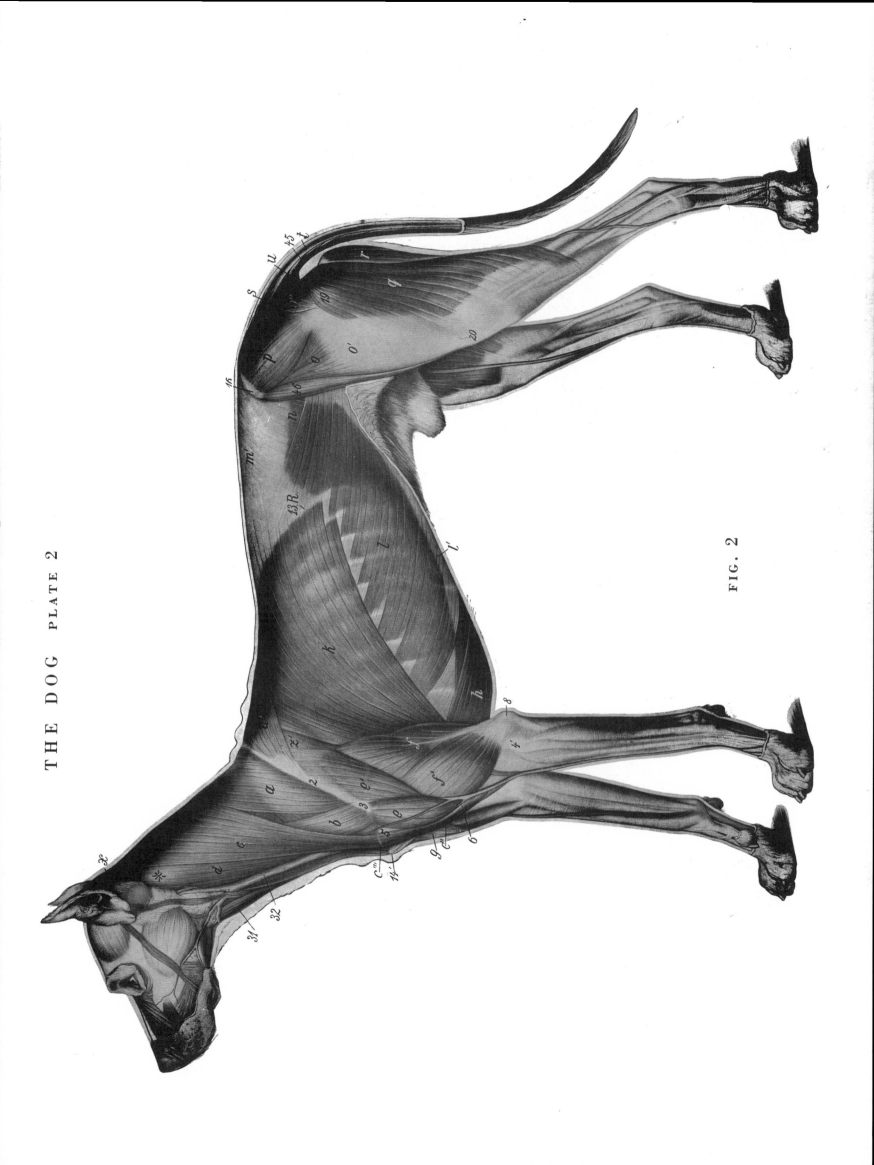

FIG. 2

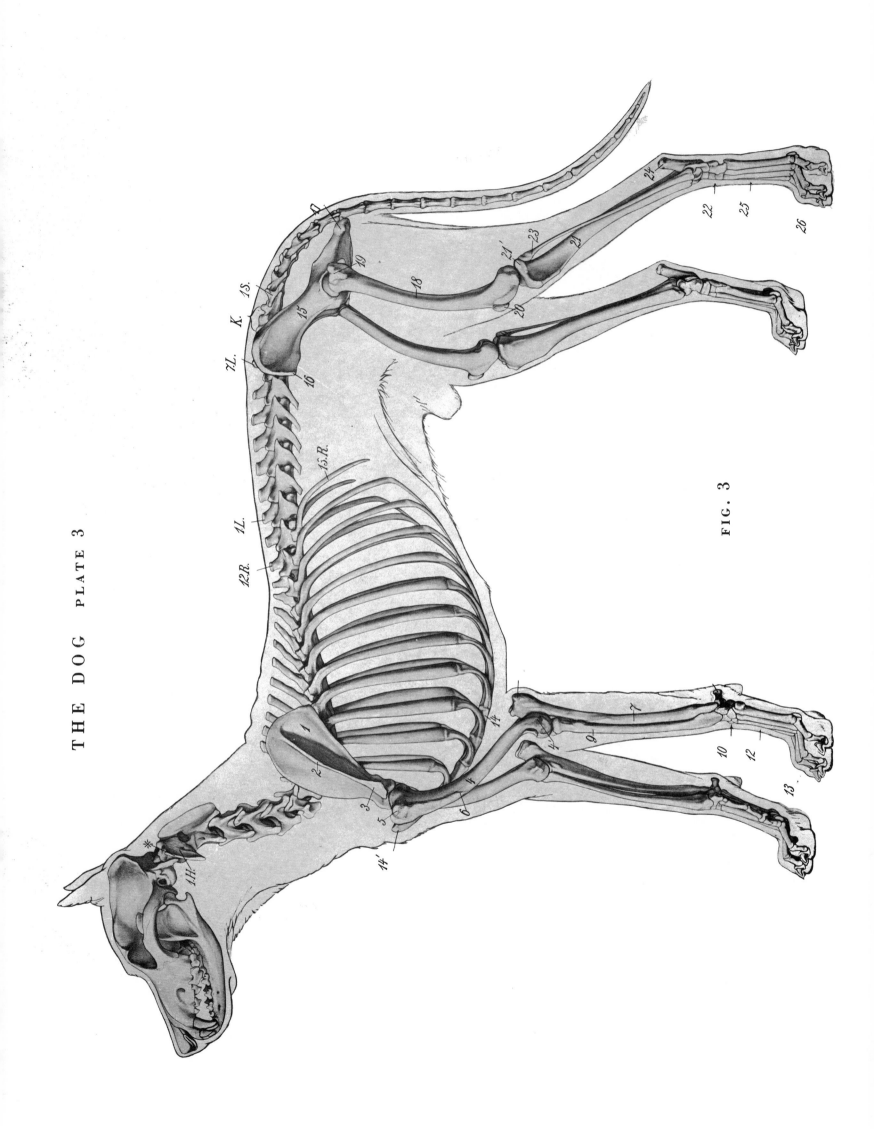

THE DOG PLATE 3

FIG. 3

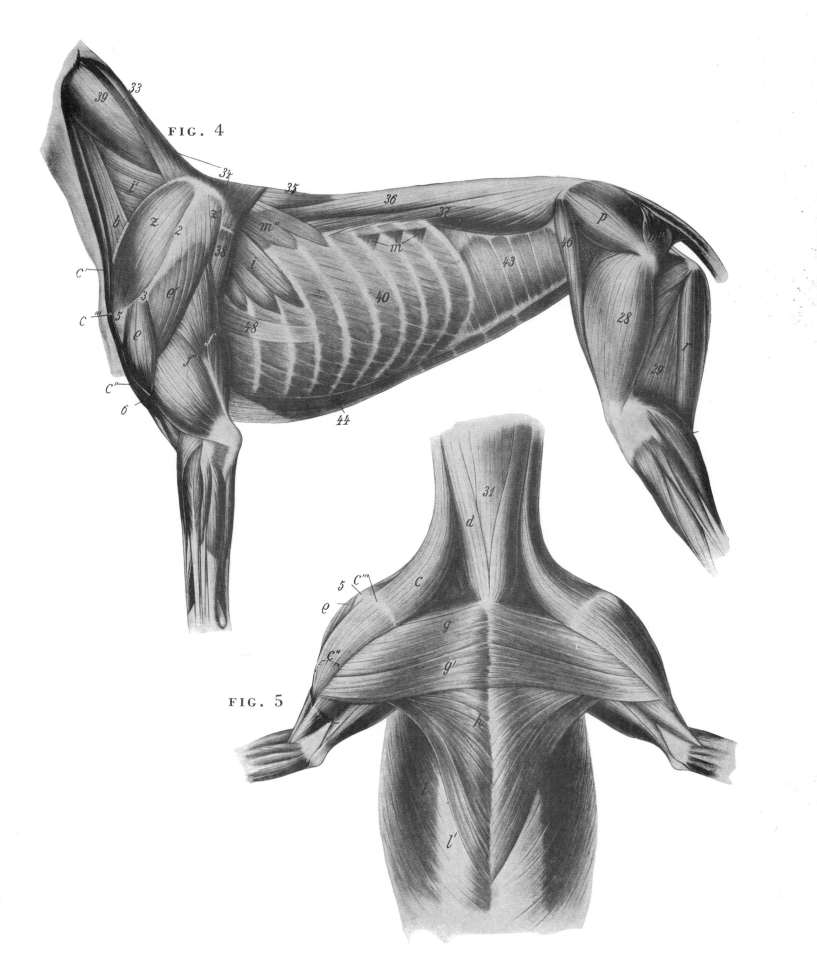

FIG. 4

FIG. 5

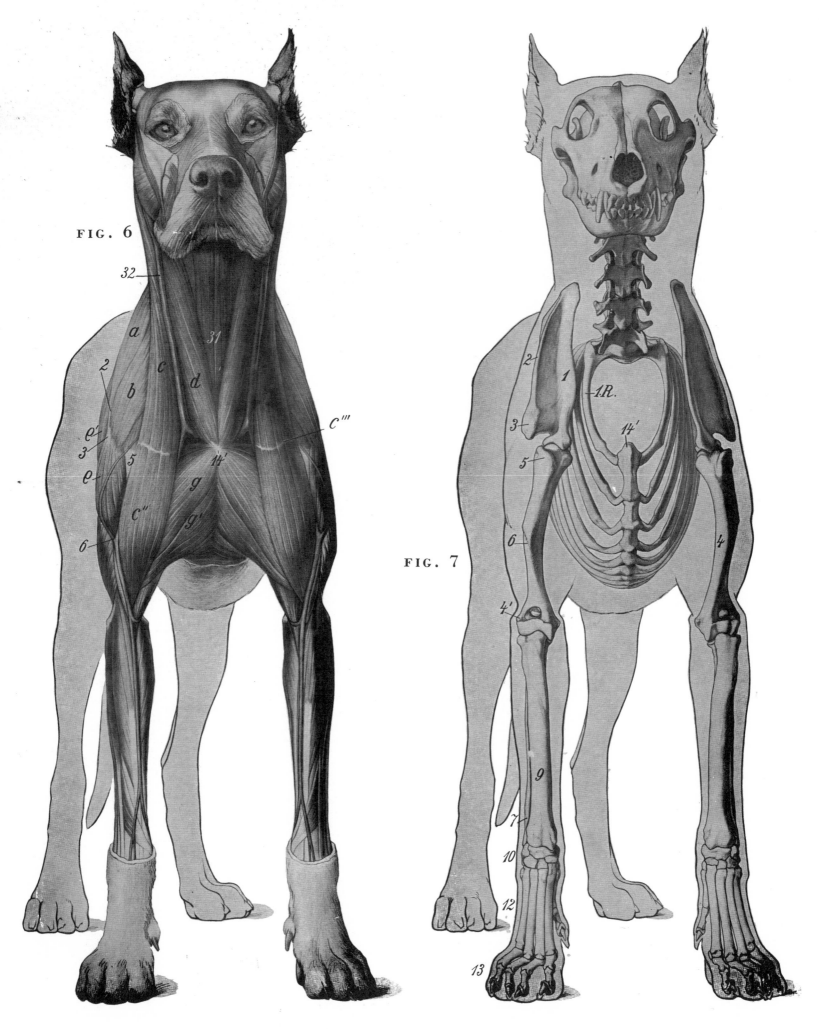

THE DOG PLATE 5

FIG. 6

FIG. 7

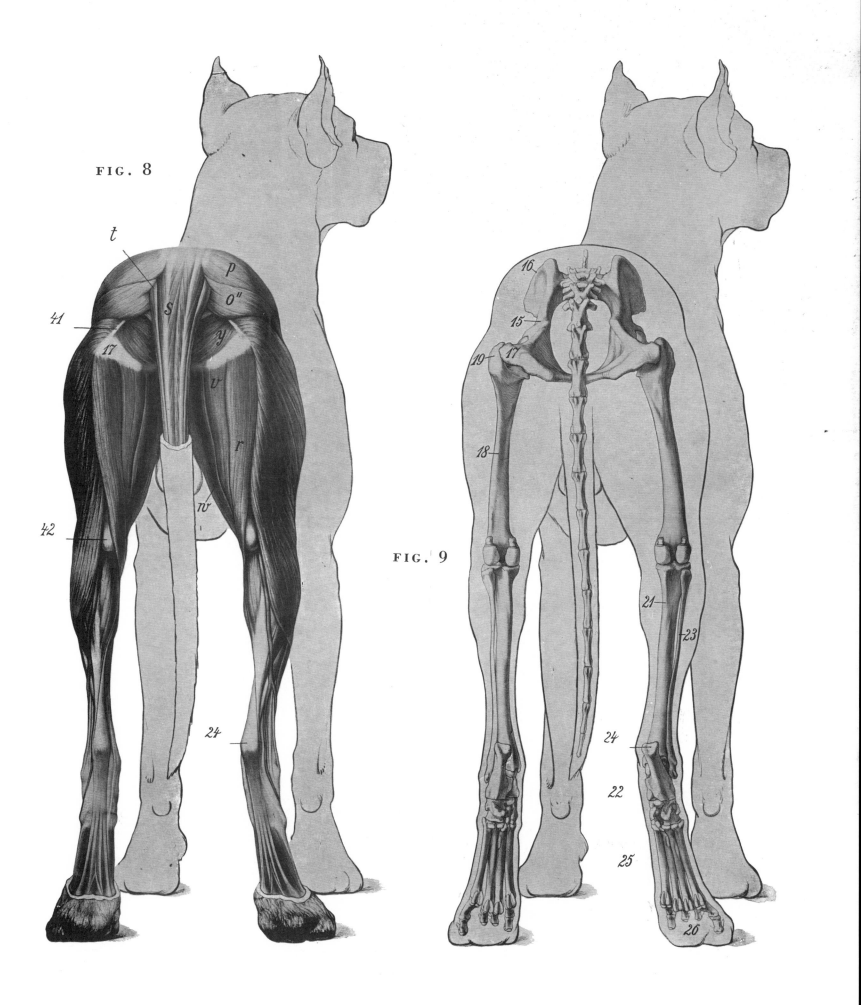

FIG. 8

FIG. 9

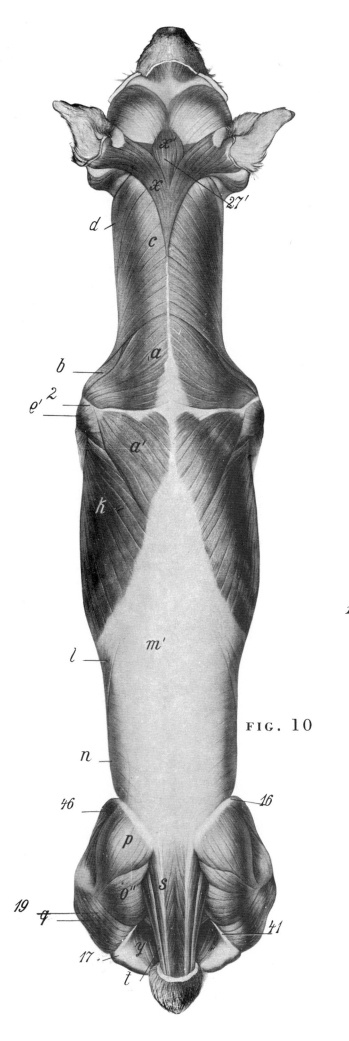

FIG. 10

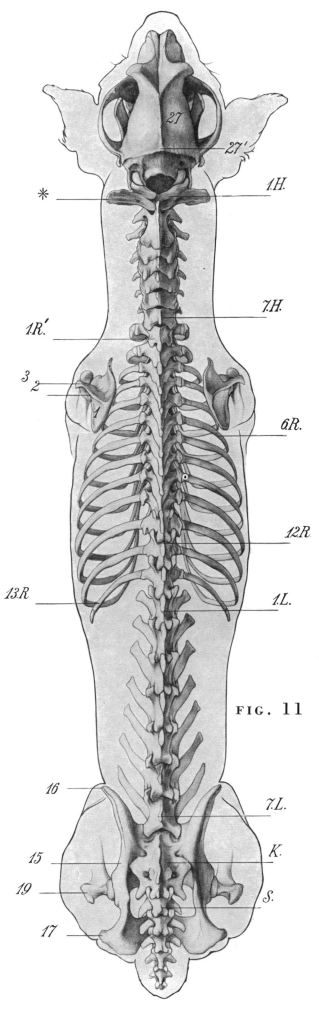

FIG. 11

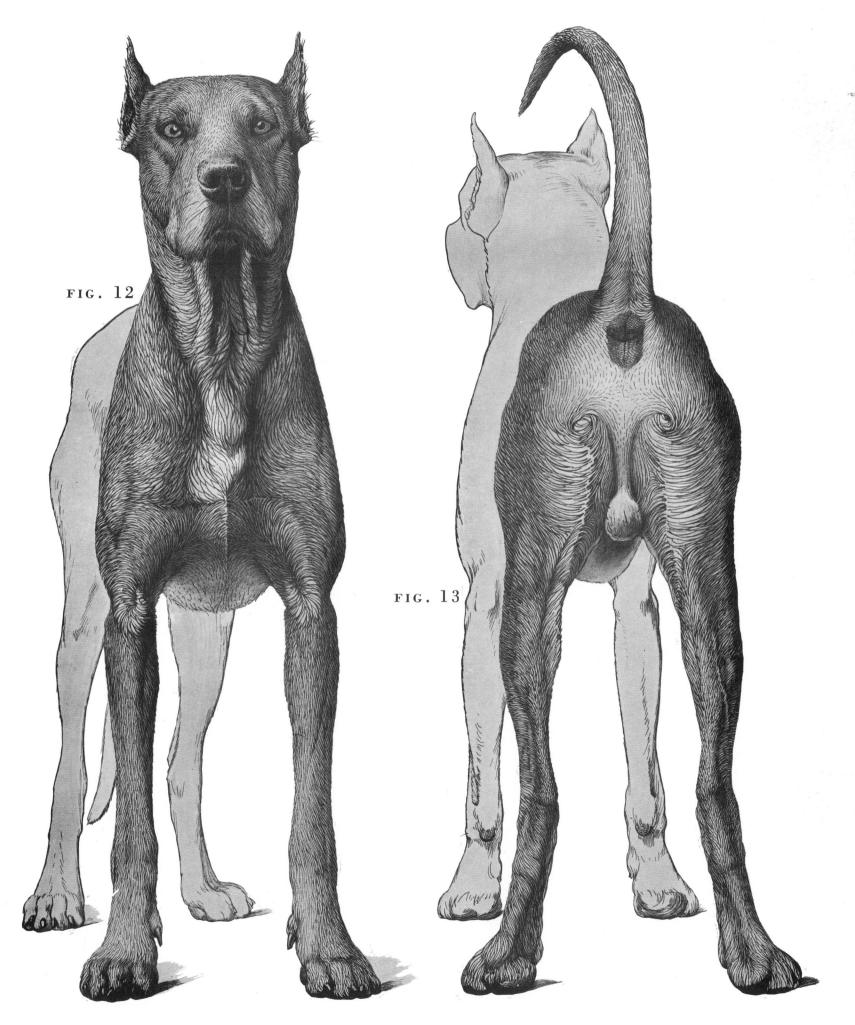

FIG. 12

FIG. 13

THE DOG · PLATES 9 10 11

FIGURES 14 15 16 17 18 19 20 21 22 23 24 25 26

A—Plantar ball
B—Digital ball
B'—Digital ball of the 1st toe
C—Carpal ball
a, a'—M. extensor carpi radialis
c, c'—M. extensor digitorum communis
d—M. extensor digiti minimi
e—M. extensor carpi ulnaris
f—M. abductor pollicis longus
g—End of M. brachialis internus
g', h'—M. biceps brachii
h, h'—M. interosseus
k—M. flexor carpi radialis
l—M. flexor carpi ulnaris

m—M. flexor dig. sublimis
m'—The four divisions of the lower part of the
 M. flexor dig. sublimis
o—M. flexor dig. profundus
o'—The divisions of the lower part of the M.
 flexor dig. profundus
q—The thin end tendons of M. extensor pollicis
 longus et indicis proprius
r—M. brachioradialis
s—M. anconaeus parvus
t—M. pronator teres
v—M. abductor digiti V proprius
w—Crural elastic ligament
4—Humerus

4'—Extensor condyle of humerus
4''—Flexor condyle of humerus
7—Ulna
7'—Lower end of ulna (external epicondyle)
8—Olecranon
9—Radius
9''—Tuberositas radii
10—Carpus
11—Os pisiforme
12—Metacarpus
15—Sesamoid bones
16—Phalanx prima
17—Phalanx secunda
18—Phalanx tertia

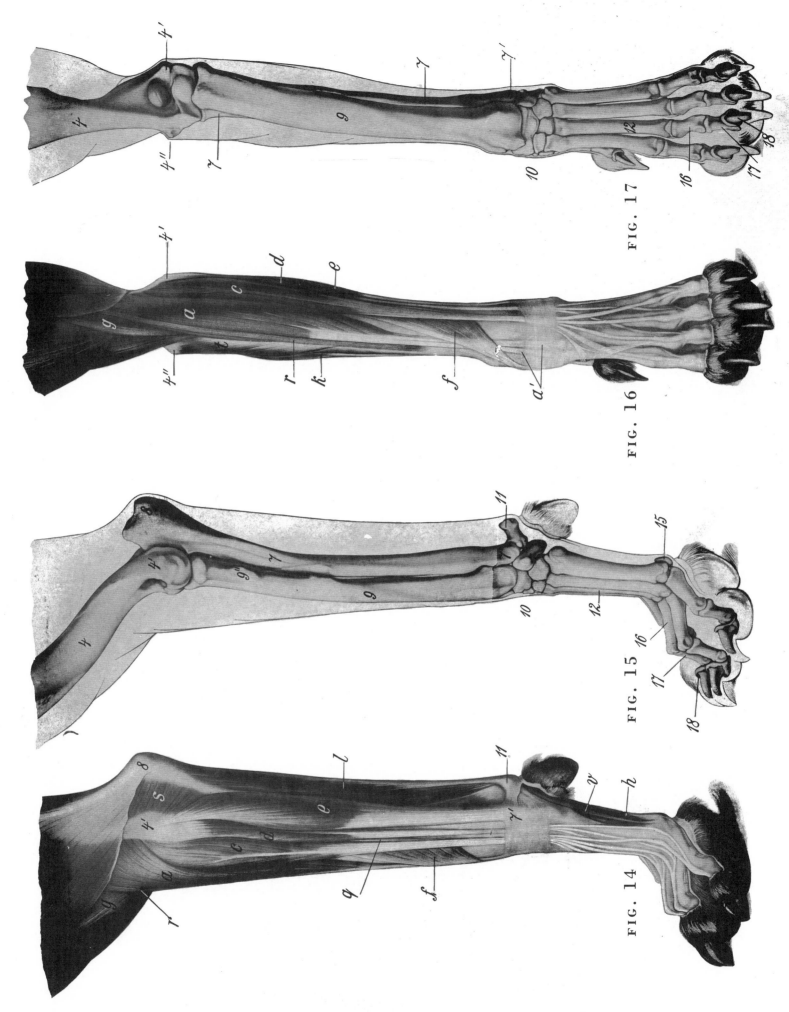

FIG. 14

FIG. 15

FIG. 16

FIG. 17

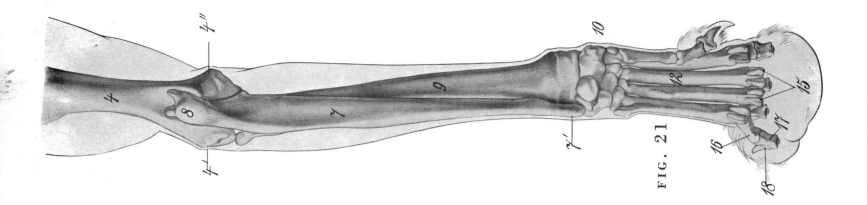

FIG. 21

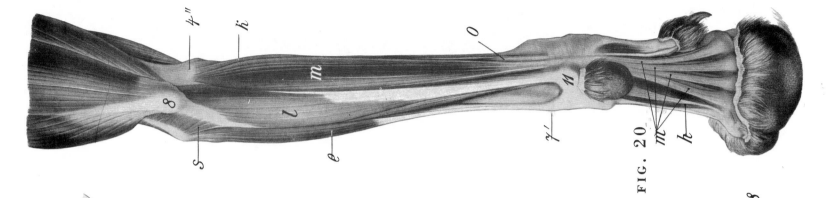

FIG. 20

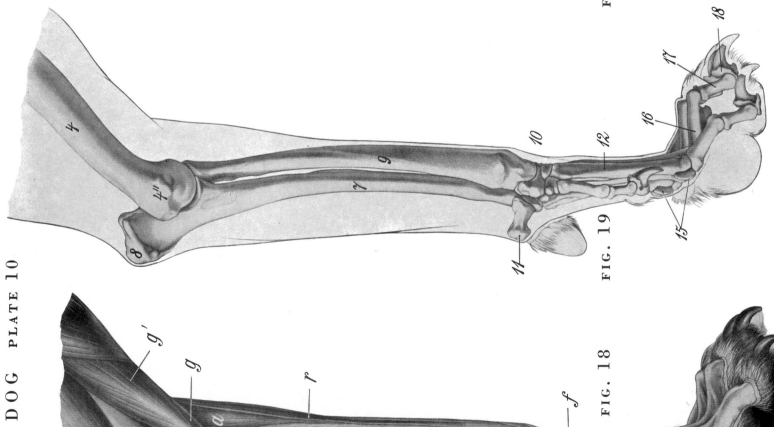

FIG. 19

FIG. 18

THE DOG PLATE 11

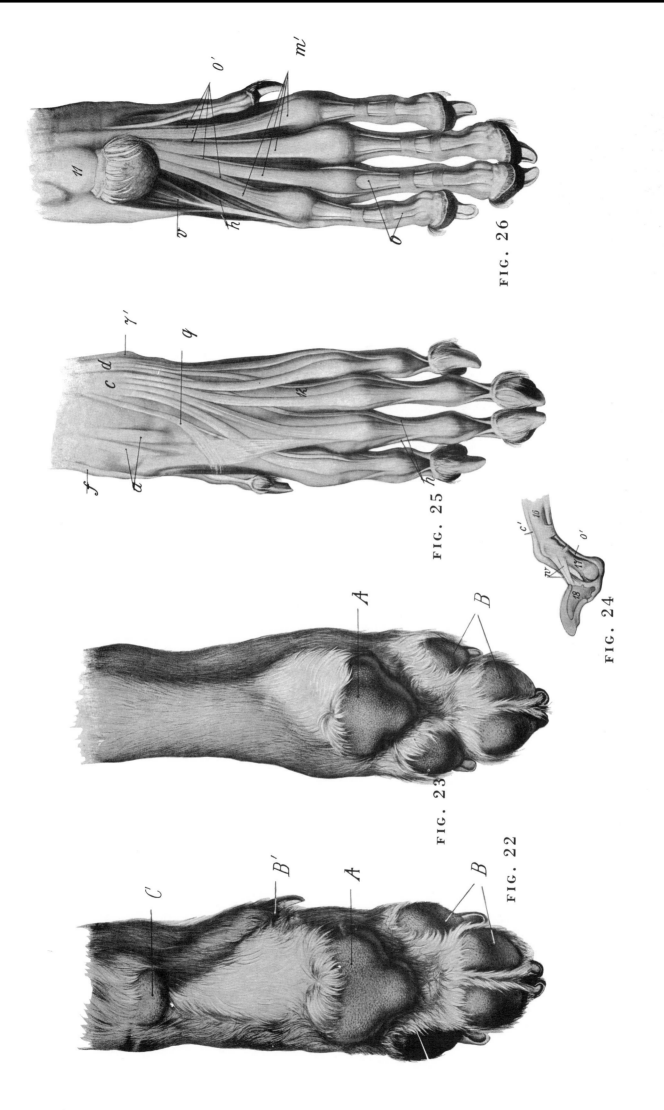

FIG. 22

FIG. 23

FIG. 24

FIG. 25

FIG. 26

THE DOG - PLATES 12 13

FIGURES 27 28 29 30 31 32 33 34

a, a'—M. tibialis anterior
b, b'—M. extensor dig. pedis longus
c—M. peronaeus longus
c'—Tendon
d'—Tendon of M. extensor dig. pedis lateralis
d''—M. peronaeus brevis
e—M. flexor hallucis longus
e'—A tendinous ligament
e''—Tendon of M. tibialis posterior
f—Terminal section of the Mm. gastrocnemii
f'—Tendo Achillis
g, g'—M. flexor dig. pedis sublimis
h—Mm. interossei
i—Annular ligaments

m, m'—M. flexor dig. pedis longus
n—Interior lateral ligament of the ankle joint
o'—Fascia lata of·femur
q, q'—End of biceps femoris
r—End of M. semitendinosus
r', r''—Two tendons at end of M. semitendinosus
w—End of M. gracilis
x, x'—End of M. sartorius
z—M. extensor dig. pedis brevis
18—Lower end of the femur
18'—Small sesamoid bones
20—Patella
21—Tibia
21'—Interior condyle of tibia

21''—Lower end of fibula
21'''—Interior knuckle
22—Tarsus
23—Fibula
24—Tuber calcanei
25—Posterior metatarsus
28—Tuberositas fibiae
29—Sesamoid bones of the toe joints of the
 metatarsus
30—Phalanx prima
31—Phalanx secunda
32—Phalanx tertia

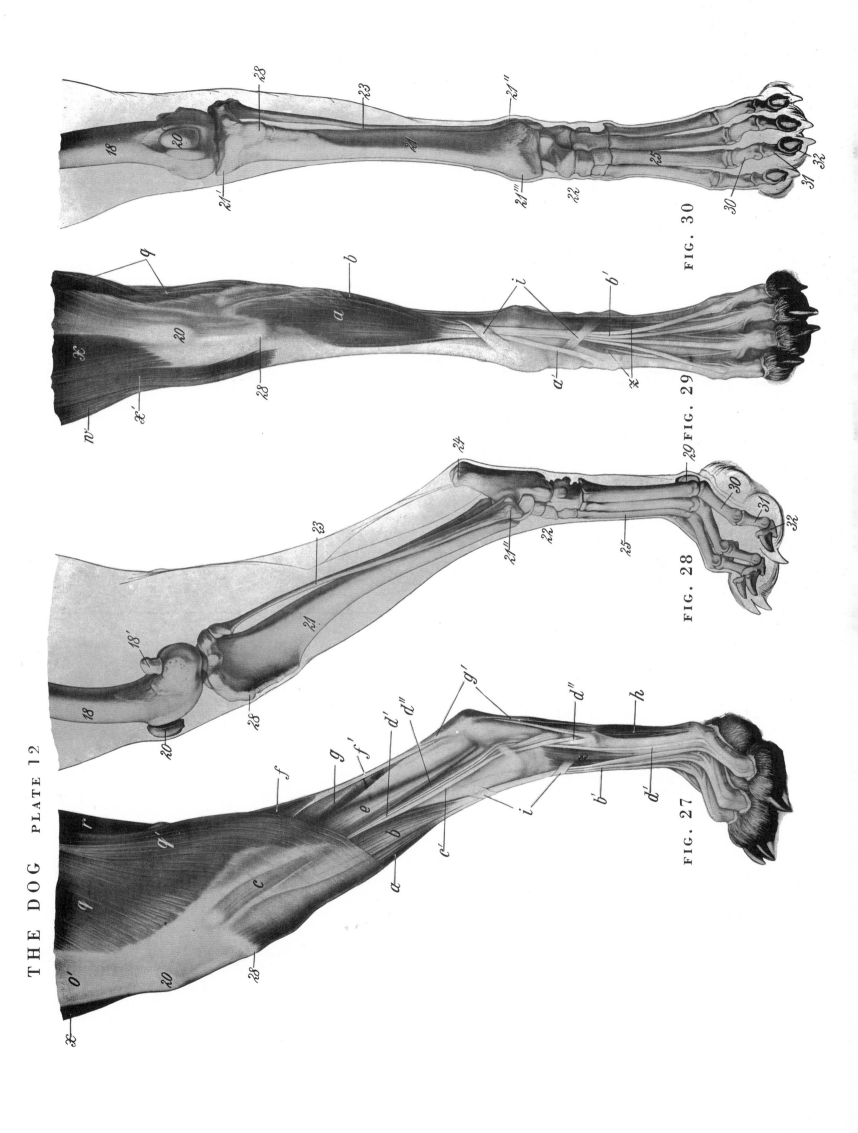

THE DOG PLATE 12

FIG. 27

FIG. 28

FIG. 29

FIG. 30

THE DOG PLATE 13

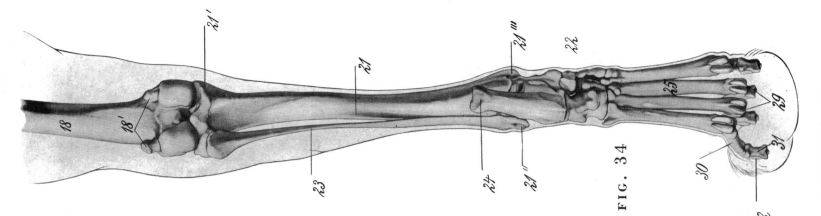

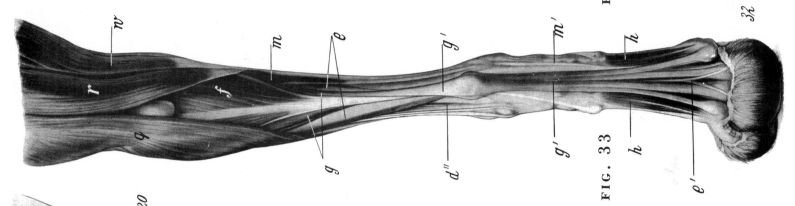

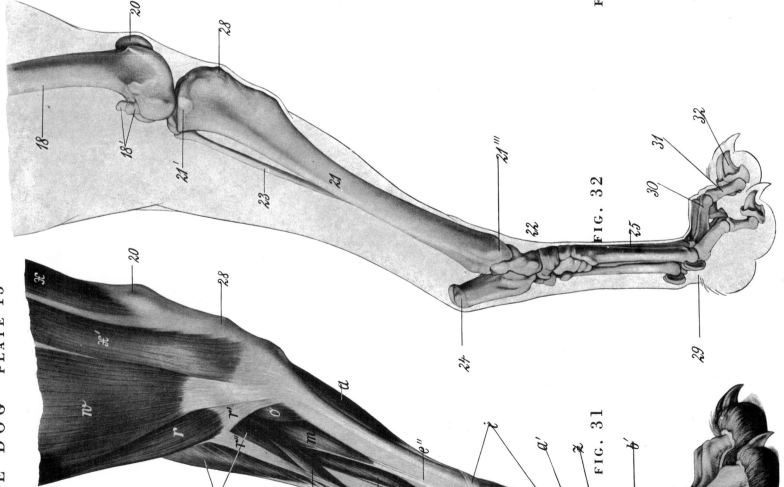

FIG. 31

FIG. 32

FIG. 33

FIG. 34

THE DOG - PLATES 14 15 16

FIGURES 35 36 37 38 39 40 41 42 43 44 45 46 47 48 49 50

a, a'—M. levator labii superioris proprius
b—M. levator nasolabialis
c—M. brachiocephalicus s. cleidomastoideus
c'—M. sternomastoideus
e—End of Mm. sternohyoidei
f—M. caninus s. pyramidalis nasi
g—M. zygomaticus
g'—M. zygomaticus minor s. M. malaris
h—M. buccalis
i—M. molaris
k²—M. orbicularis oris
m—M. masseter
n—M. depressor auris
o—Exterior adductor of the ear
p, p'—Common muscle of the ear
q—End of the long abductor of the ear
r—Long levator of the auricle
u—M. orbicularis palpebrarum
u', u'', u'''—Mm. corrugatores supercilii
v—End of the two-bellied (digastric) muscle
w—M. mylohyoideus
y—Cervical subcutaneous muscle (cervical panniculus)
z—M. temporalis
z'—M. occipitalis

1—Left auricle
2, 2'—Posterior edge of the auricle
4—Incisura intertragica
8—Scutulum
9—Arcus zygomaticus
11—Processus coronoideus of the inferior maxillary bone
12—Frontal process of the molar bone
12'—Zygomatic process of the frontal bone
12''—Orbital band on the frontal bone
13—Os occipitale
13'—Spine of the occipital bone
13''—Jugular process of the occipital bone
13'''—Condyloid process of the occipital bone
14—Os parietale
14'—Crest of the parietal bone
15—Os frontale
16—Os temporale
17—Meatus acusticus externus
18—Temporo-maxillary articulation
19—Orbita
20—Os zygomaticum s. jugale
21—Os lacrimale
22—Os nasale
23—Os incisivum
24—Upper incisor teeth

24'—Lower incisor teeth
25—Upper canine tooth
26—Maxilla
27—Facial crest
28—Unpaired portion of the lower jawbone
28'—Paired portion of the body of the lower jawbone
29—Lower canine tooth
30—Branch of the lower jaw
30''—Processus angularis
31—Condyloid process of the lower jaw
32—Atlas
34—Upper lateral cartilage of the nose
34'—Lower lateral cartilage of the nose
35—External insertion cartilage
36—Lymph follicle of the oesophagus
38—V. jugularis
39—V. facialis
44—Glandula parotis
49—Nose
50—Glandula submaxillaris
52—Eyelid
53—Caruncula lacrimalis
55—Anterior part of the sclera
55'—Cornea
56—Pupil

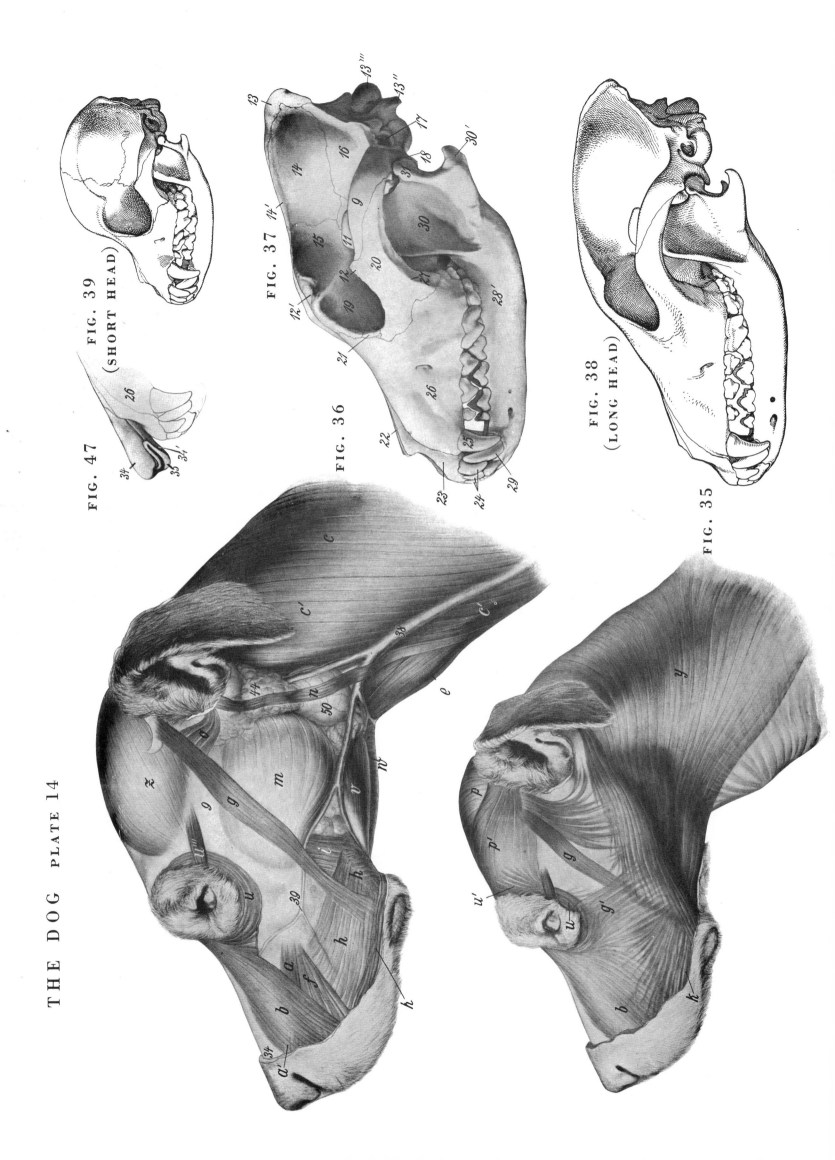

THE DOG PLATE 14

FIG. 39
(SHORT HEAD)

FIG. 47

FIG. 37

FIG. 36

FIG. 38
(LONG HEAD)

FIG. 35

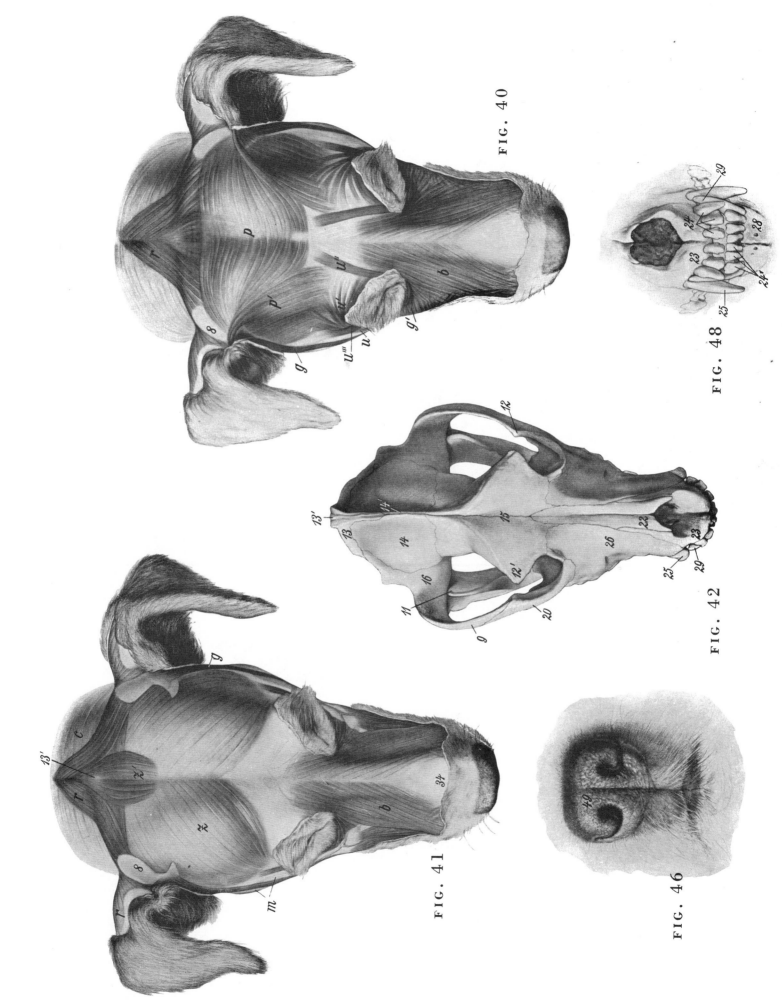

FIG. 40

FIG. 48

FIG. 42

FIG. 41

FIG. 46

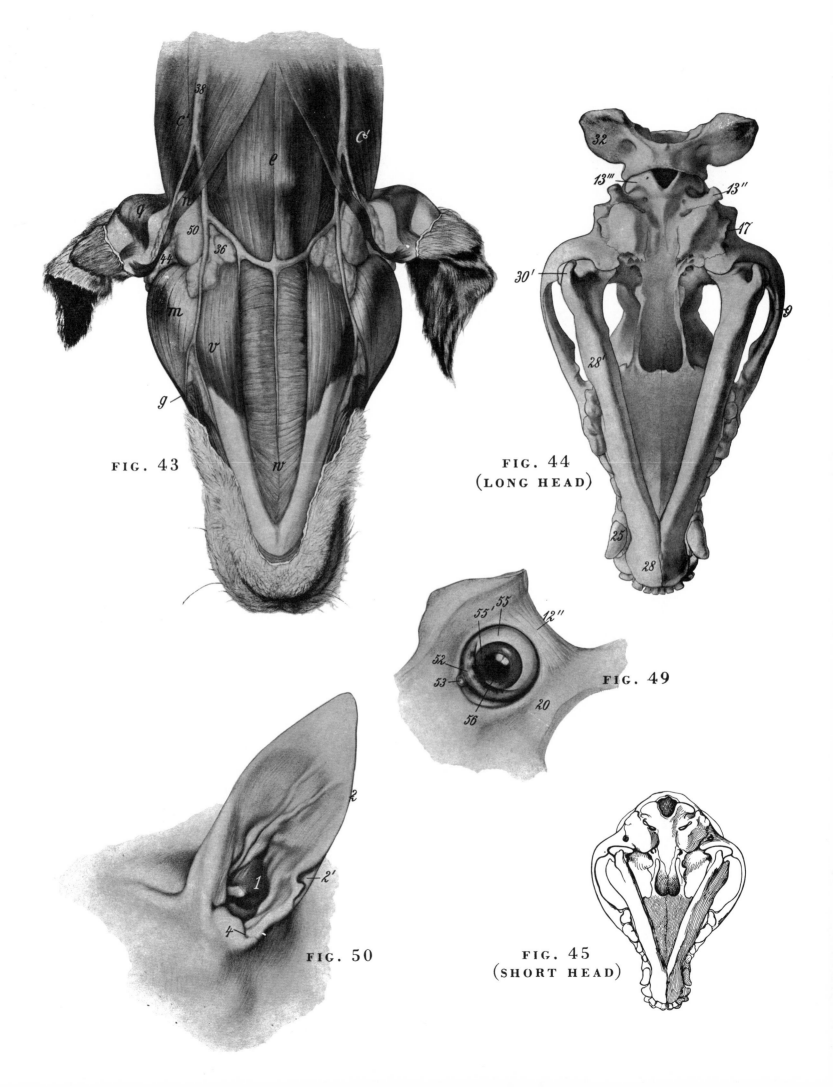

FIG. 43

FIG. 44
(LONG HEAD)

FIG. 49

FIG. 50

FIG. 45
(SHORT HEAD)

The Lion

THE LION · PLATES 1 2 3 4 5 6

FIGURES 1 2 3 4 5 6 7 8 9

a, a'—M. trapezius
b—Shoulder-transverse-process muscle
c, c', c''—M. cleidomastoideus
d—M. sternomandibularis
e, e'—M. deltoideus
f, f'—M. triceps brachii
g, g'—M. pectoralis major
h—Posterior part of the M. pectoralis minor
k—M. latissimus dorsi
l—M. obliquus abdominis externus
l'—Aponeurosis
l''—Fold of muscle at thigh
m'—Lumbo-dorsal fascia
o—M. tensor fasciae latae
o'—Fascia lata
o''—M. glutaeus maximus
p—M. glutaeus medius
p'—Fascia glutaea
q, q'—M. biceps femoris
r—M. semitendinosus
s—Levator of the tail
t—Mm. intertransversarii of the tail
v—M. semimembranosus
w—M. gracilis
x—M. occipitalis
y, y'—Muscles of the ear

1H—1st cervical vertebra (Atlas)
7H—7th cervical vertebra
K—Sacrum
6K—6th costal cartilage
1L—1st lumbar vertebra
7L—7th lumbar vertebra
1R—1st rib
6R—6th rib
12R—12th thoracic (dorsal) vertebra
13R—13th rib
1Rx—1st thoracic (dorsal) vertebra
1S—1st caudal vertebra
*—Ala border of atlas
1—Scapula
2—Spina scapulae
3—Acromion
4—Humerus
4'—External epicondyle
5—External tuberosity
6—Rotator
7—Ulna
8—Olecranon
9—Radius
10—Carpus
11—Os pisiforme
12—Metacarpus

13—Phalanges manus
14—Sternum
14'—Manubrium sterni
15—Ossa pelvis
16—Tuber coxae
17—Tuber ischiadicum
18—Os femoris
19—Trochanter major
20—Patella
21—Tibia
21'—External condyle of the tibia
22—Tarsus
23—Fibula
24—Tuber calcanei
25—Metatarsus
26—Phalanges pedis
27'—Occipital tuberosity
28—Parietal bones
30—Transverse processes of the lumbar vertebrae
44—Incipient part of the M. rectus abdominis
46—Anterior belly of the M. sartorius
47—M. tensor fasciae antebrachii
48—M. abductor cruris anterior

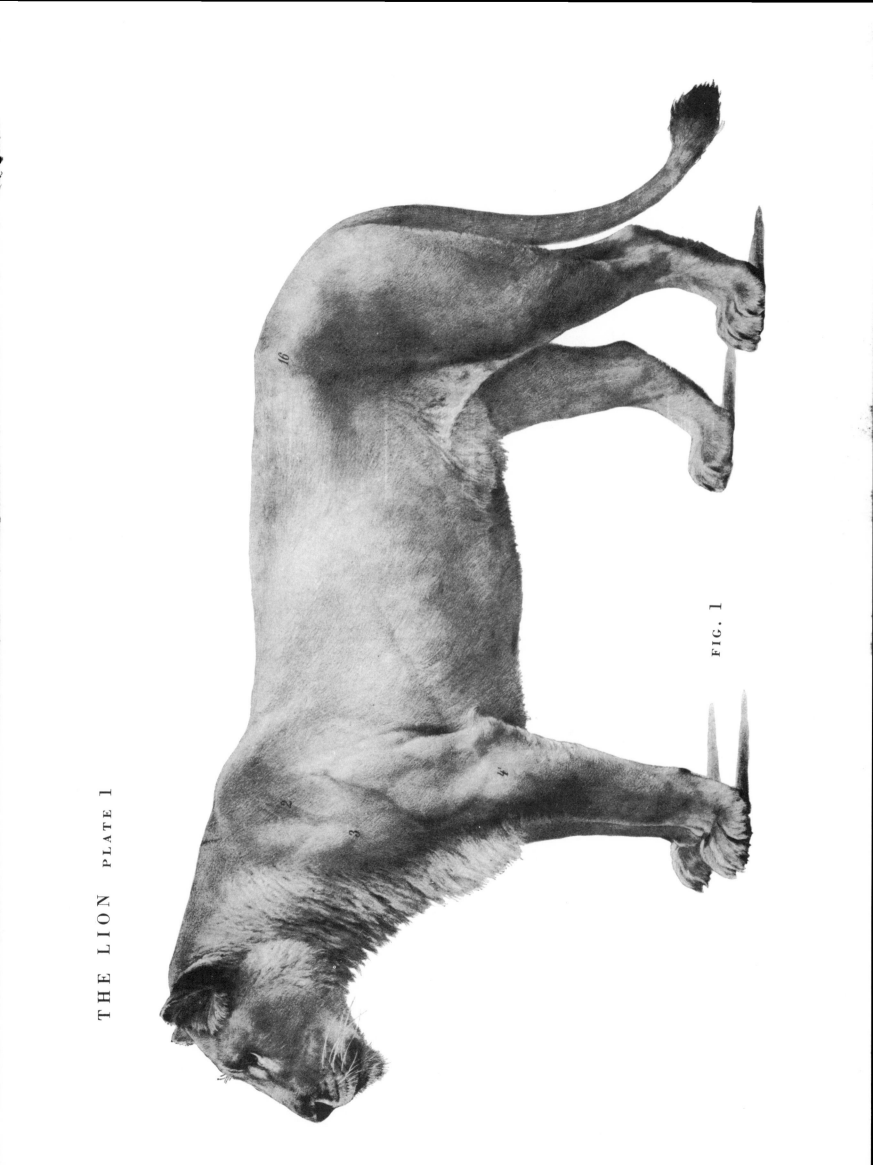

THE LION PLATE 1

FIG. 1

THE LION PLATE 2

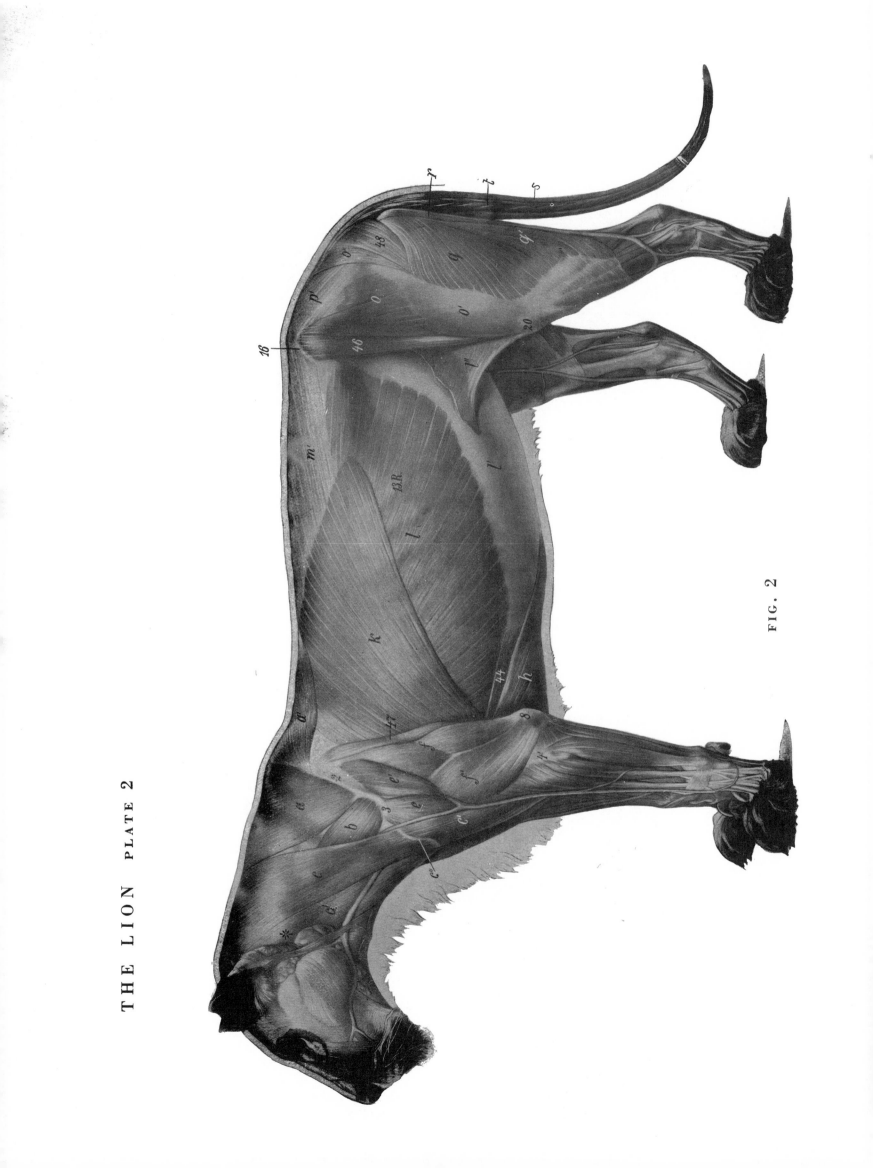

FIG. 2

THE LION PLATE 3

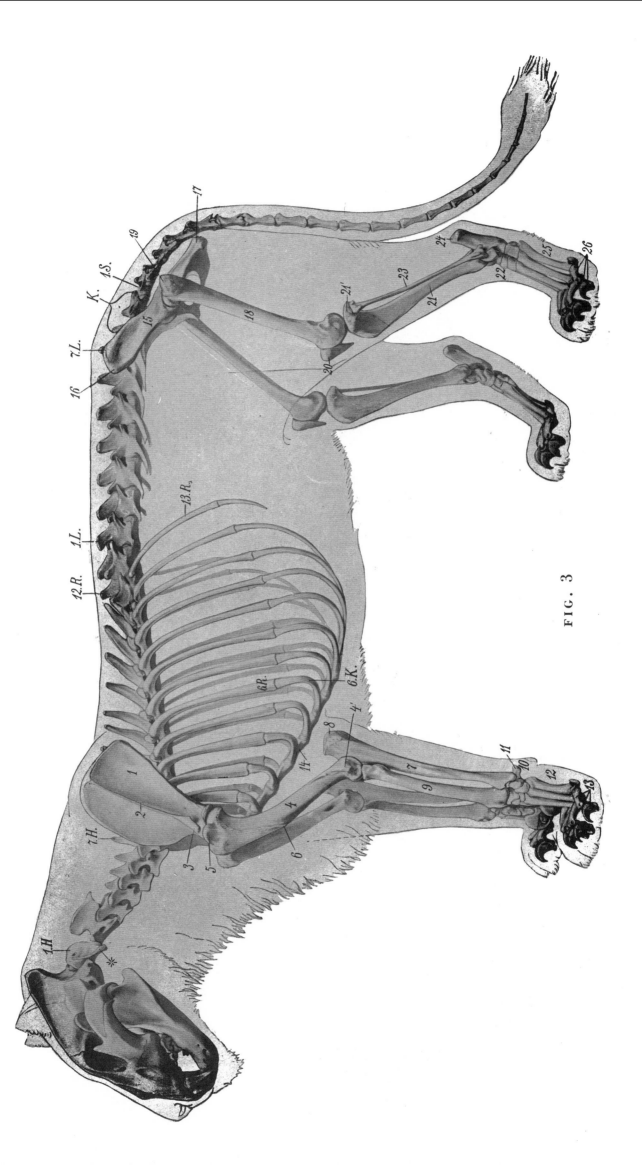

FIG. 3

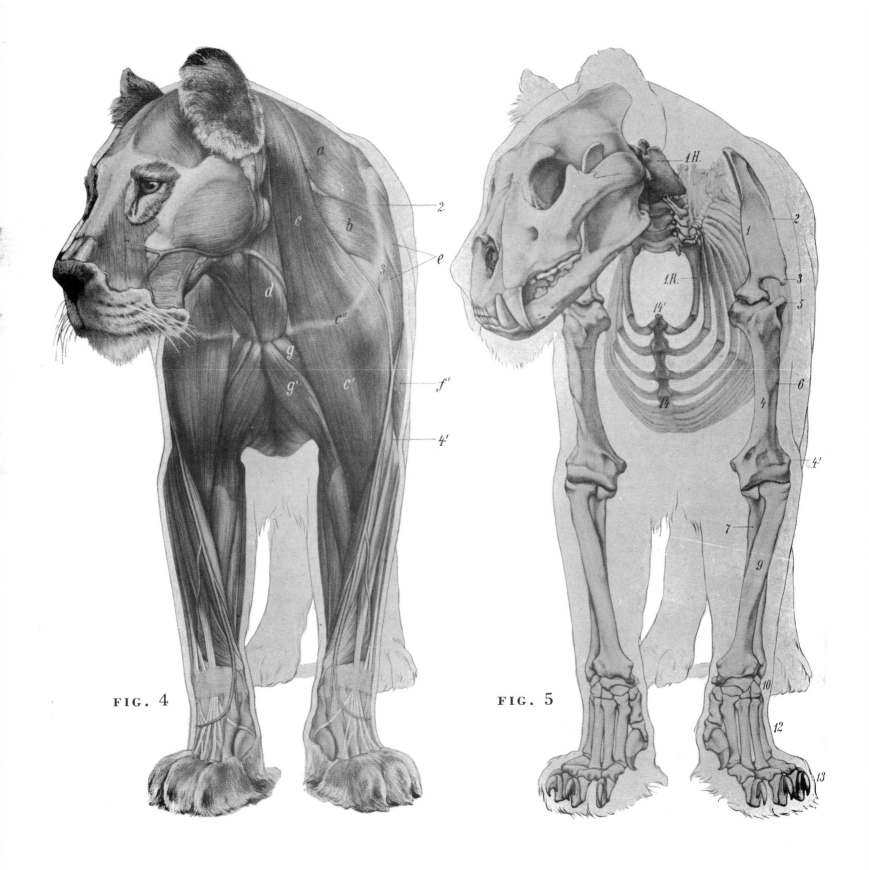

FIG. 4

FIG. 5

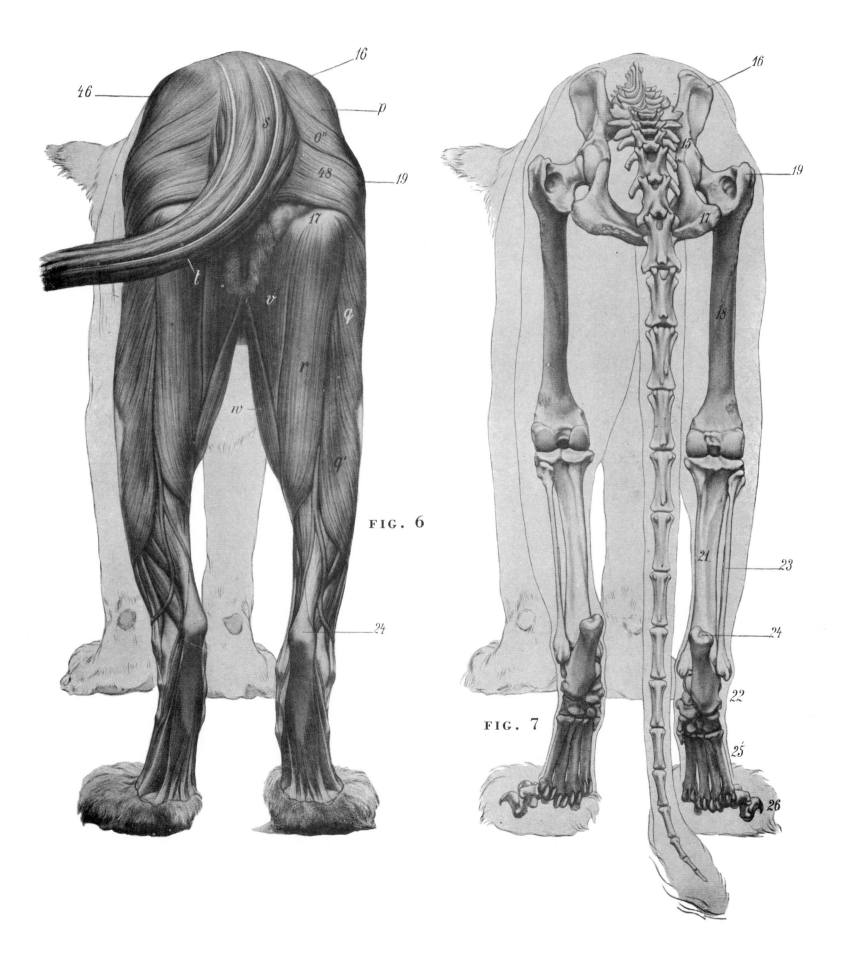

FIG. 6

FIG. 7

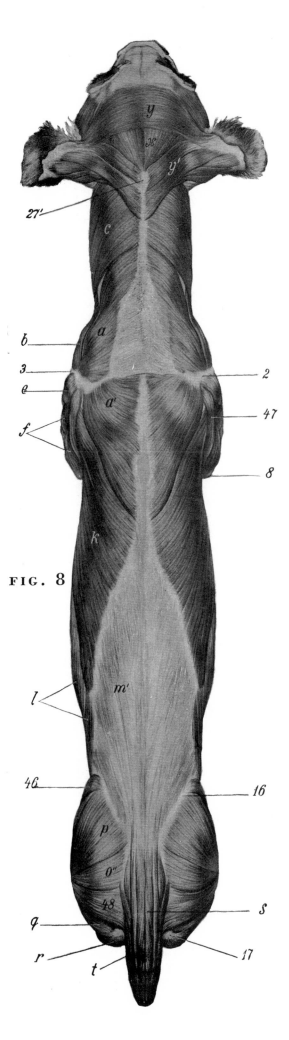

FIG. 8

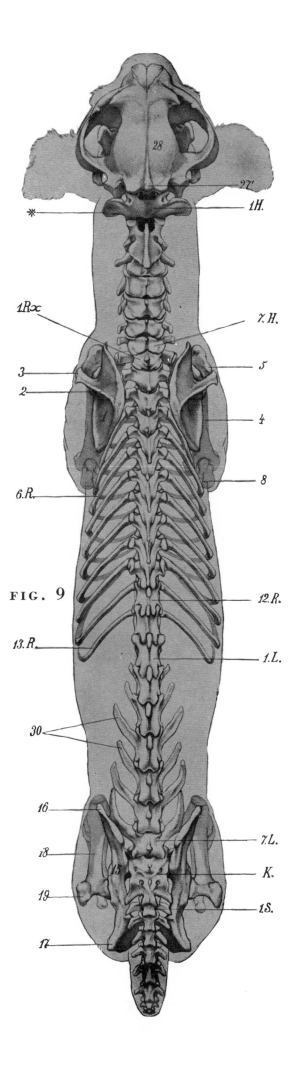

FIG. 9

THE LION - PLATES 7 8 9

FIGURES 10 11 12 13 14 15 16 17 18 19 20 21 22

a, a'–M. extensor carpi radialis
c–M. extensor digitorum communis
c'–Tendons on phalanx of toe
d–M. extensor digitorum lateralis s. digiti quinti proprius
e–M. extensor carpi ulnaris
f–M. abductor pollicis longus
g–End of the M. brachialis internus
g'–End of the M. pectoralis major
h–One of the Mm. interossei
h'–Extensor tendon
i–Flexor tendons
k–M. flexor carpi radialis
l, l'–M. flexor carpi ulnaris
m–M. flexor digitorum sublimis
m'–Tendons from M. flexor digitorum sublimis

o–Parts of the M. flexor digitorum profundus
q–M. extensor pollicis et indicis proprius
r–M. brachioradialis
s–M. anconaeus parvus
t–M. pronator teres
u–M. plantaris brevis
v–M. abductor digiti quinti
w–A strong elastic ligament
x–Caput mediale of the M. triceps brachii
y–Plantar balls
y'–Digital balls
4–Humerus
4'–Its extensor condyle
4''–Its flexor condyle
7–Ulna

7'–Lower end of the ulna
8–Olecranon
9–Radius
9''–Tuberositas radii lateralis
10–Carpus
11–Os pisiforme
12–Metacarpus
15–Sesamoid bones of the 3rd & 4th metatarsal digital joint
16–Phalanx prima
17–Phalanx secunda
17'–Ball-like beginning of ligament connecting phalanx secunda with phalanx tertia
18–Phalanx tertia
19–Ring-shaped fold of skin

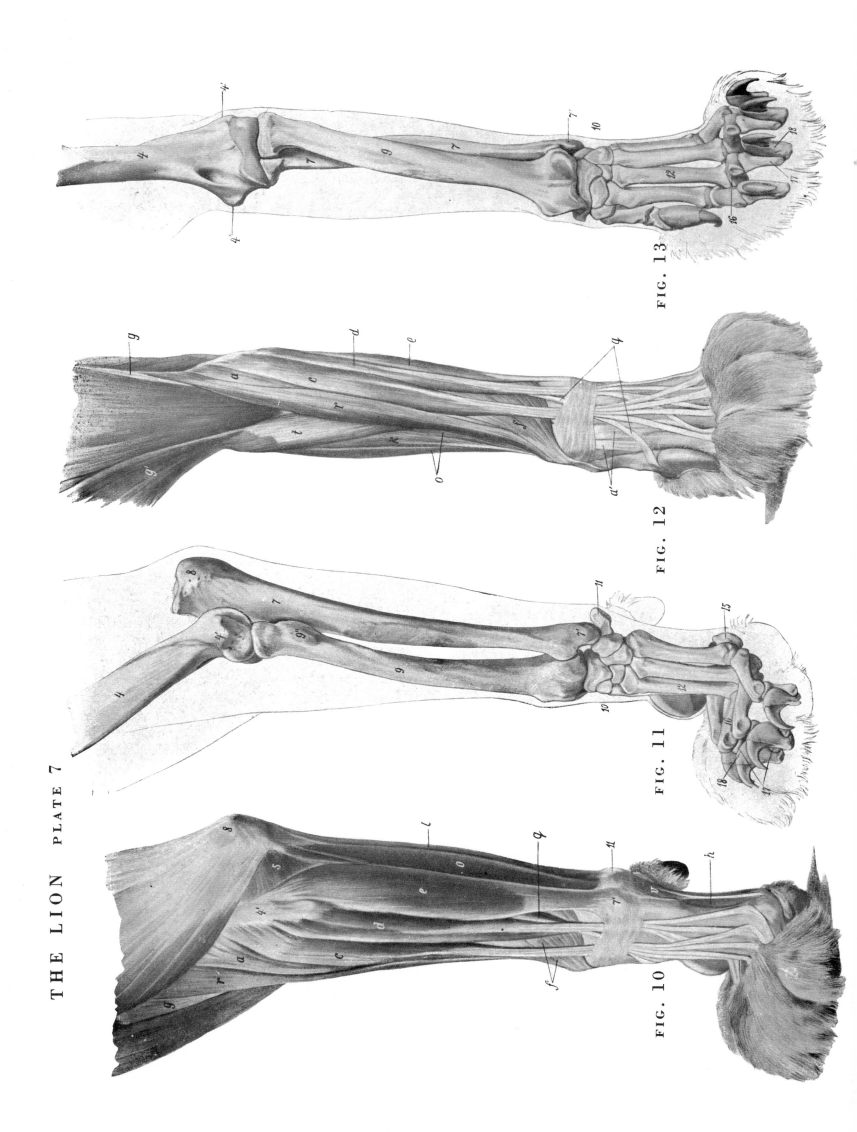

THE LION PLATE 7

FIG. 10

FIG. 11

FIG. 12

FIG. 13

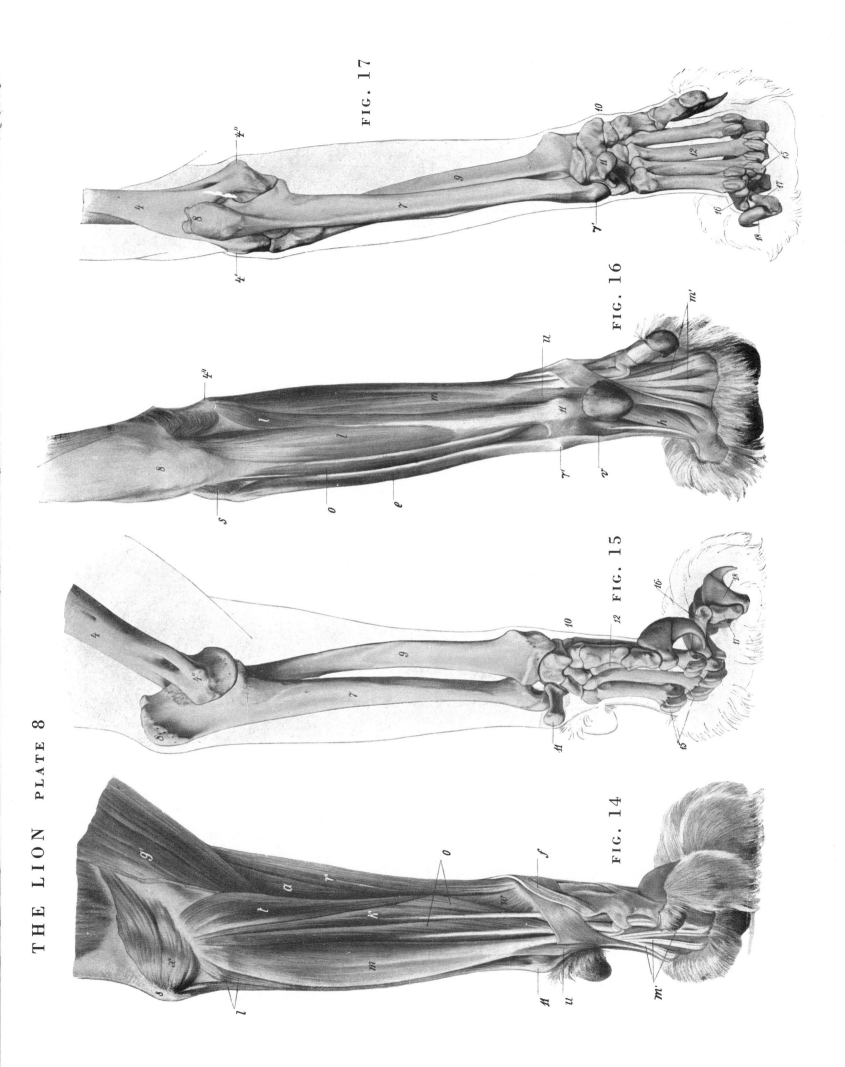

THE LION PLATE 8

FIG. 14

FIG. 15

FIG. 16

FIG. 17

THE LION PLATE 9

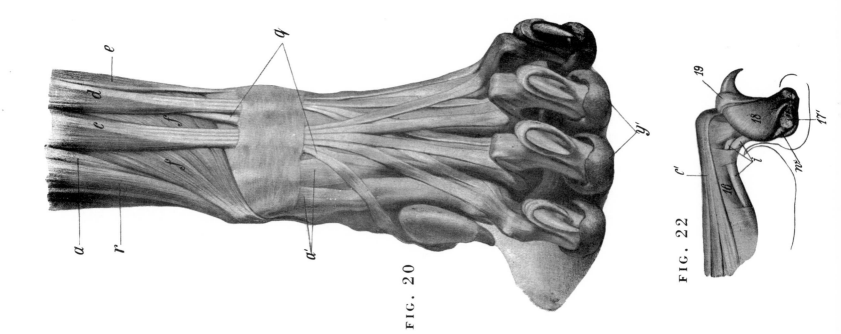

FIG. 18

FIG. 19

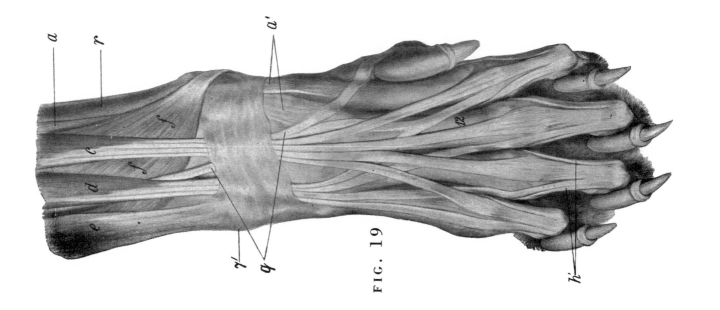

FIG. 20

FIG. 21

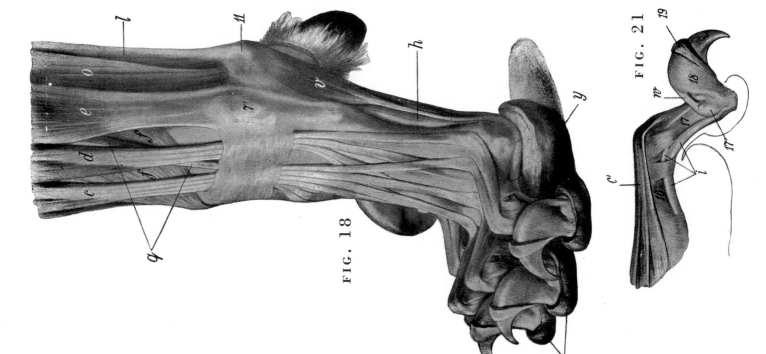

FIG. 22

THE LION · PLATE 10

FIGURES 23 24 25 26 27

A—*Plantar balls*
B, B'—*Digital balls*
C—*Tarsal balls*
D—*Joint between 1st and 2nd digit*
E, E'—*East of the 3rd digit*
b—*Shoulder-transverse-process muscle*
c, c', c''—*M. cleidomastoideus*
d—*M. sternomandibularis*
e, e'—*M. deltoideus*
f, f'—*Caput longum et laterale of M. triceps brachii*
h—*Posterior part of M. pectoralis minor*
i—*Thoracic portion of M. serratus anterior*
i'—*Cervical portion of M. serratus anterior*

k—*M. latissimus dorsi*
l—*M. obliquus abdominis externus*
m—*M. serratus posterior*
o''—*M. glutaeus maximus*
p—*M. glutaeus medius*
q. q'—*M. biceps femoris*
r—*M. semitendinosus*
s—*Levator of the tail*
t—*Mm. intertransversarii of the tail*
x—*Cervical portion of M. rhomboideus*
z—*M. supraspinatus*
13R—*13th rib*
2—*Spina scapulae*
3—*Acromion*

8—*Olecranon*
16—*Tuber coxae*
20—*Patella*
21'—*External condyle of tibia*
28, 28'—*M. quadriceps femoris*
30—*M. gastrocnemius*
36—*Lumbar portion of M. longissimus dorsi*
38—*Parts of origin of M. teres major*
43—*M. transversus abdominis*
44—*Incipient part of the M. rectus abdominis*
44'—*End of M. rectus abdominis*
46—*M. sartorius*
47—*M. tensor fasciae antebrachii*
48—*M. abductor cruris anterior*

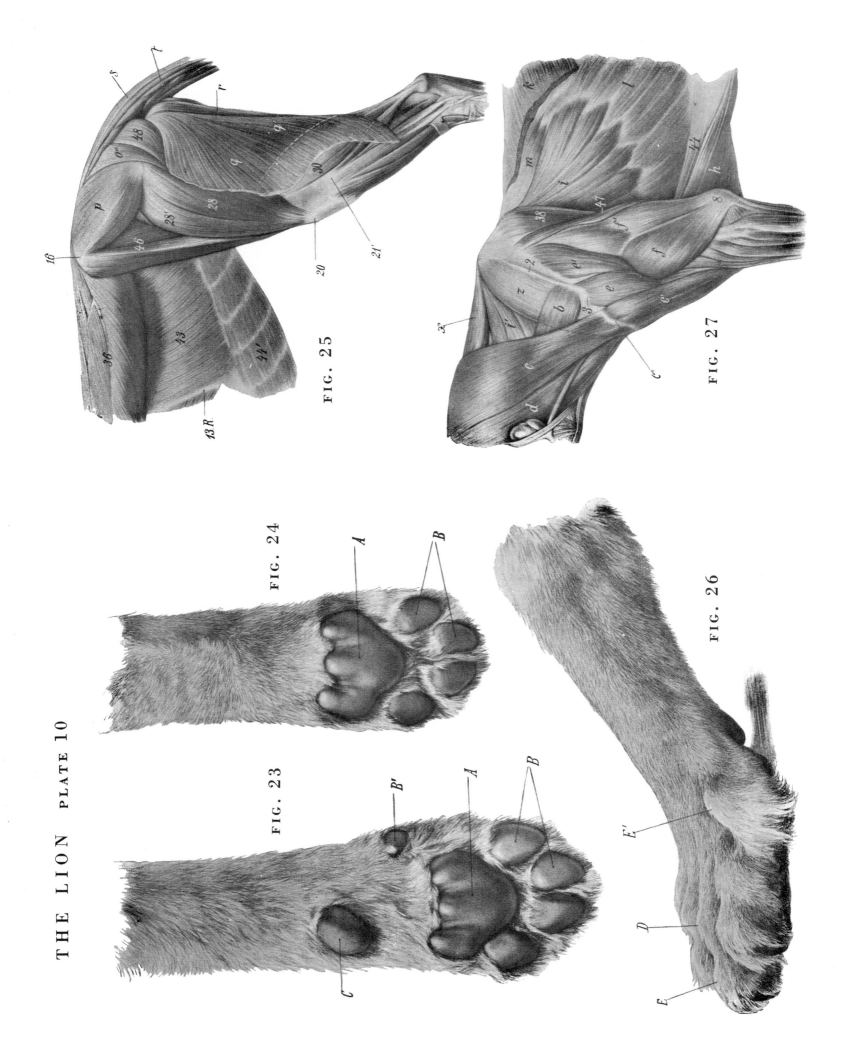

THE LION PLATE 10

FIG. 23

FIG. 24

FIG. 25

FIG. 26

FIG. 27

THE LION · PLATES 11 12

FIGURES 28 29 30 31 32 33 34 35

a, a'—M. tibialis anterior
b, b'—M. extensor digitorum longus
c—M. peronaeus longus
d'—M. extensor digitorum pedis lateralis
d''—M. peronaeus brevis
e—M. flexor hallucis longus
e'—A tendinous ligament
e''—Tendon of the M. tibialis posterior
f—End part of the Mm. gastrocnemii
f'—Tendo Achillis
f''—M. soleus
g, g'—Superficial flexor tendon
h—Mm. interossei
i—Annular ligaments

k—Abductor of the 5th toe
m—M. flexor digitorum pedis longus
n—Lateral ligament of the ankle joint
o'—Fascia lata
q, 'q'—End of the M. biceps femoris
r—End of the M. semitendinosus
r', r''—Tendons at end of M. semitendinosus
w—End of the M. gracilis
x—End of the M. sartorious
z—M. extensor digitorum pedis brevis
18—End of the os femoris
20—Patella
21—Tibia
21'—Internal condyle of the tibia

21''—Lower end of the fibula
21'''—Internal malleolus of tibia
22—Tarsus
23—Fibula
24—Tuber calcanei
25—Metatarsus
28—Swelling of the tibia
29—Sesamoid bones of the metatarsal digital
 joints
30—Phalanx prima
31—Phalanx secunda
32—Phalanx tertia

THE LION PLATE 11

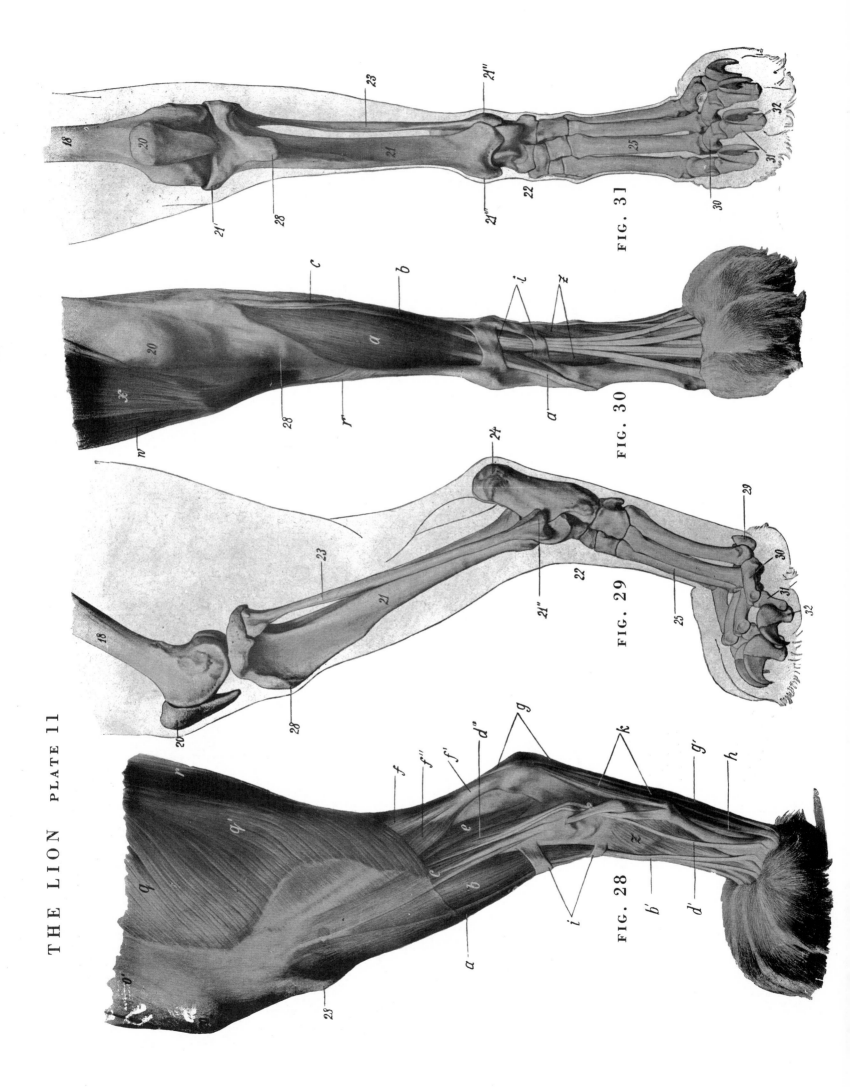

FIG. 28

FIG. 29

FIG. 30

FIG. 31

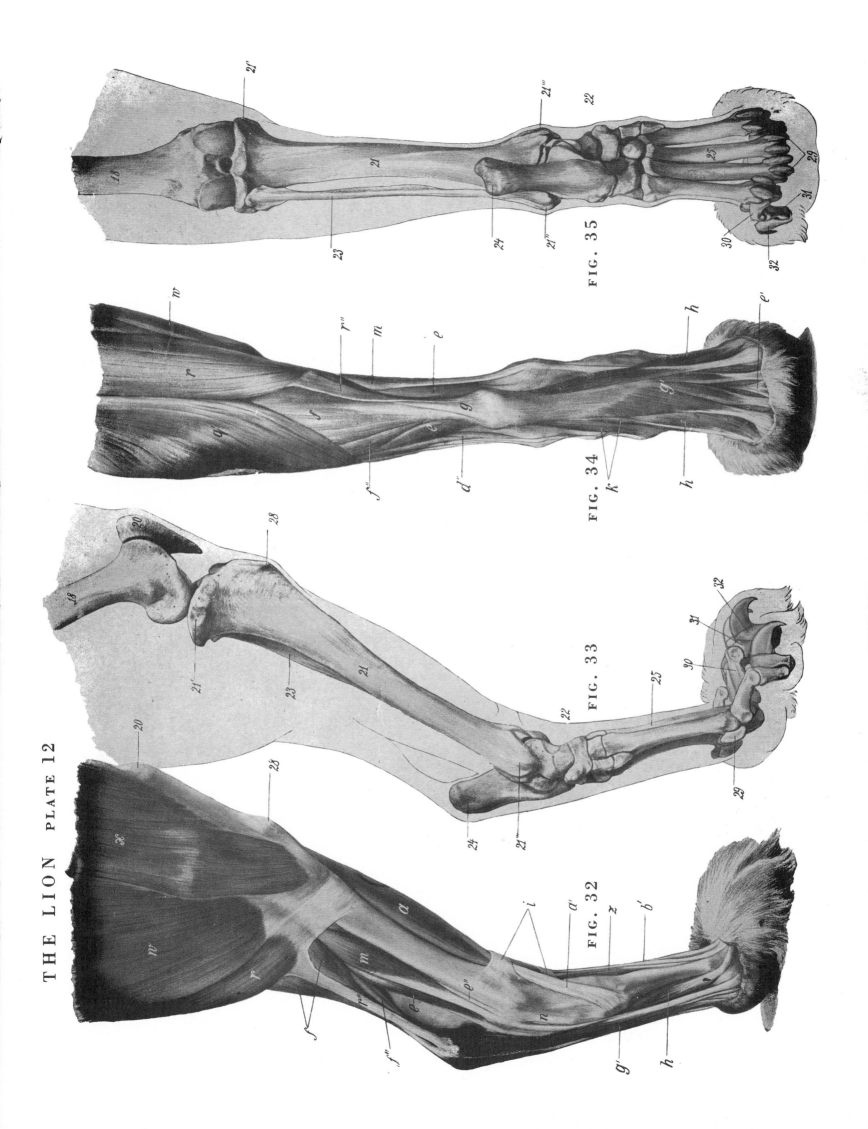

THE LION PLATE 12

FIG. 32

FIG. 33

FIG. 34

FIG. 35

THE LION · PLATES 13 14 15

FIGURES 36 37 38 39 40 41 42 43 44 45 46

b—M. levator nasolabialis
c—M. cleidomastoideus
d, d'—M. sternomandibularis
e—End part of the M. sternohyoideus
f—Part of the M. caninus s. M. pyramidalis nasi
g—M. zygomaticus
g'—M. malaris
h—M. buccinator
i—M. quadratus s. depressor labii inferioris
k—M. orbicularis oris
m—M. masseter
n—Depressor of the auricle
p—M. scutularis
p'—Muscles of the ear
q—Abductor of the auricle
r—Levator of the auricle
u, u', u''—M. corrugator supercilii
v—End of the two-bellied muscle
w—M. myohyoideus
y—Cervical subcutaneous muscle
z—M. temporalis
z'—M. occipitalis
*—Atlas
1—Seat of the auricle

2, 2'—Anterior edge of the auricle
3—Posterior edge of the auricle
4—Incisura intertragica
9—Arcus zygomaticus
11—Processus coronoideus of the lower jawbone
12—Frontal process of the malar bone
12'—Zygomatic process of the frontal bone
13—Os occipitale
13'—Crest and spine of the os occipitale
14—Os parietale
14'—Crest and spine of the os parietale
15—Crest of os parietale
16—Os temposrale
17—Meatus acusticus externus
18—Temporo-maxillary joint
19—Orbita
20—Os zygomaticum
21—Os lacrimale
22—Os nasale
23—Os incisivum
24—Upper incisor teeth
24'—Lower incisor teeth
25—Upper canine tooth
26—Maxilla

27—Facial crest
28—Unpaired part of the lower jawbone
28'—Paired part of the lower jawbone
29—Lower canine tooth
30—Branch of the lower jaw
30'—Processus angularis
31—Condyle process of the lower jaw
32—1st cervical vertebra (Atlas)
33—2nd cervical vertebra
34—Lateral cartilage of the nose
34'—Nose cartilage
35—Cartiloginous epiphysis
36—lymph gland of the oesophagus
38—V. jugularis
39—V. facialis
44—Glandula parotis
50—Glandula submaxillaris
59—Prominence corresponding to the pomum
 Adami in the human
63—Laryngeal muscles
64—End of the M. sternothyroideus
65—Thyrohyoid muscles

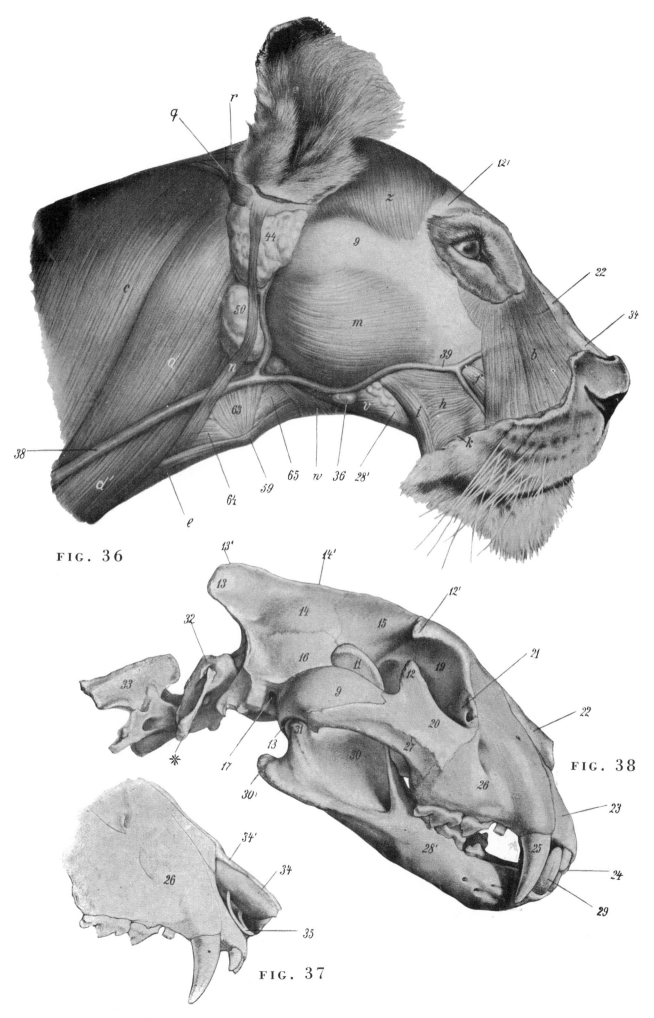

FIG. 36

FIG. 37

FIG. 38

THE LION PLATE 14

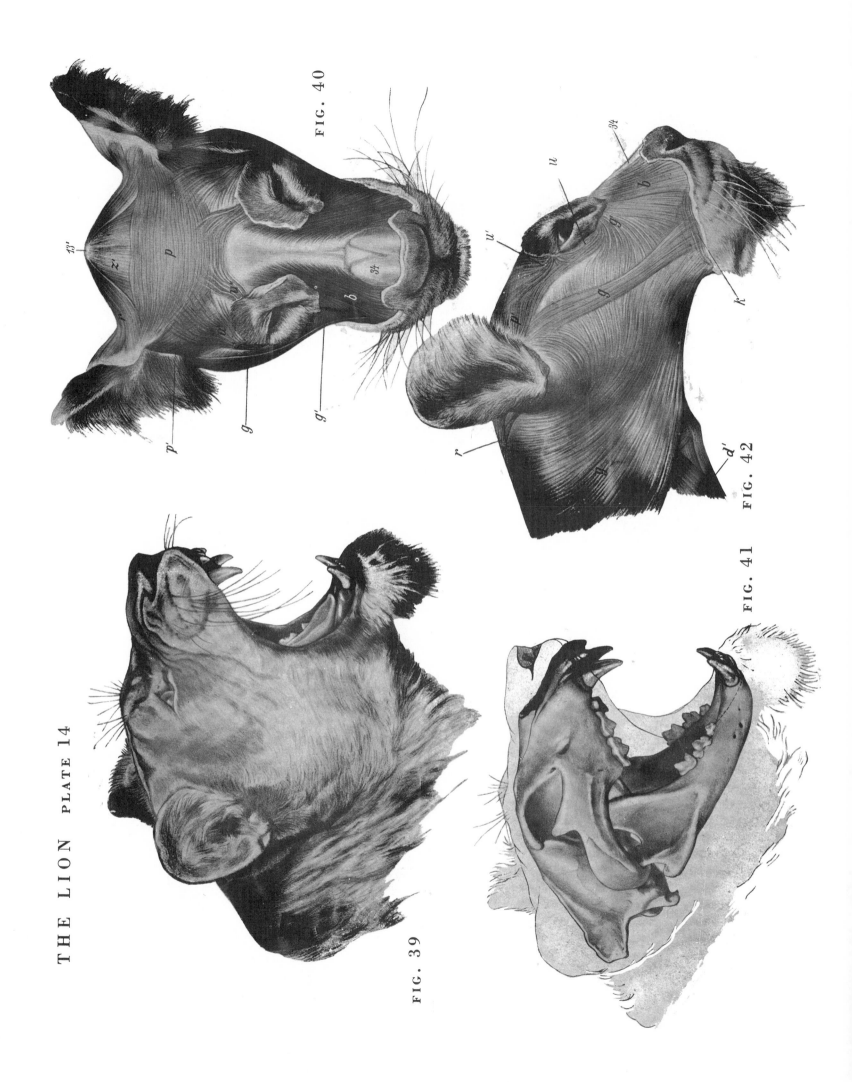

FIG. 39

FIG. 40

FIG. 41

FIG. 42

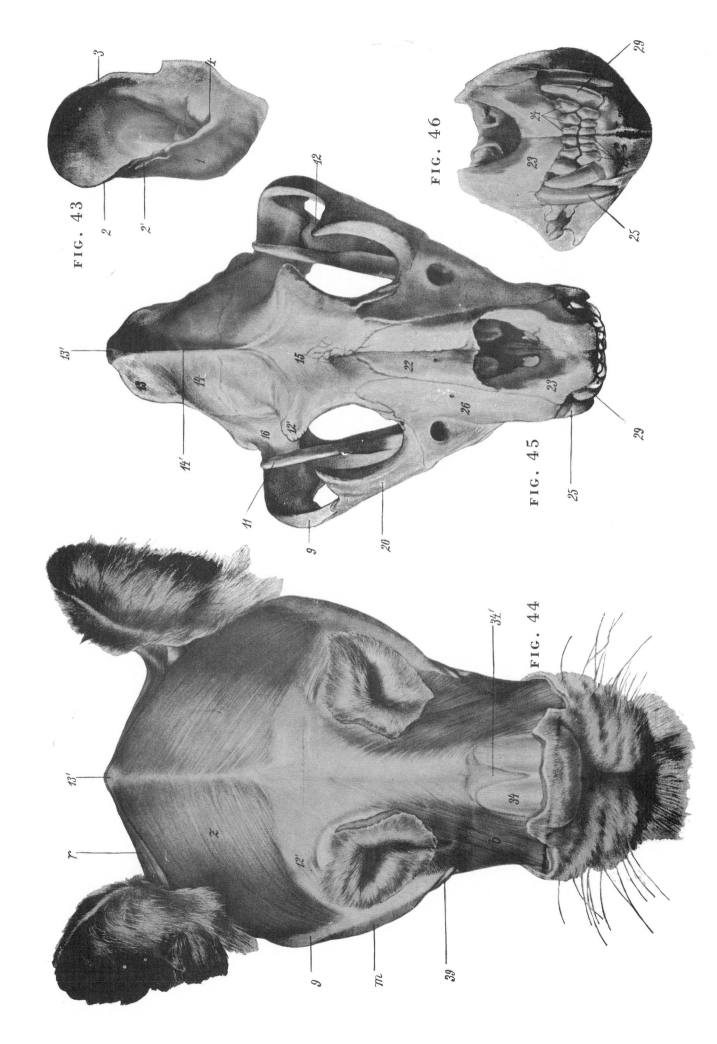

THE LION PLATE 15

FIG. 43

FIG. 44

FIG. 45

FIG. 46

THE LION · PLATE 16

FIGURE 47

a—*Groove of the lips*
b—*Gum*
c—*Mucous membrane of the cavity*
d—*Tip of the tongue*

e—*Gap between teeth*
f—*Mucous membrane of the lip*
g—*Upper left canine tooth (dens caninus)*
g'—*Lower left canine tooth*

h—*Upper left incisor tooth (dentes incisivi)*
h'—*Lower left incisor teeth*
i—*2nd lower molar tooth*

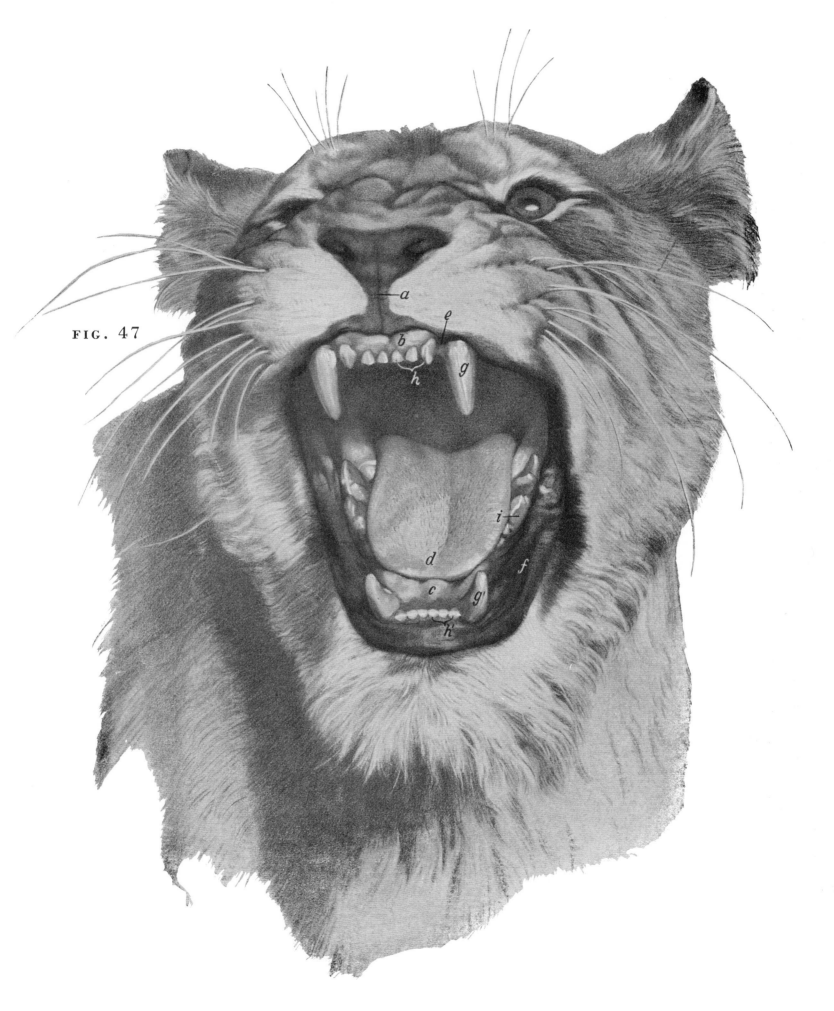

FIG. 47

The Cow and Bull

THE COW AND BULL · PLATES 1 2 3 4

FIGURES 1 2 3 67 68 69 70 71

a—M. trapezius
b—Shoulder-transverse-process muscle
c, c'—M. brachiocephalicus
d—M. sternomandibularis
d'—M. sternomastoideus
e, e'—M. deltoideus
f, f'—M. triceps brachii
g—M. pectoralis major
h, h'—M. pectoralis minor
i—Thoracic portion of M. serratus anterior
i'—Cervical portion of M. serratus magnus
k—M. latissimus dorsi
l—M. obliquus abdominis externus
l'—Aponeurosis
m—M. serratus posterior
m'—Lumbo-dorsal fascia
n—A small part of origin of the M. obliquus abdom. internus
o—M. tensor fasciae latae
o'—Fascia lata of thigh
p—M. glutaeus medius
q, q'—M. biceps femoris
r—M. semitendinosus
s, t—Short and long levators of the tail
u—Abductor of the tail
v'—M. biceps brachii
w—M. splenius
x—M. rhomboideus
y—End of M. longissimus capitis
z—M. supraspinatus

z'—M. infraspinatus
z''—Broad tendon over the humerus
1H—1st cervical vertebra (Atlas)
7H—7th cervical vertebra
K—Sacrum
6K—6th costal cartilage
1L—1st lumbar vertebra
6L—6th lumbar vertebra
1R—1st thoracic (dorsal) vertebra
6R—6th rib
12R—12th thoracic (dorsal) vertebra
13R—13th rib
1S—1st caudal vertebra
*—Alar border of the atlas
1—Scapula
1'—Border of the cartilago scapulae
2—Spina scapulae
3—Acromion
4—Humerus
4'—Epicondyle
5—Tuberculum majus
6—Rotator
7—Ulna
8—Olecranon
9—Radius
10—Carpus
11—Os pisiforme
12—Metacarpus
13—Phalanges manus
14—Sternum

14'—Manubrium sterni
14''—Cartilago xiphoidea
15—Ossa pelvis
16—Tuber coxae
16'—Tuber sacrale
17—Tuber ischiadicum
18—Os femoris
19—Trochanter major
20—Patella
21—Tibia
21'—External condyle of the tibia
22—Tarsus
23—Os malleolare
24—Tuber calcanei
25—Metatarsus
26—Phalanges pedis
27—Muscles of the ear
28—M. quadriceps femoris
28'—M. rectus femoris
29—M. semimembranosus
30—Mm. gastrocnemii
31—Broad pelvic ligament
32—Plane of the cross section of the neck shown
 in Figures 70 (cow) and 71 (bull) on
 Plate 4
33—Transverse processes of the cervical vertebrae
34—V. jugularis
35, 36, 37—Large veins clearly protruding through
 the outer skin

THE COW AND BULL PLATE 1

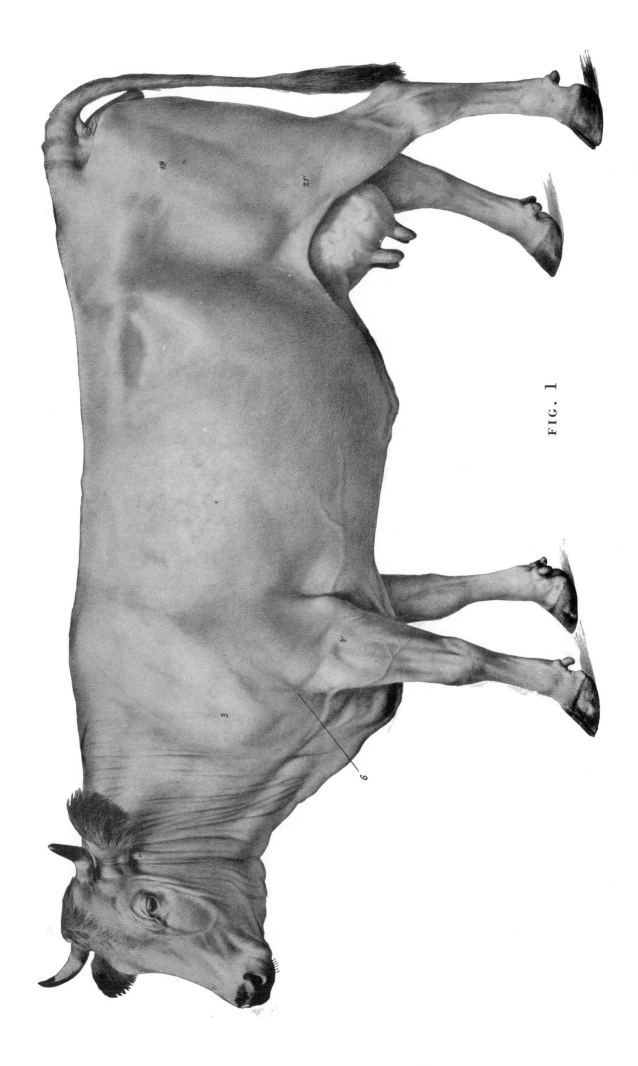

FIG. 1

THE COW AND BULL PLATE 2

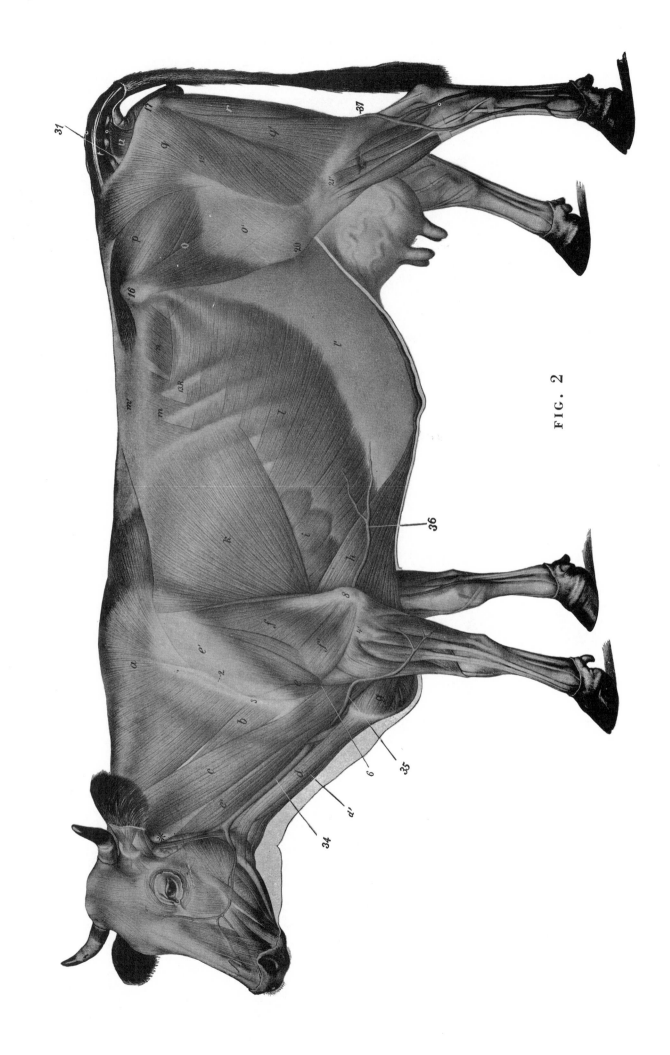

FIG. 2

THE COW AND BULL PLATE 3

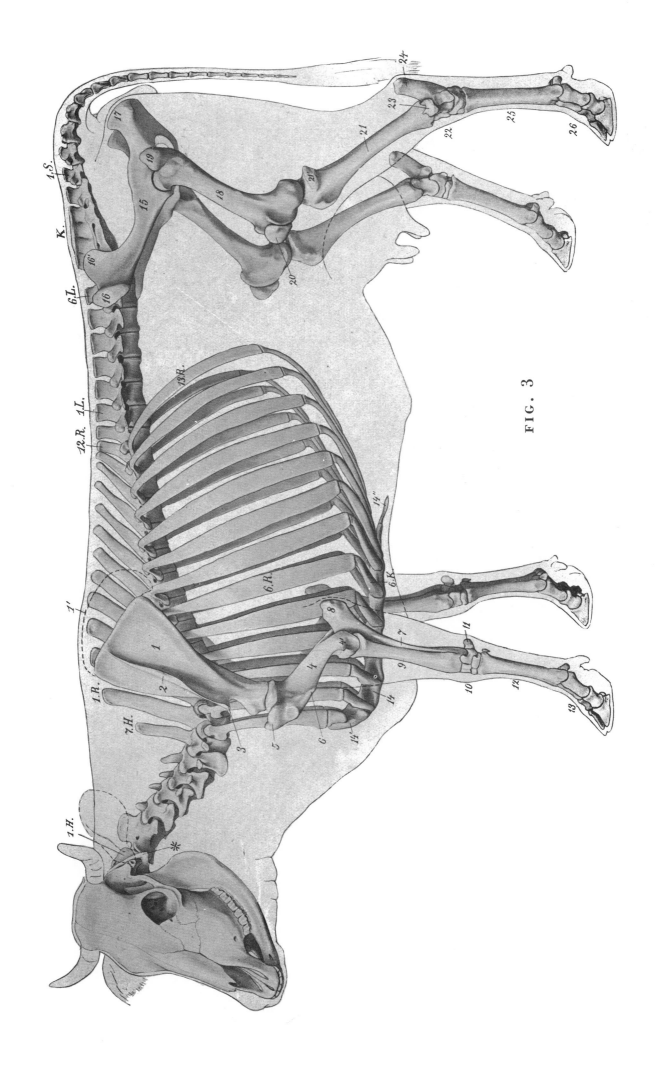

FIG. 3

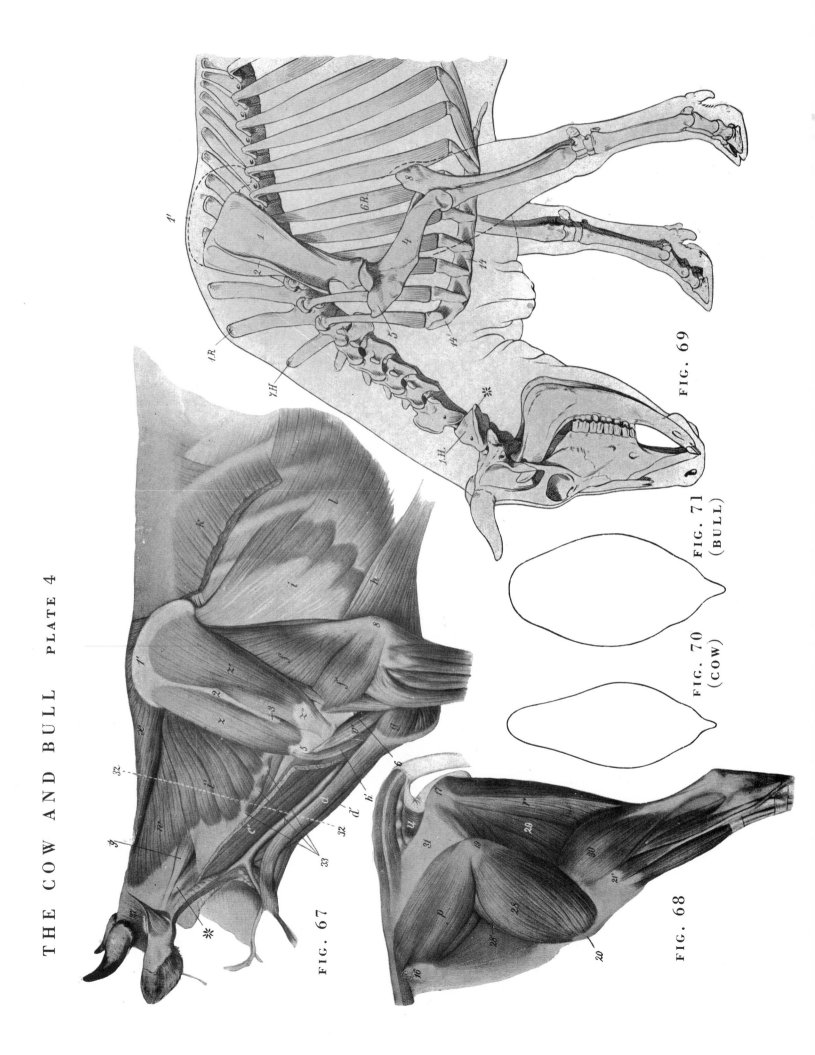

THE COW AND BULL PLATE 4

FIG. 67

FIG. 68

FIG. 69

FIG. 70
(COW)

FIG. 71
(BULL)

THE COW AND BULL · PLATES 5 6

FIGURES 4 5 6 7 8 9

a—M. trapezius
b—Shoulder-transverse-process muscle
c, c'—M. brachiocephalicus, c cervical, c'
 mastoidal part
d—M. sternomandibularis
d'—M. sternomastoideus
e—End of the M. sternohyoideus
g—M. pectoralis major
i—V. jugularis
i'—Cutaneous vein
k—Larynx
p—M. glutaeus medius
q, q'—M. biceps femoris
r—M. semitendinosus
s—Levator of the tail

u—Abductor of the tail
v—M. semimembranosus
w—M. gracilis
x—Posterior-upper margin of the broad pelvic
 ligament
1—Scapula
2—Spina scapulae
3—Acromion
4—Humerus
5—Tuberculum majus of the humerus
6—Rotator of the humerus
9—Radius
14, 14'—Sternum & manubrium sterni
1R—1st rib

7H—7th cervical vertebra
*—Ala border of the 1st cervical vertebra (Atlas
 border)
16—Tuber coxae
17—Tuber ischiadicum
18—Os femoris
19—Trochanter major of the os femoris
19'—Trochanter minor of the os femoris
21—Tibia
22—Tarsus
24—Tuber calcanei
25—Metatarsus
26—Phalanges pedis
37—Large cutaneous vein on the tibia

THE COW AND BULL PLATE 5

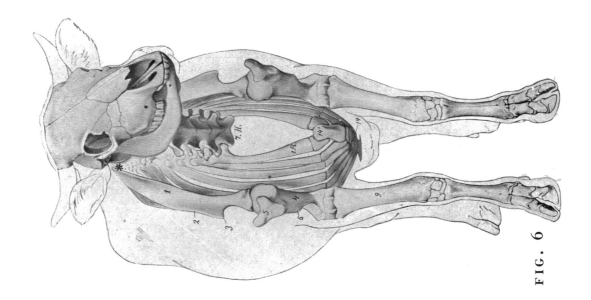

FIG. 6

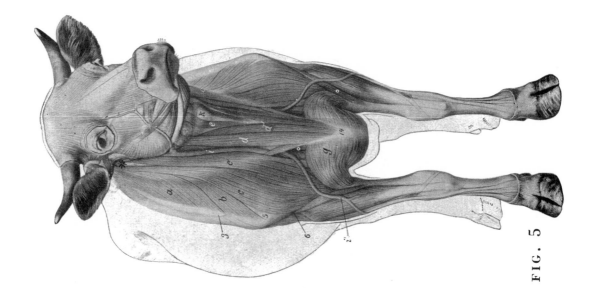

FIG. 5

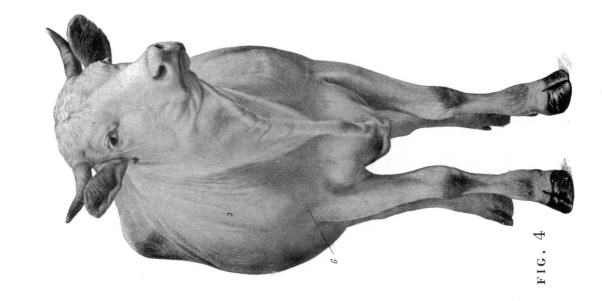

FIG. 4

THE COW AND BULL PLATE 6

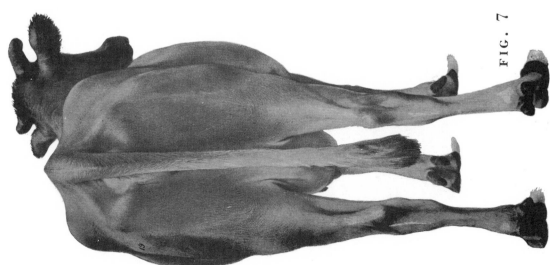

FIG. 7

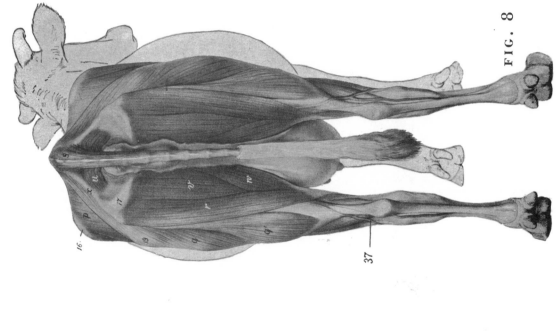

FIG. 8

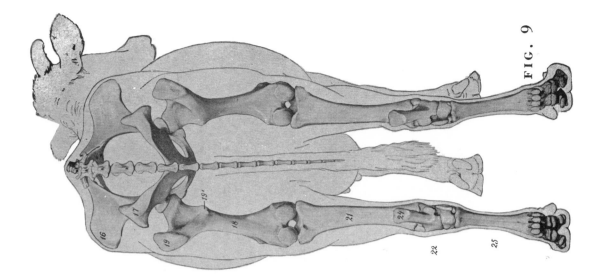

FIG. 9

THE COW AND BULL · PLATES 7 8

FIGURES 10 11 12 13 14 15 16 17 18

a—M. extensor carpi radialis
b—M. extensor digiti tertii proprius
c—M. extensor digitorum communis
d—M. extensor digiti quarti proprius
e—M. extensor carpi ulnaris
e'—Tendon on leg
f—M. abductor pollicis longus
f'—Ulnar head of the flexor carpi ulnaris
g—M. brachialis internus
h—M. interosseus medius
i—Flexor tendons

i'—Assisting flexor tendon
k—M. flexor carpi radialis
l—Humeral head of the M. flexor carpi ulnaris
m—M. flexor digitorum sublimis
n—Plane of the cross section of the metacarpus
 shown in Fig. 18 on Plate 8
4—Humerus
4'—Extensor condyle of the humerus
7—Ulna
8—Olecranon
9—Radius

9'—External tuberosity of the radius
10—Bones of the carpus
11—Os pisiforme
12—Skeleton of the metacarpus
12'—Swelling of the primary metatarsal bone
14—Rudimentary external small metacarpal bone
15—Sesamoid bone of the 1st digital joint
16—Phalanx prima
17—Phalanx secunda
18—Phalanx tertia
19—Sesamoid bones of the 3rd digital joint

[94]

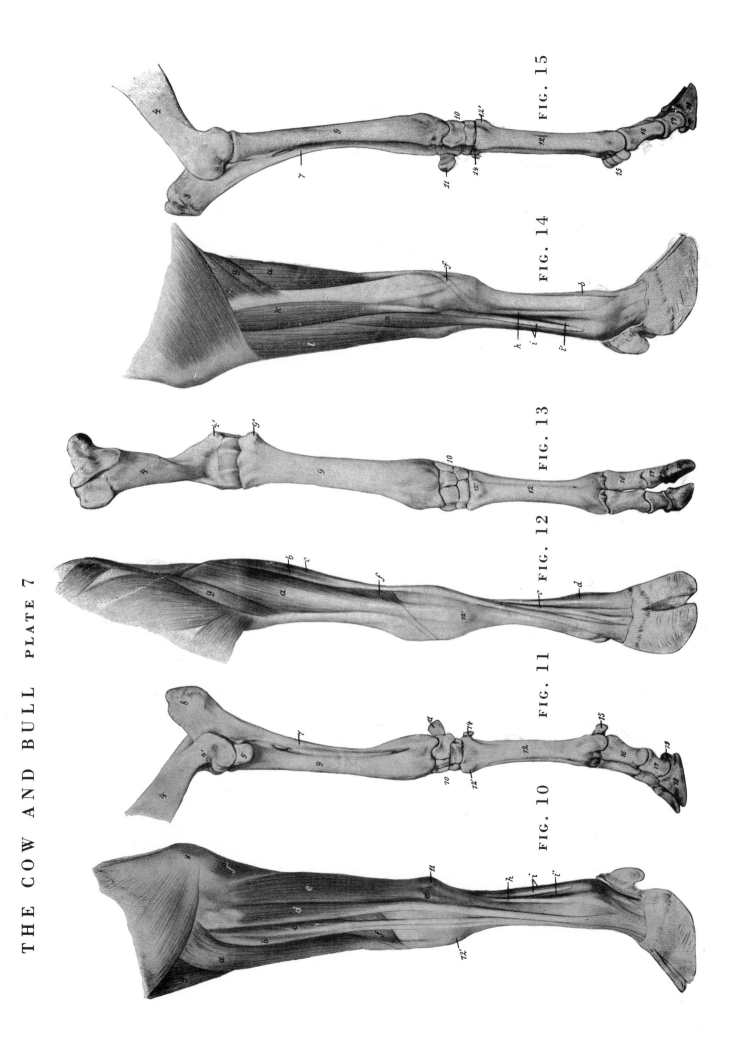

THE COW AND BULL PLATE 7

FIG. 10 FIG. 11 FIG. 12 FIG. 13 FIG. 14 FIG. 15

THE COW AND BULL PLATE 8

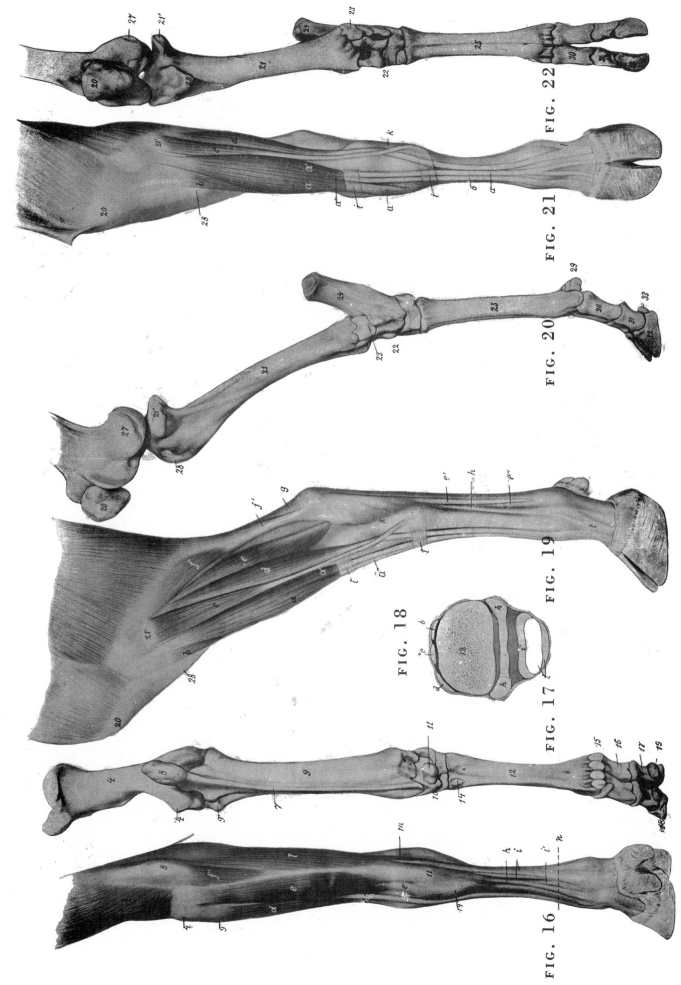

FIG. 16　FIG. 17　FIG. 18　FIG. 19　FIG. 20　FIG. 21　FIG. 22

THE COW AND BULL · PLATES 8 9

FIGURES 19 20 21 22 23 24 25 26 27 28 29

[97]

a, a', a''—M. extensor digitorum pedis longus
b, b'—M. tibialis anterior
c—M. peronaeus longus
d—M. extensor digiti quarti proprius
e, e'—M. flexor digitorum pedis profundus
e''—Strengthening tendons for the flexor tendons
f, f'—Mm. gastrocnemii
g—Superficial flexor tendon
h—M. interosseus medius
i—Annular ligaments
k—External lateral ligament of the tarsal
 articulation

l—Muscular attachment of tendon from M.
 interosseus medius to extensor tendon
m—M. flexor digitorum pedis longus
n—A ligament of the tarsus
o—M. politeus
20—Patella
21—Tibia
21'—External condyle of the tibia
22—Tarsus
23—Os malleolare
24—Tuber calcanei
25—Metatarsus

27—External condyle of the os femoris
28—Crista tibiae
29—Sesamoid bones of the 1st digital joint
30—Phalanx prima
31—Phalanx secunda
32—Phalanx tertia
33—Lower sesamoid bone
34—Front view of hoof
35—Bottom view of hoof showing primary and
 secondary claws
36—Rear view of hoof showing primary and
 secondary claws

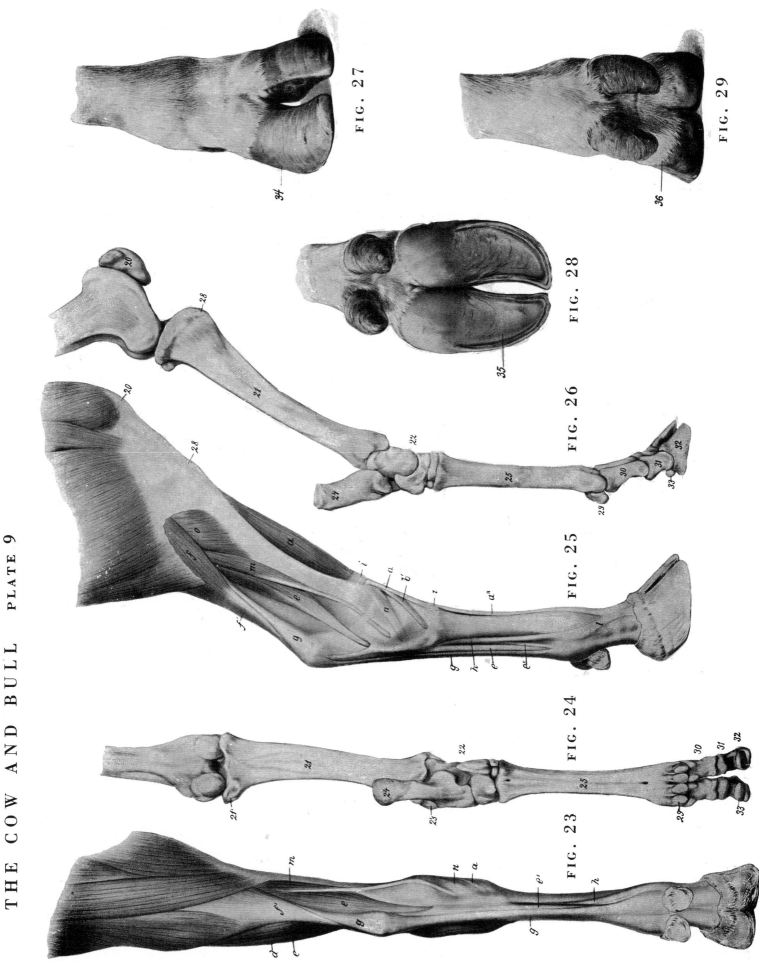

THE COW AND BULL PLATE 9

FIG. 23

FIG. 24

FIG. 25

FIG. 26

FIG. 27

FIG. 28

FIG. 29

THE COW AND BULL · PLATES 10 11 12

FIGURES 30 31 32 33 34 35 40 41 42 44 45 46 47 48 49 50 51 52

a, a'—M. levator labii superioris proprius
b—M. levator nosolabialis
c, c'—Cervial part and mastoidal part of the M. cleidomastoideus
d—M. sternomandibularis
d'—M. sternomastoideus
e—End of the M. sternohyoideus
e'—A thin muscular fasciculus
f—M. caninus s. pyramidalis nasi
g—M. zygomaticus major
g'—M. zygomaticus minor s. M. malaris
h—M. buccinator
i—M. depressor s. quadratus labii inferioris
k—M. orbicularis oris
m—M. masseter
n—Depressor of the ear
o'—Inferior adductor of the auricle
o''—Superior adductor of the auricle
o'''—Short levator of the auricle
p, p'—M. scutularis
q—Long abductor of the auricle
u—M. frontalis
w—M. mylohyoideus
z—M. orbicularis oculi
l—Auricula
2—External or posterior edge of the auricle
3—Internal or anterior edge of the auricle
8—Scutulum

9—Arcus zygomaticus
11—Proc. coronoideus of the lower jawbone
12—Orbital arch
13, 13', 13'', 13'''—Os occipitale
14—Os parietale
15—Os frontale
16—Os temporale
17—Meatus acusticus externus
18—Temporo-maxillary joint
19—Orbita
20—Os zygomaticum
21—Os lacrimale
22—Os nasale
23—Os incisivum
24'—Lower incisor teeth
24''—Edge of lower incisor tooth of a five-year old animal; this is worn away in a ten-year old animal
26—Maxilla
27—Facial condyle
28—Incisor (unpaired) part of the lower jawbone
28'—Molar (paired) part of the lower jawbone
30—Branch of the lower jaw
30'—Angle of the lower jaw
31—Condyloid process of the lower jaw
32—1st cervical vertebra
34—Upper lateral cartilage
37—V. maxillaris externa

38—V. jugularis
39—V. facialis
44—Glandula parotis
45—Chin
48—Angle of the mouth
49—Muzzle
50, 50'—Glandula submaxillaris
51—Upper eyelid
51'—Lower eyelid
52—3rd eyelid containing cartilago nictitans
53—Caruncula lacrimalis
54—Lacus lacrimalis
55, 55'—Eyeball
56—Pupil
57—Black-brown pigmented marginal band
58—Medial eyelid band
59—Larynx
60—Tip of the tongue
61—Large papillae on the mucous membrane of the lips
62—Part of the oral-cavity floor lying under the tip of the tongue
63—Plane of the cross section of the head shown in Fig. 40 on Plate 10
64—Plane of the cross section of the head shown in Fig. 41 on Plate 10
65—Plane of the cross section of the head shown in Fig. 42 on Plate 10

THE COW AND BULL PLATE 10

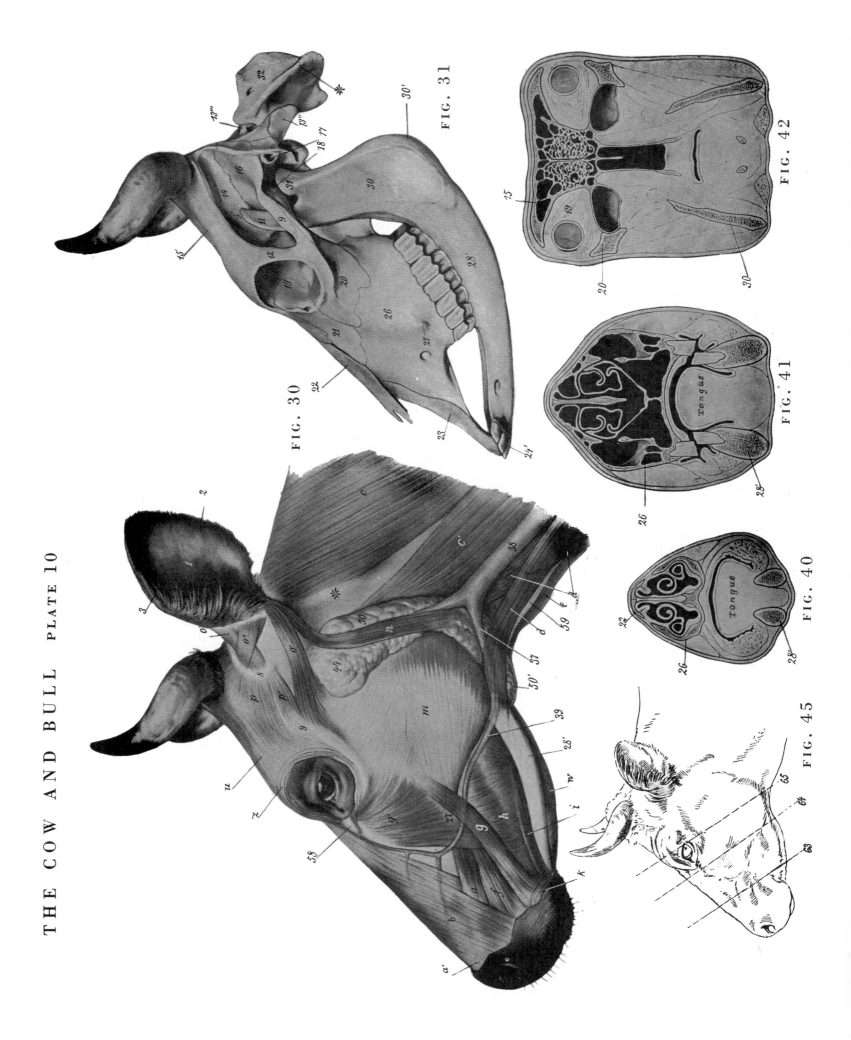

FIG. 30

FIG. 31

FIG. 42

FIG. 41

FIG. 40

FIG. 45

Tongue

Tongue

Tongue

THE COW AND BULL PLATE 11

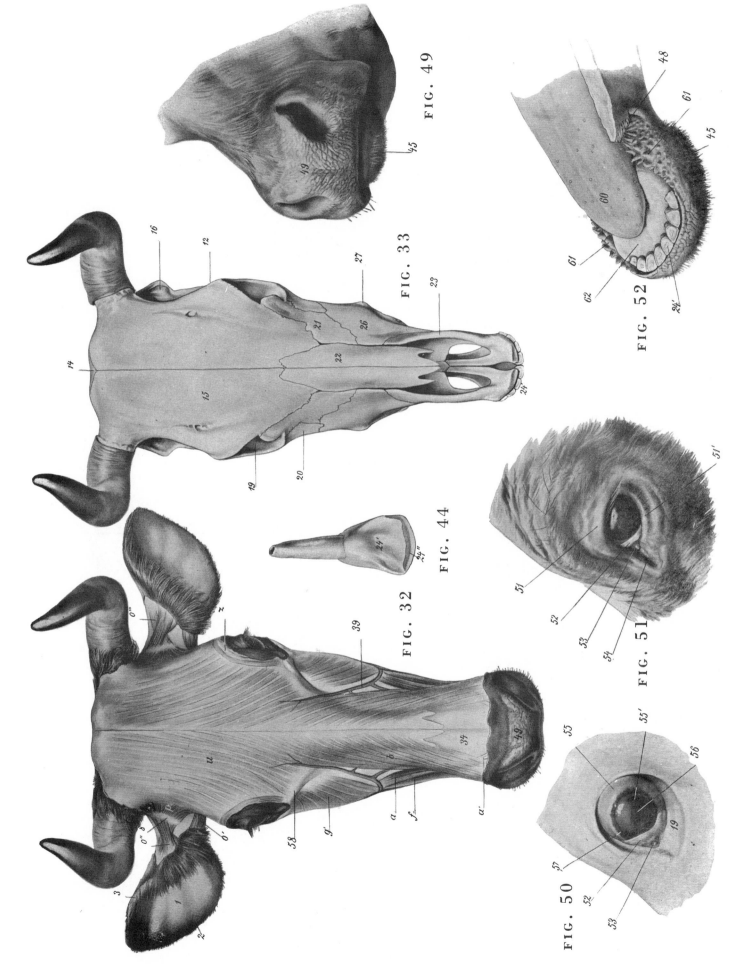

FIG. 49

FIG. 33

FIG. 32

FIG. 44

FIG. 52

FIG. 51

FIG. 50

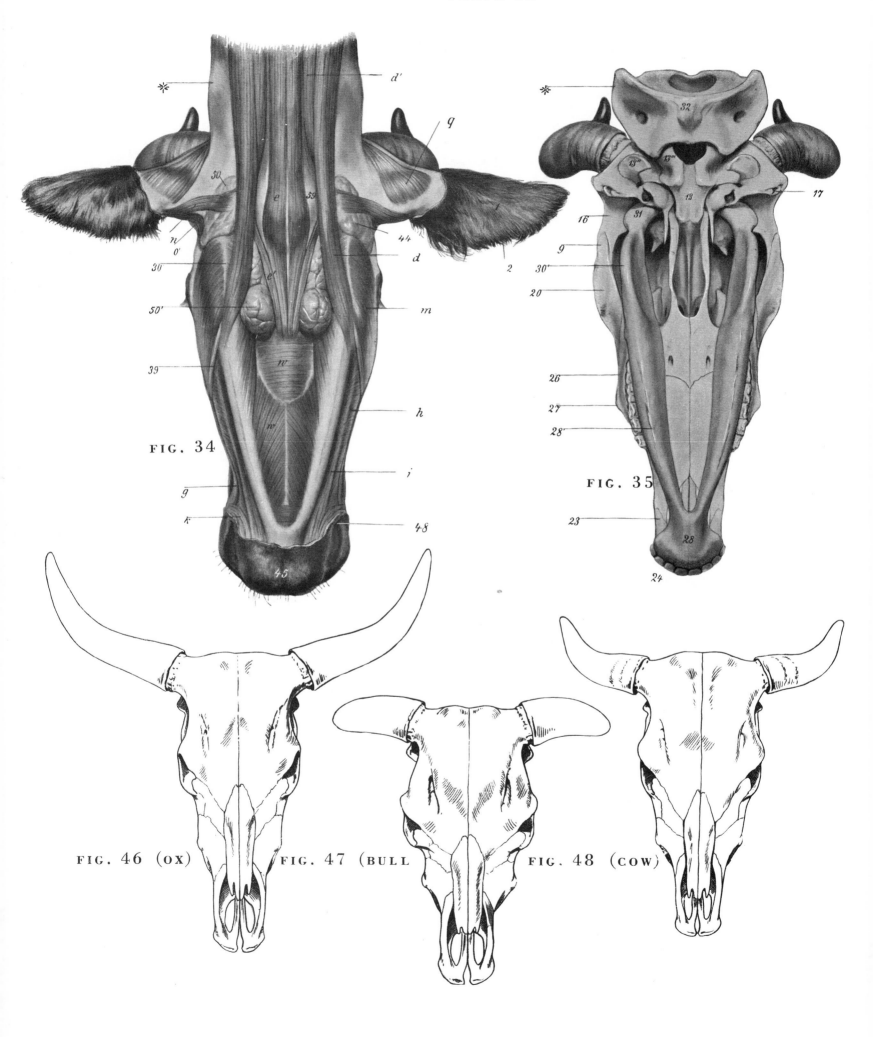

FIG. 34

FIG. 35

FIG. 46 (OX) FIG. 47 (BULL) FIG. 48 (COW)

THE COW AND BULL · PLATES 13 14

FIGURES 55 56 57 58 59 60 61 62

a—*M. trapezius*
b—*Shoulder-transverse process muscle*
c—*M. cleido-mastoideus*
e, e'—*M. deltoideus*
k—*M. latissimus dorsi*
l—*M. obliquus abdominis externus*
m—*M. serratus posterior*
m'—*Lumbo-dorsal fascia*
o—*M. tensor fasciae latae*
p—*M. glutaeus medius*
q—*M. biceps femoris*
s, t—*Long and short levators of the tail*
u—*Abductor of the tail*
v—*Muscles of the ear*
w—*Free edge of the pelvic ligament*
1H—*1st cervical vertebra*
7H—*7th cervical vertebra*
1L—*1st lumbar vertebra*
6L—*6th lumbar vertebra*
K—*Sacrum*
1R—*1st thoracic vertebra*
6R—*6th rib*
12R—*12th thoracic vertebra*
13R—*13th rib*
1S—*1st caudal vertebra*
*—*Ala border of atlas*

1—*Scapula*
1'—*Border of the scapular cartilage*
2—*Spina scapulae*
3—*Acromion*
4—*Humerus*
5—*Tuberculum majus of humerus*
8—*Olecranon*
15—*Ilium*
16—*Tuber coxae*
16'—*Tuber sacrale*
17—*Tuber ischiadicum*
18—*Femur*
19—*Trochanter major of the femur*
24—*Tuber calcanei*
27—*Os occipitale*
28—*Os parietale*
28'—*Cerebral crest*
29—*Os frontale*
30—*Transverse processes of the lumbar vertebrae*
31,—*The two iliac condyles of the pelvis of the bull*
32—*The two articular cavities of the pelvis of the bull*
33—*The two tubera ischii of the pelvis of the bull (compare with pelvis of the cow in Fig. 57 on Plate 14)*

34—*Plane of the cross section of the front leg shown in Fig. 58 on Plate 14*
35—*Plane of the cross section of the hind leg shown in Fig. 59 on Plate 14*
36—*Radius and ulna*
37—*M. extensor carpi radialis*
38—*M. extensor digiti tertii proprius*
39—*M. extensor digitorum communis*
40—*M. extensor digiti quarti proprius*
41—*M. extensor carpi ulnaris*
42—*M. flexor carpi ulnaris*
43—*M. flexor carpi radialis*
44, 44'—*M. flexor digitorum sublimis et profundus*
45—*V. cephalica antibrachii*
46—*Tibia*
47—*M. extensor digitorum longus and M. tibialis anterior*
48—*M. peronaeus longus*
49—*M. extensor digiti quarti pedis proprius*
50, 50'—*M. flexor digitorum pedis profundus*
51—*M. flexor digitorum longus*
52—*Tendo Achillis*
53—*Superficial flexor tendon*
54—*Cutaneous vein*
55—*Outer skin*

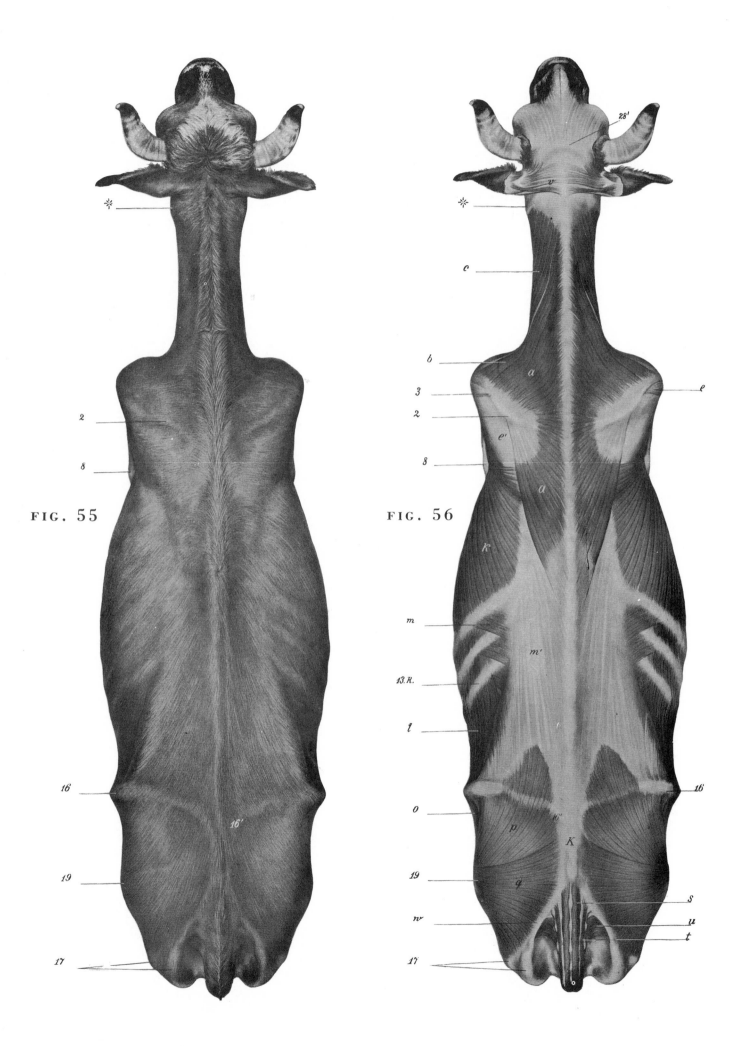

FIG. 55

FIG. 56

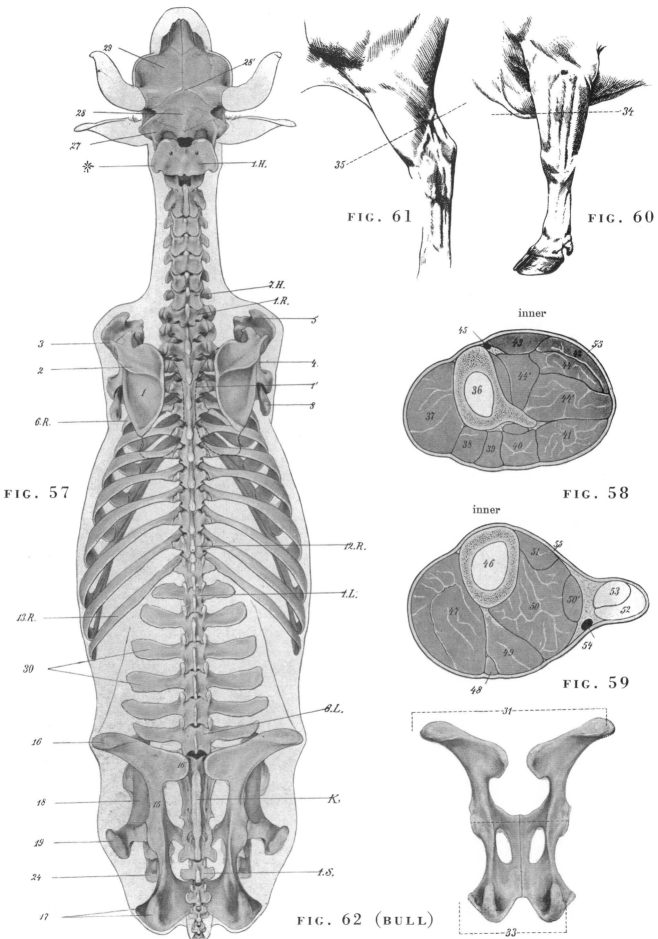

FIG. 61 FIG. 60

inner

FIG. 58

inner

FIG. 59

FIG. 57

FIG. 62 (BULL)

THE COW AND BULL · PLATES 15 16

FIGURES 63 64 65 66 53 54

a—*Hair whorl*
b—*Free end of the 6th thoracic vertebra*
c, c'—*Cross-sectioned 8th and 7th rib*
d—*Cross-sectional costal cartilage*
e—*Cross-sectional sternum*
f—*Cross-sectioned outer skin*

g—*Cross-sectioned muscles*
h—*Thyroid cartilage*
i—*Anterior resp. interior edge of auricle*
i'—*Posterior resp. exterior edge of auricle*
k—*Folds of skin on the inner surface of the auricle*
l—*Cartilagenous external auditory canal*

m—*Plane of the cross section of the body shown in Fig. 64 on Plate 15*
1, 2, 3, 4, 5, 6—*Schematic diagram of the gait of the cow (dark footprints represent the feet bearing the weight at the moment)*

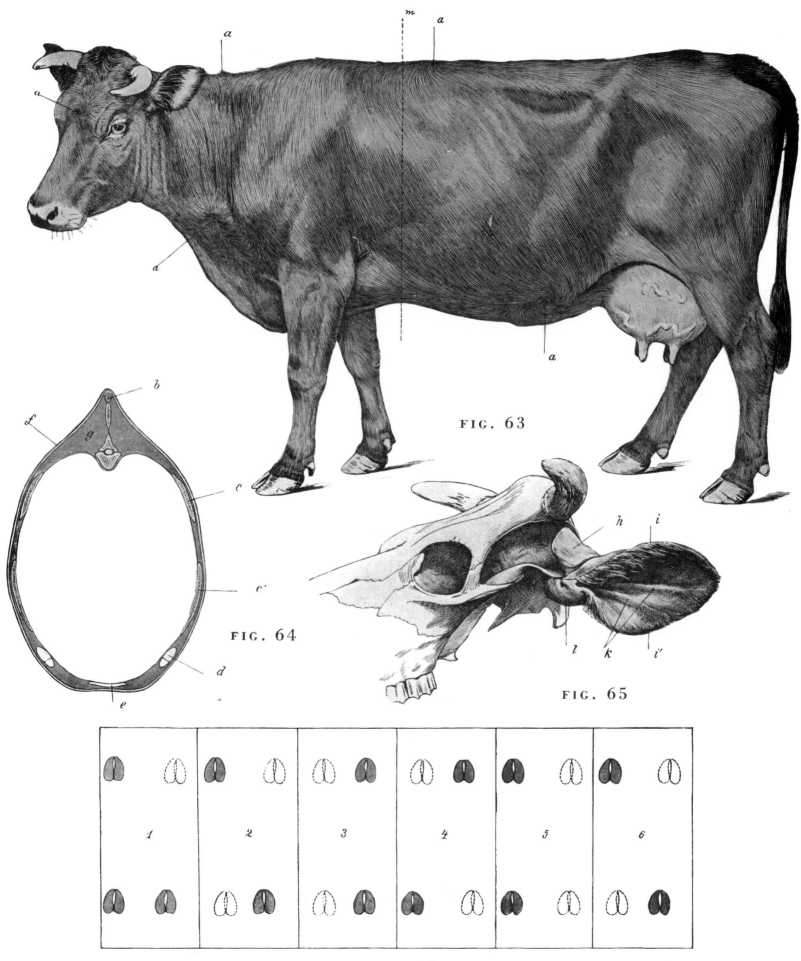

FIG. 63

FIG. 64

FIG. 65

FIG. 66

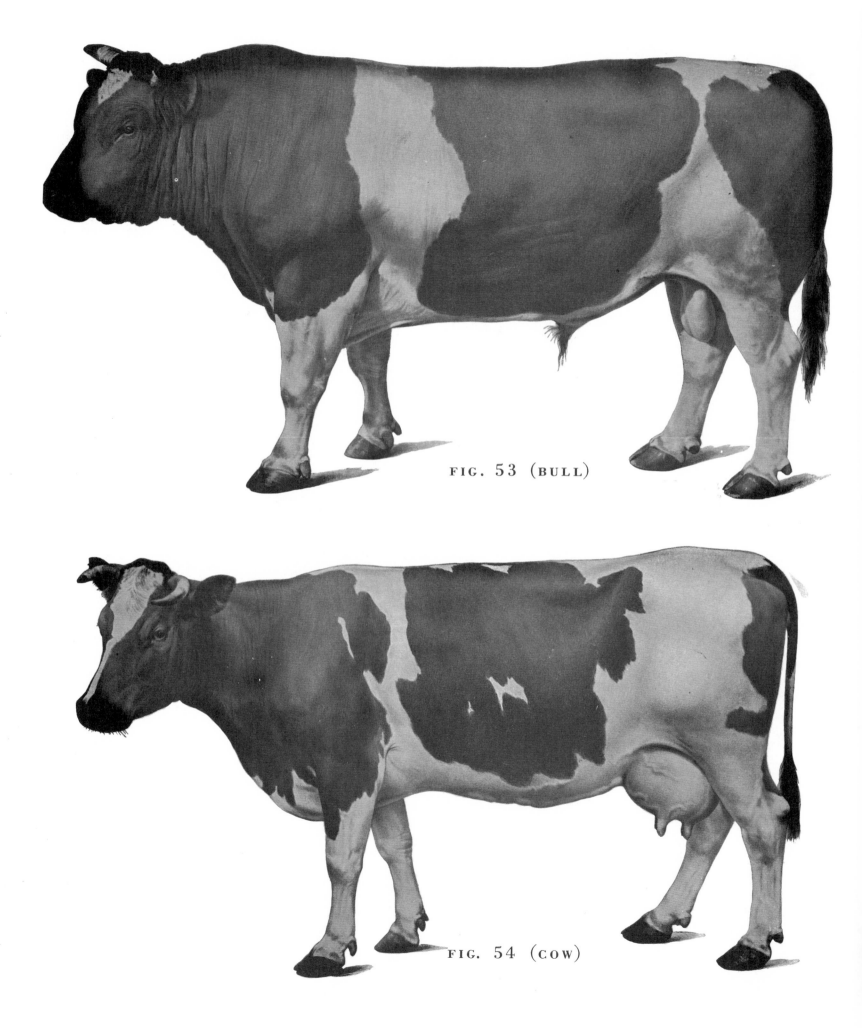

FIG. 53 (BULL)

FIG. 54 (COW)

The Stag, Roe, Goat

THE STAG, ROE, GOAT · PLATES 1 2 3 4 5 6

FIGURES 1 2 3 4 5 6

a, a'—M. trapezius
b—Shoulder-transverse-process muscle
c—M. brachiocephalicus (cephalic section)
c'—M. brachiocephalicus (cervical section)
c''—Lower portion of M. brachiocephalicus
c'''—Tendinous band
d, d'—M. sternomandibularis
e—M. deltoideus
e'—M. deltoideus at the aponeurosis
f, f'—M. triceps brachii
g, g'—M. pectoralis major s. superficialis
h—Posterior part of M. pectoralis minor s. profundus
i—End teeth of M. serratus anterior
k—M. latissimus dorsi
l—M. obliquus abdominis externus
l'—Aponeurosis
m—M. serratus posterior
m'—Lumbo-dorsal fascia
n—A small part of origin of M. obliquus abdominis internus
o, o''—M. tensor fasciae latae
o'—Broad thigh portion of the M. tensor fasciae latae
p—M. glutaeus medius
q, q'—M. biceps femoris
r—M. semitendinosus
s—Edge portion of M. semimembranosus
t—Edge portion of M. sternothyroideus
u—M. omohyoideus

v—M. sternohyoideus
w—A part of M. scalenus
x—Muscle slip from brachiocephalus to pectoralis major
y—Edge portion of M. tensor fasciae antebrachii
z—M. tensor fasciae antebrachii
z'—Cervical subcutaneous muscle
1H—1st cervical vertebra (Atlas)
7H—7th cervical vertebra
K—Sacrum
6K—Costal cartilage
1L—1st lumbar vertebra
6L—6th lumbar vertebra
7L—7th lumbar vertebra
1R—1st thoracic (dorsal) vertebra
6R—6th rib
12R—12th thoracic (dorsal) vertebra
13R—13th rib
S—Caudal vertebra
*—Ala of Atlas
1—Scapula
1'—Border of scapular cartilage
2—Spina scapulae
3—Acromion
4—Humerus
4'—External epicondyle
5—External tuberosity
6—Rotator of humerus
7—Ulna
8—Olecranon

9—Radius
10—Carpus
11—Os pisiforme
12, 12'—Metacarpus
13—Phalanx prima
13'—Phalanx secunda
13''—Phalanx tertia
14—Sternum
14'—Manubrium sterni
14''—Cartilago xiphoidae
15—Ossa pelvis
16—Tuber coxae
16'—Tuber sacrale
17—Tuber ischidicum
18—Os femoris
19—Trochanter major
20—Patella
21—Tibia
21'—External epicondyle of tibia
21''—Swelling of tibia
22—Tarsus
23—Os malleolare
24—Tuber calcanei
25, 25'—Metatarsus
26—Phalanx prima
26'—Phalanx secunda
26''—Phalanx tertia
27—Free border of pelvic ligament
28—End of M. brachialis internus
29—M. extensor carpi radialis

THE STAG, ROE, GOAT PLATE 1

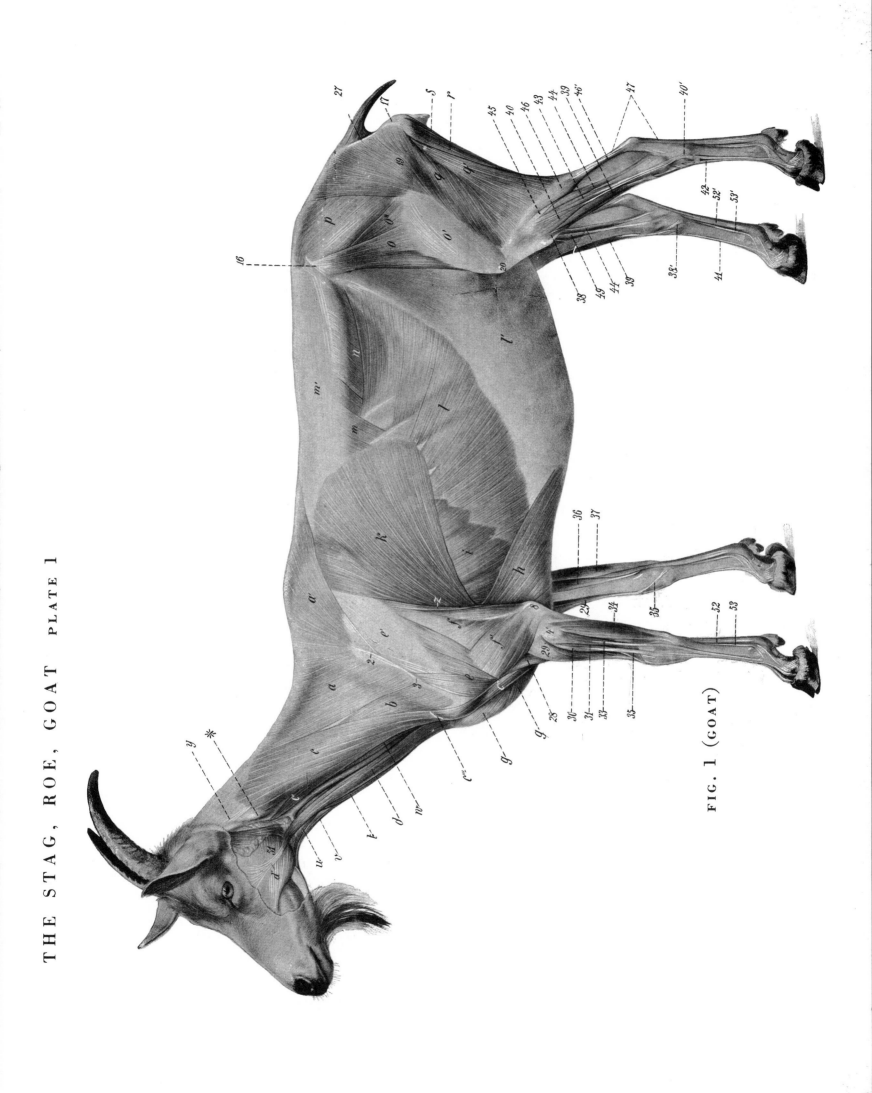

FIG. 1 (GOAT)

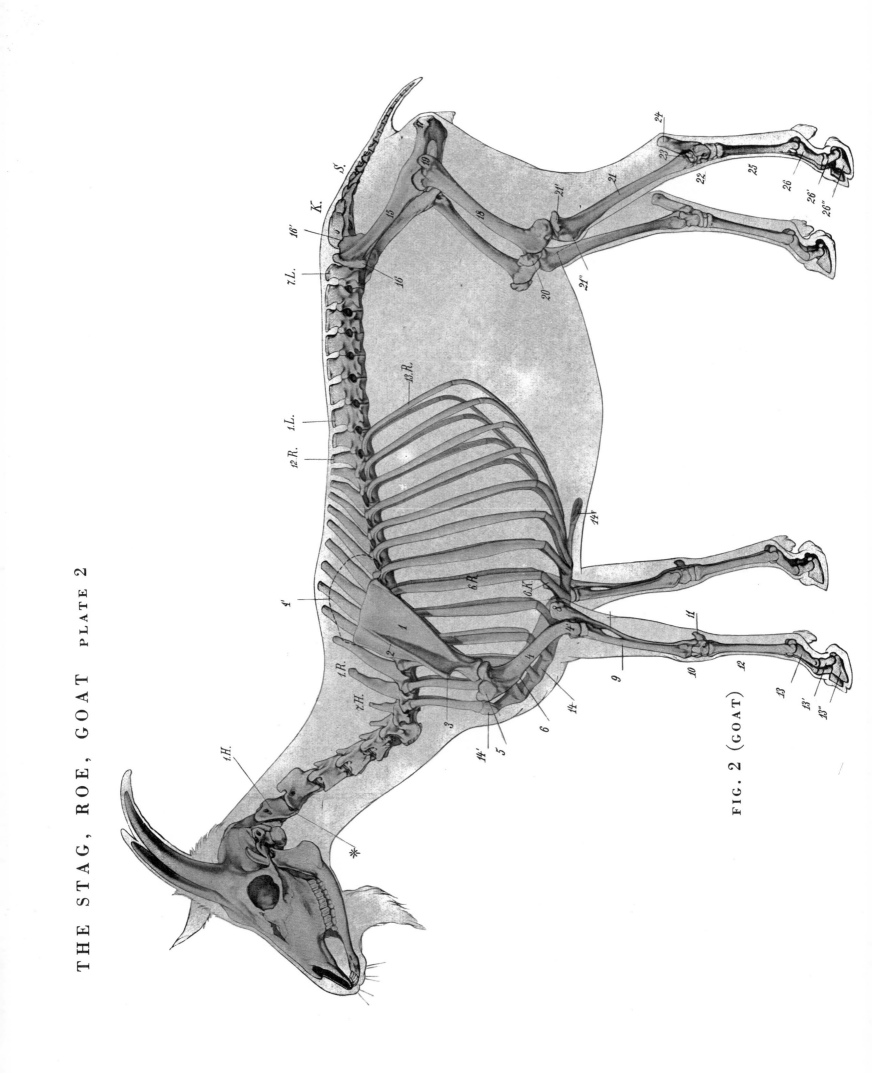

FIG. 2 (GOAT)

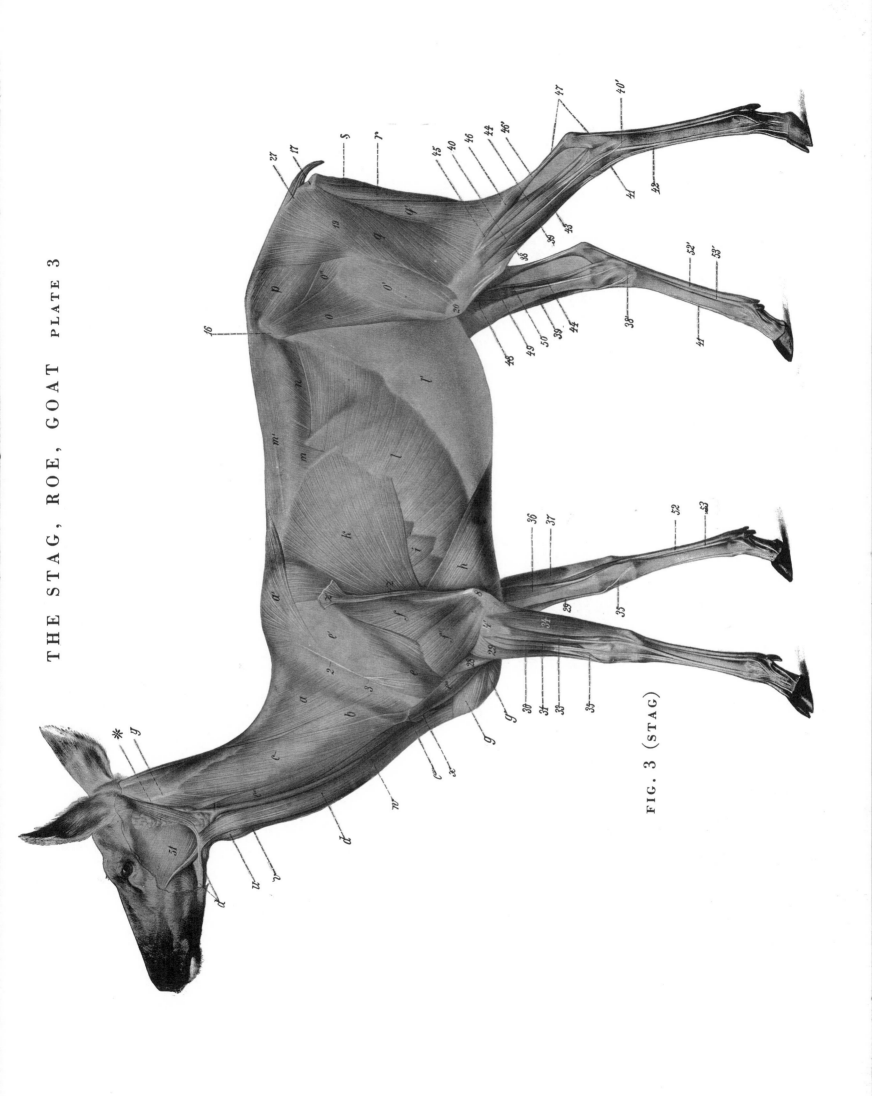

FIG. 3 (STAG)

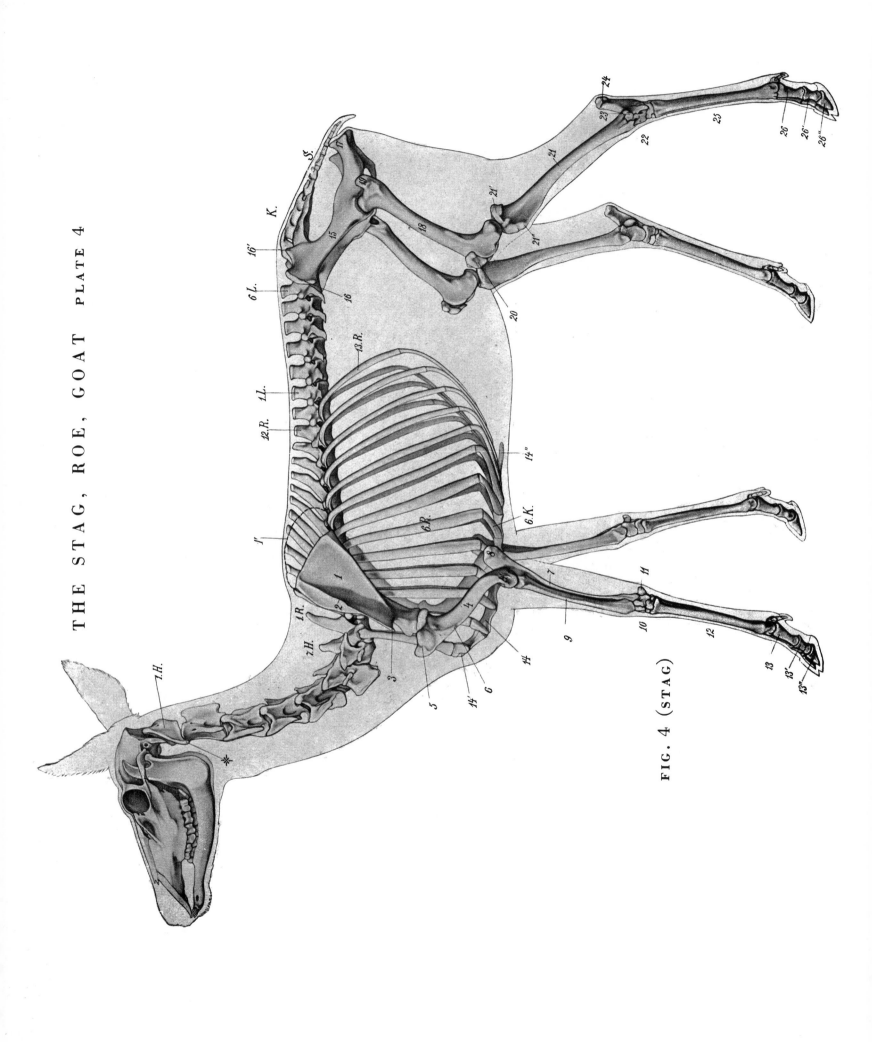

FIG. 4 (STAG)

THE STAG, ROE, GOAT PLATE 5

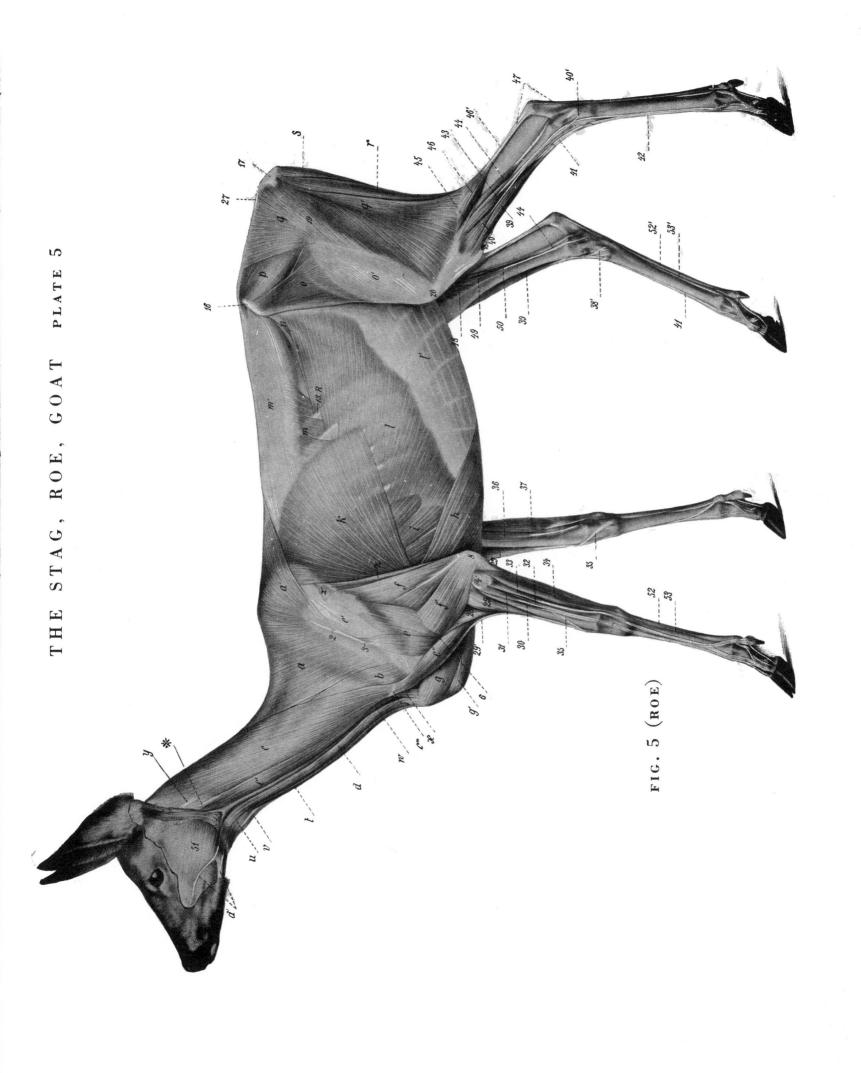

FIG. 5 (ROE)

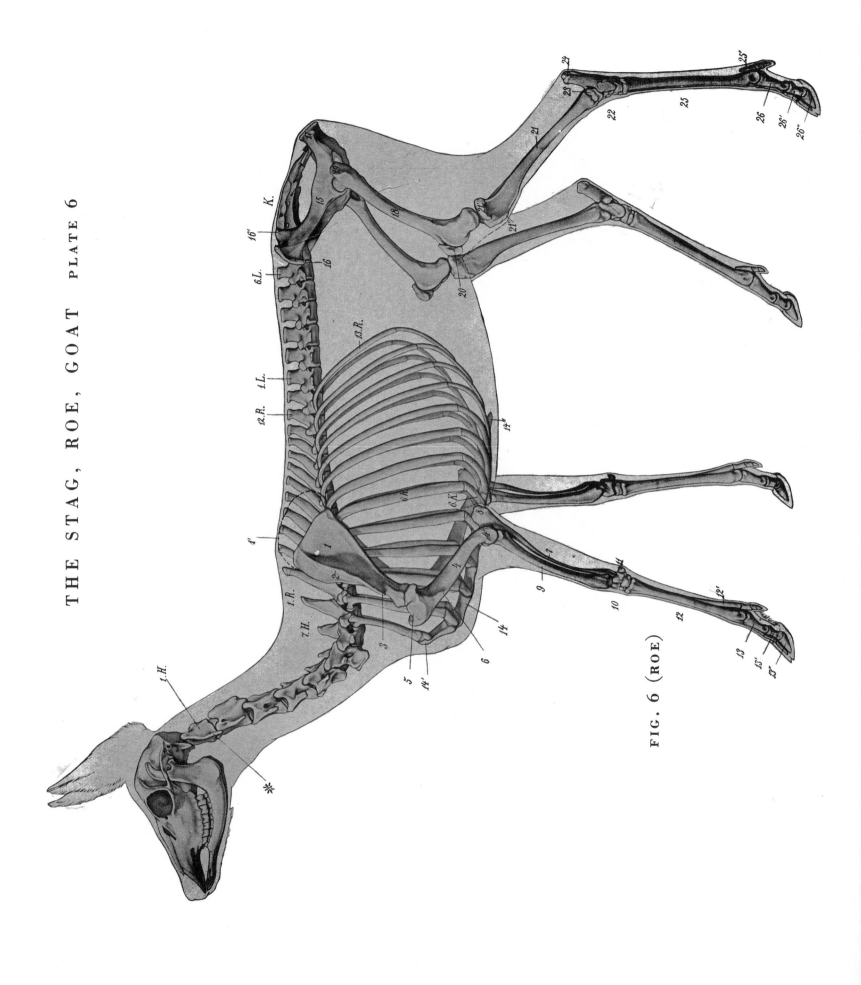

FIG. 6 (ROE)

THE STAG, ROE, GOAT · PLATES 7 8

FIGURES 7 8 9 10 11 12 13 14 15 16 17

a—M. levator labii superioris proprius
b—M. levator nasolabialis
d, d''—M. sternomandibularis
e—End portion of M. sternohyoideus
f—M. caninus s. pyramidalis nasi
g—M.zygomaticus
g'—M. malaris
h—M. buccinator
i—M. depressor s. quadratus labii inferioris
m—M. masseter
n—Depressor of the auricle
o'—Inferior adductor of the auricle
o''—Superior adductor of the auricle
p, p'—M. scutularis
q—Long abductor of the auricle
w—M. mylohoideus
y—Tendon of M. longissimus capitis
z—M. orbicularis oculi
z'—M. corrugator supercilii
*—Ala of atlas
1—Auricula
2—External resp. posterior edge of auricle
3—Internal resp. anterior edge of auricle
8—Scutellum

9—Arcus zygomaticus
11—Processus coronoideus of the lower jawbone
12—Orbital arch
13, 13', 13'', 13'''—Os occipitale
14—Os parietale
15—Os frontale
15'—Base of antlers
15''—Horny process of goat
16—Os temporale
17—Meatus acusticus externus
18—Temporo-maxillary articulation
19—Orbita
20—Os zygomaticus
21, 21', 21''—Os lacrimale
22—Os nasale
23—Os incisivum
24'—Lower incisor teeth
25—Upper canine tooth of the stag
26—Maxilla
27—Facial crest
28—Canine tooth (unpaired) part of the lower jawbone
28'—Molar tooth (paired) part of the lower jawbone

30—Branch of the lower jaw
30'—Mandibular condyle
31—Condyle process of the lower jaw
38—End of the jugular vein
39—V. facialis
44—Glandula parotis
50—Lower end of glandula submaxillaris
51—Lower end of metatarsal bone
52—Phalanx prima
53—Phalanx secunda
54—Phalanx tertia
55—Lower sesamoid bone
56—An upper sesamoid bone
57—1st toe joint
58—2nd toe joint
59—3rd toe joint
60—Extensor tendon
61—M. interosseus
62—Superficial flexor tendon
63—Deep flexor tendon
64—Outer skin
65, 65''—Horny wall of the claw
66—Plantar surfaces of the claws
67—Hind claws

29'—Tendon of brachiocephalicus
30—M. extensor digiti tertii proprius
31—M. extensor digitorum communis
32—A thin muscle only existing with the roe
33—M. extensor digiti quarti proprius
34—M. extensor carpi ulnaris
35—M. abductor pollicis longus
36—M. flexor carpi radialis
37—M. flexor carpi ulnaris
38—M. tibialis anterior
38'—Tendon of M. tibialis anterior

39—M. extensor digitorum pedislongus
40, 40'—M. peronaeus longus
41—Tendon
42—Tendon
43—M. extensor digiti quarti pedis proprius
44—M. flexor digitorum profundus
45—M. soleus
46—Mm. gastrocnemii
46'—Tendo Achillis
47—Superfical flexor tendon
48—M. popliteus

49—M. flexor digitorum pedis longus
50—M. tibialis posterior
51—M. masseter
52—Superficial and deep flexor tendon of anterior metatarsus
52'—Superficial and deep flexor tendon of metatarsus
53—M. interosseus of anterior metatarsus
53'—M. interosseus of posterior metatarsus

THE STAG, ROE, GOAT PLATE 7

FIG. 7 (STAG)

FIG. 8 (ROE)

FIG. 9 (STAG)

FIG. 10 (GOAT)

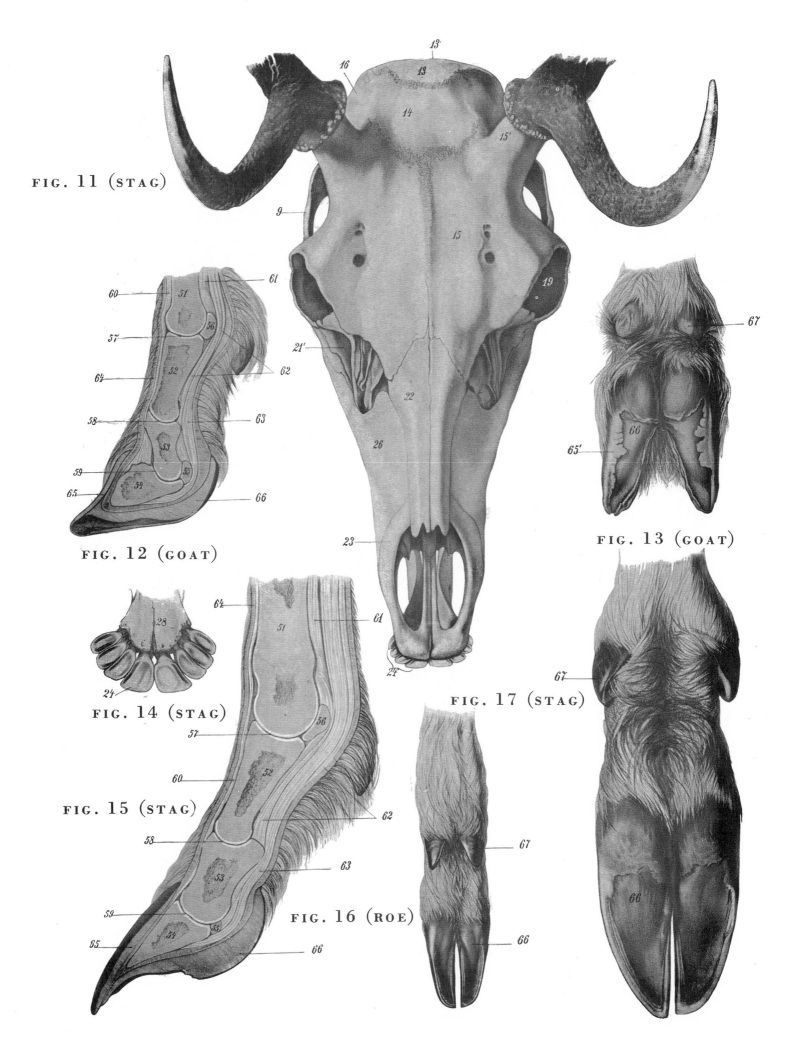

FIG. 11 (STAG)

FIG. 12 (GOAT)

FIG. 13 (GOAT)

FIG. 14 (STAG)

FIG. 15 (STAG)

FIG. 16 (ROE)

FIG. 17 (STAG)

Appendix

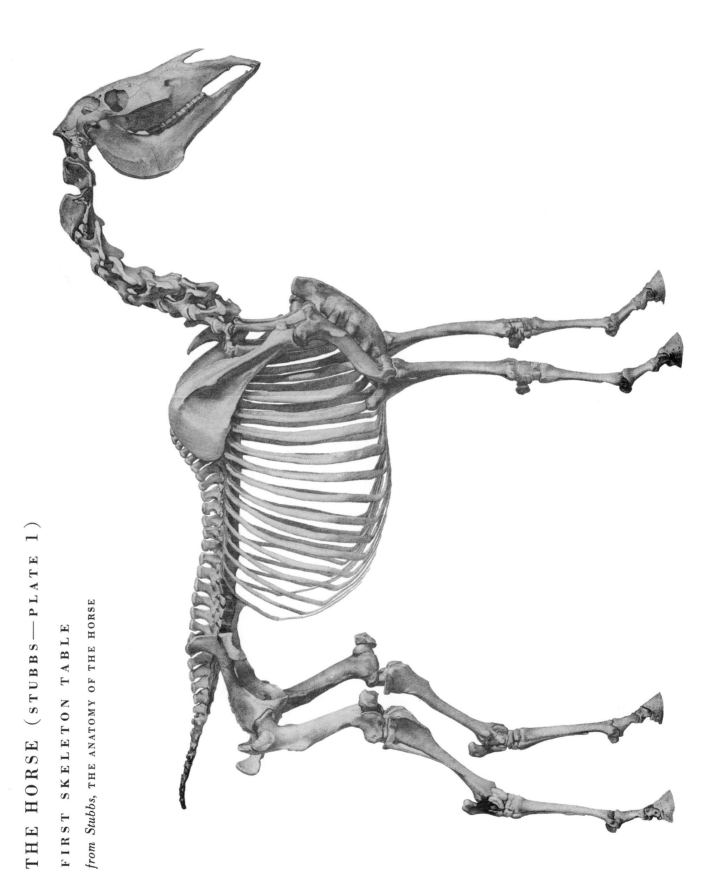

THE HORSE (STUBBS—PLATE 1)

FIRST SKELETON TABLE

from Stubbs, THE ANATOMY OF THE HORSE

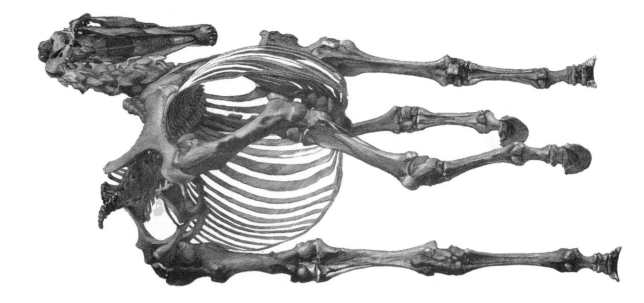

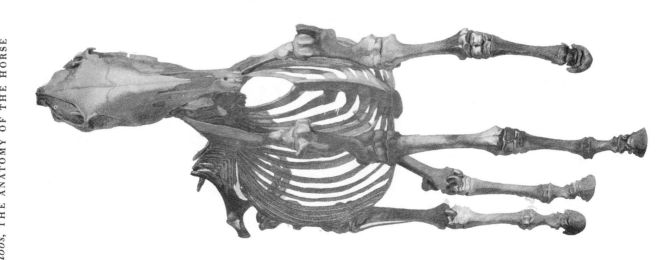

THE HORSE (STUBBS—PLATE 2)

SECOND AND THIRD SKELETON TABLES

from Stubbs, THE ANATOMY OF THE HORSE

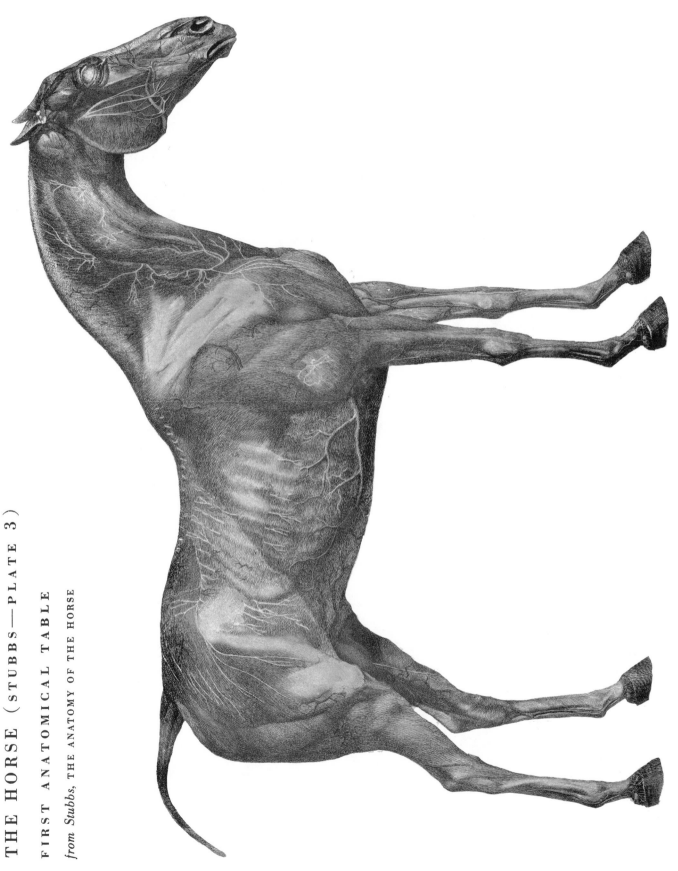

THE HORSE (STUBBS—PLATE 3)

FIRST ANATOMICAL TABLE

from Stubbs, THE ANATOMY OF THE HORSE

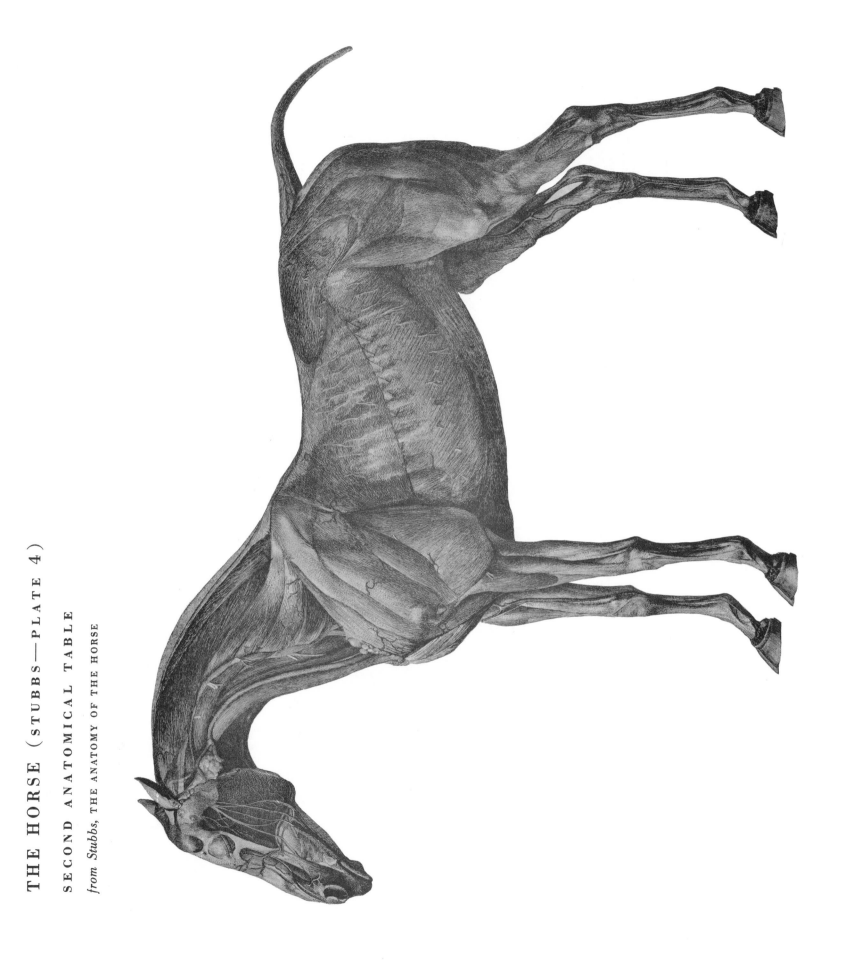

THE HORSE (STUBBS—PLATE 4)

SECOND ANATOMICAL TABLE

from Stubbs, THE ANATOMY OF THE HORSE

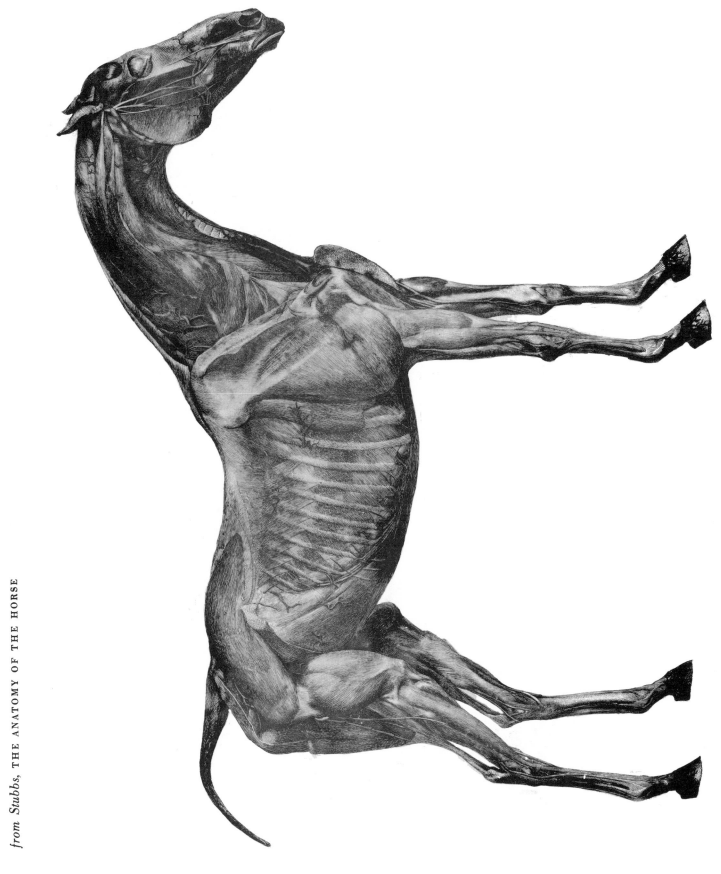

THE HORSE (STUBBS—PLATE 5)

THIRD ANATOMICAL TABLE

from Stubbs, THE ANATOMY OF THE HORSE

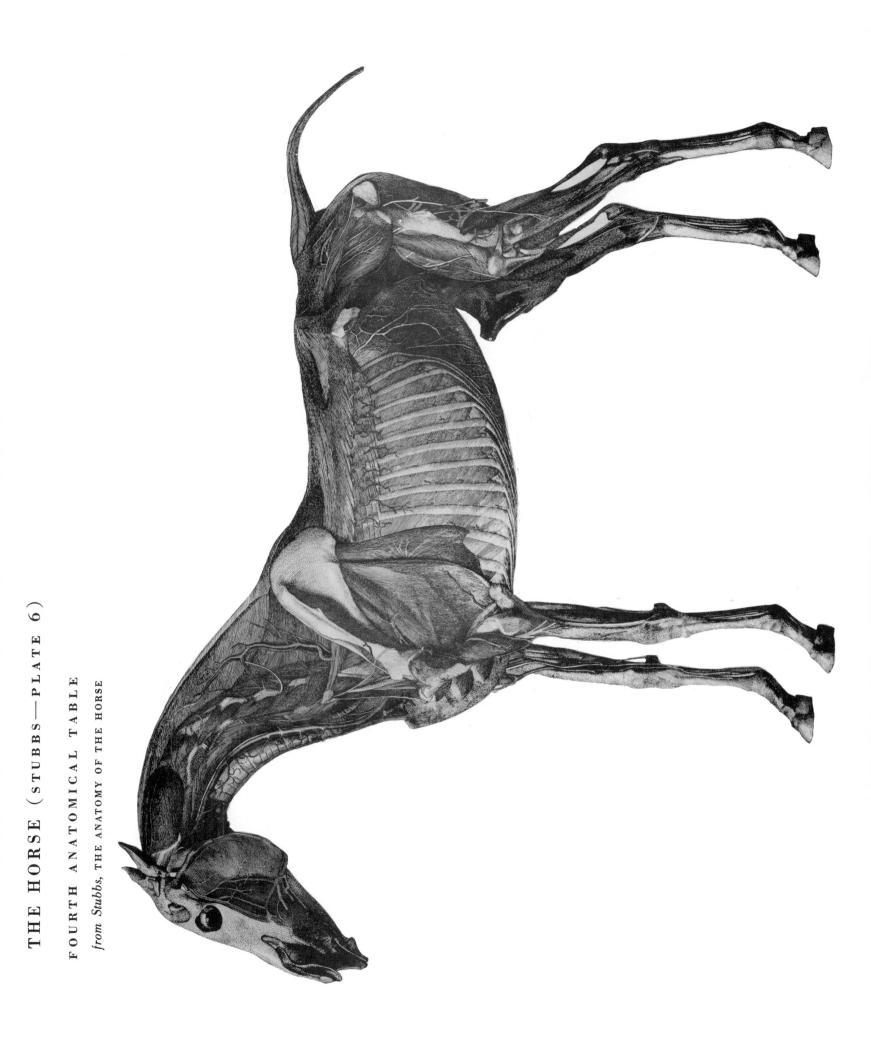

THE HORSE (STUBBS—PLATE 6)

FOURTH ANATOMICAL TABLE

from *Stubbs*, THE ANATOMY OF THE HORSE

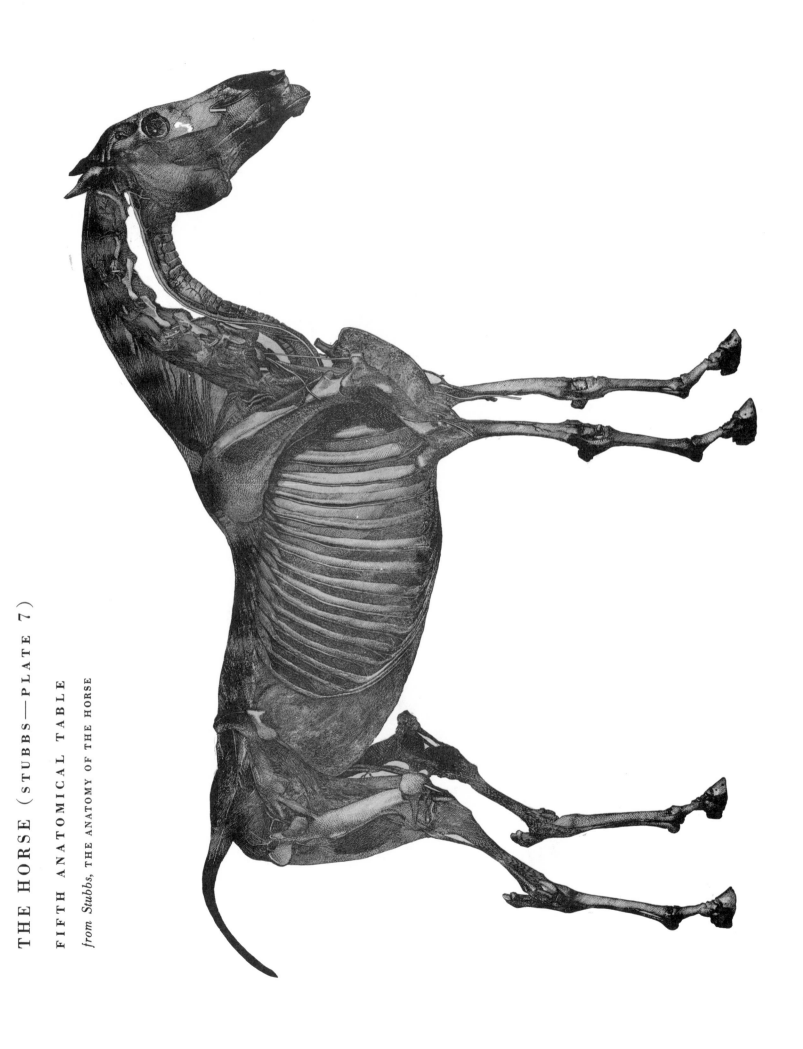

THE HORSE (STUBBS—PLATE 7)

FIFTH ANATOMICAL TABLE

from Stubbs, THE ANATOMY OF THE HORSE

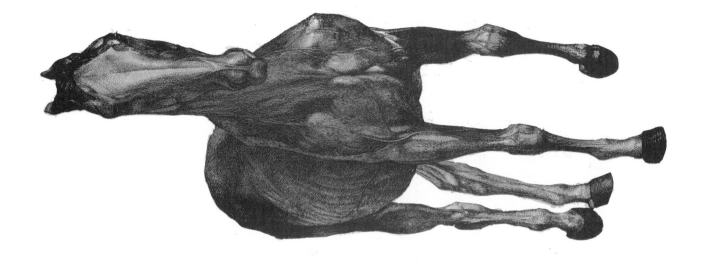

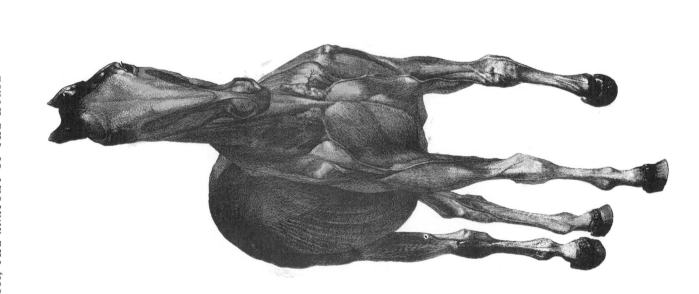

THE HORSE (STUBBS—PLATE 8)

SIXTH AND SEVENTH ANATOMICAL TABLES

from Stubbs, THE ANATOMY OF THE HORSE

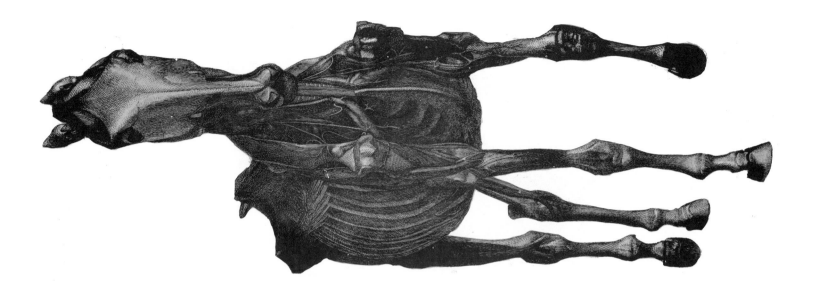

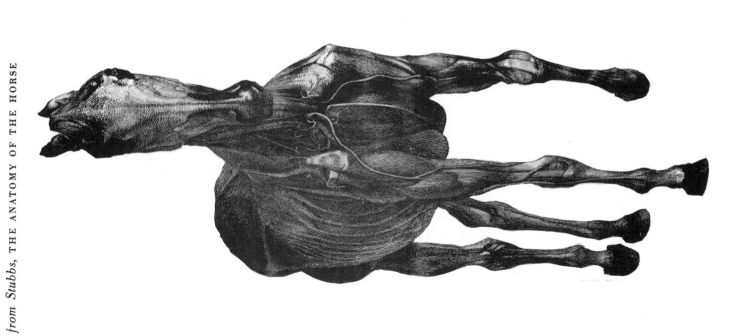

THE HORSE (STUBBS—PLATE 9)

EIGHTH AND NINTH ANATOMICAL TABLES

from Stubbs, THE ANATOMY OF THE HORSE

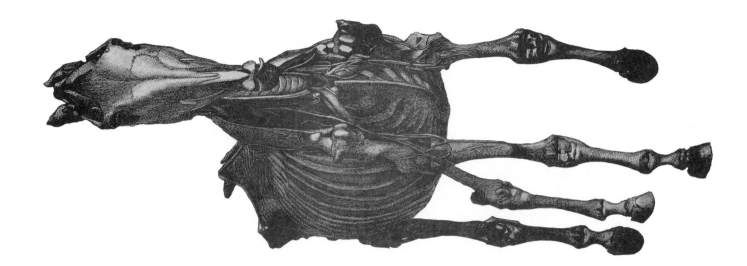

THE HORSE (STUBBS—PLATE 10)

TENTH AND ELEVENTH ANATOMICAL TABLES

from Stubbs, THE ANATOMY OF THE HORSE

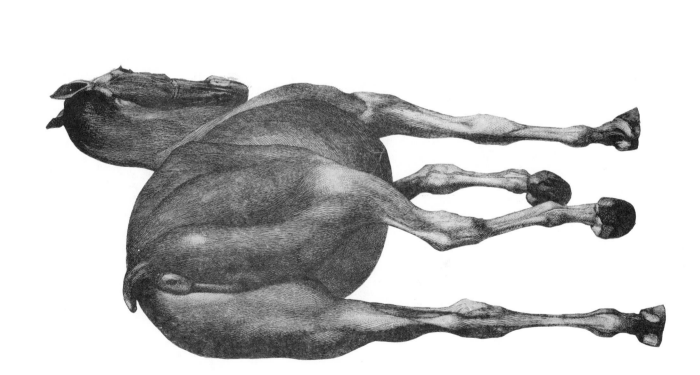

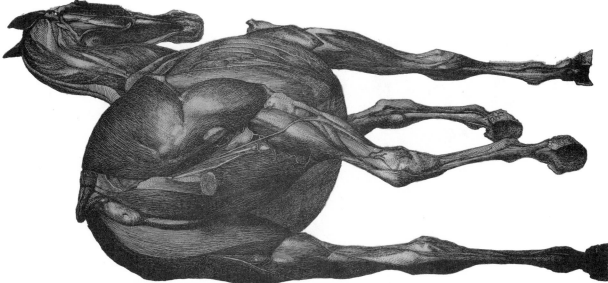

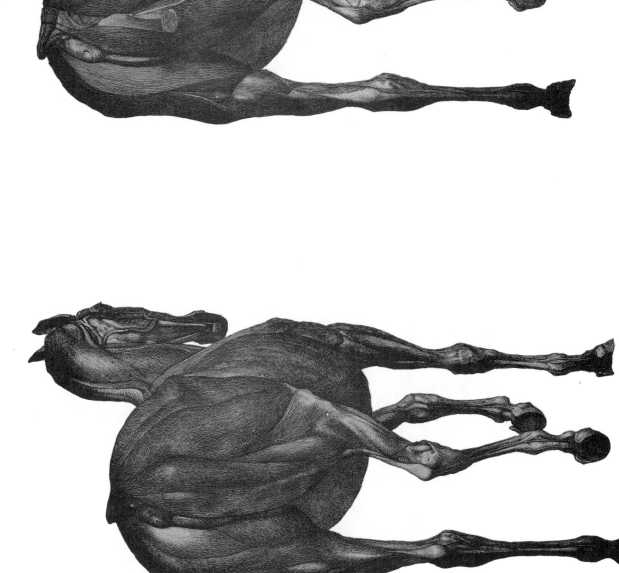

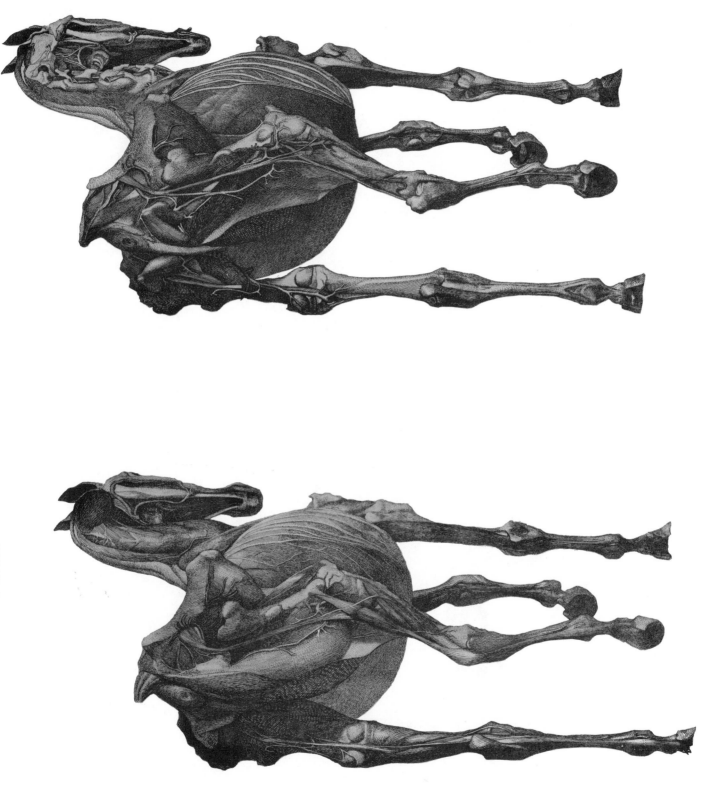

THE HORSE (STUBBS—PLATE 12)

FOURTEENTH AND FIFTEENTH ANATOMICAL TABLES

from Stubbs, THE ANATOMY OF THE HORSE

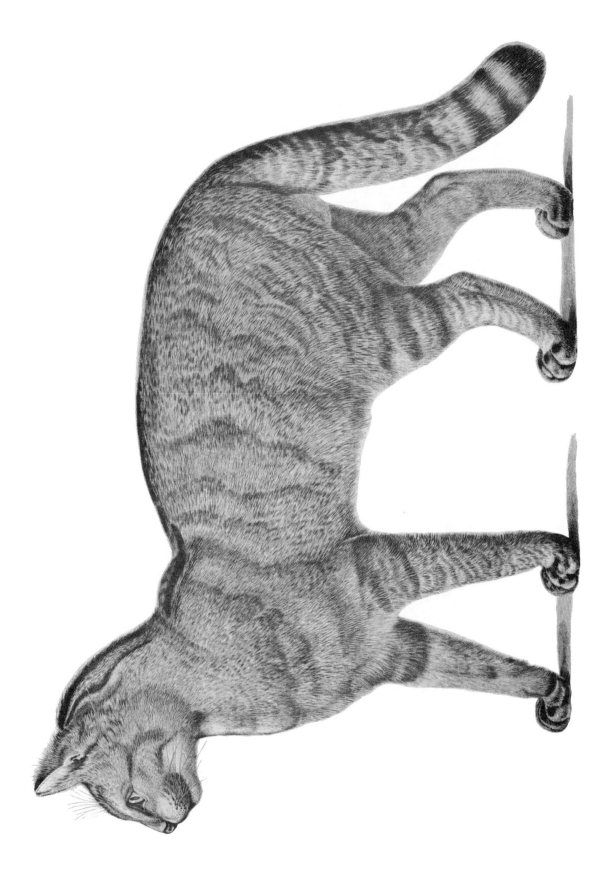

THE CAT (STRAUS-DURCKHEIM — PLATE 1)

from Straus-Durckheim, ANATOMIE DESCRIPTIVE ET COMPARATIVE DU CHAT

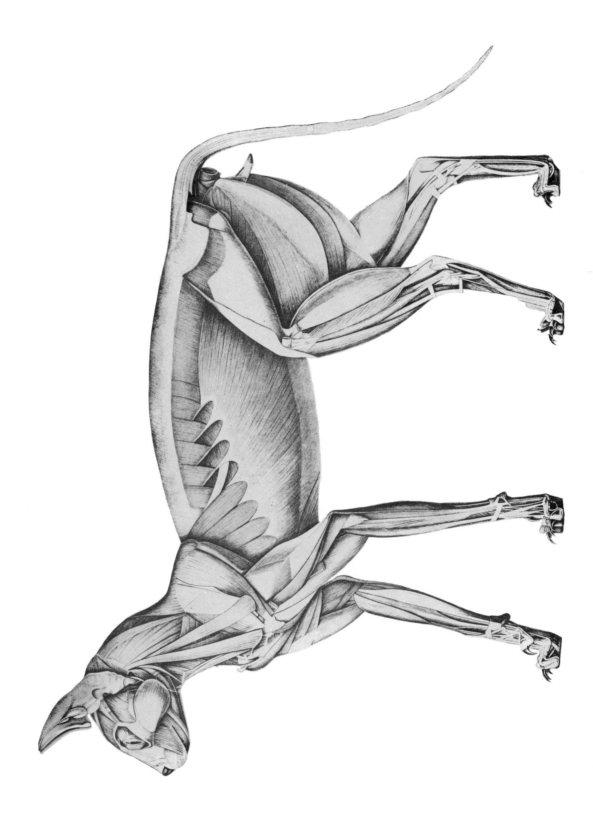

THE CAT (STRAUS-DURCKHEIM —PLATE 2)

from Straus-Durckheim, ANATOMIE DESCRIPTIVE ET COMPARATIVE DU CHAT

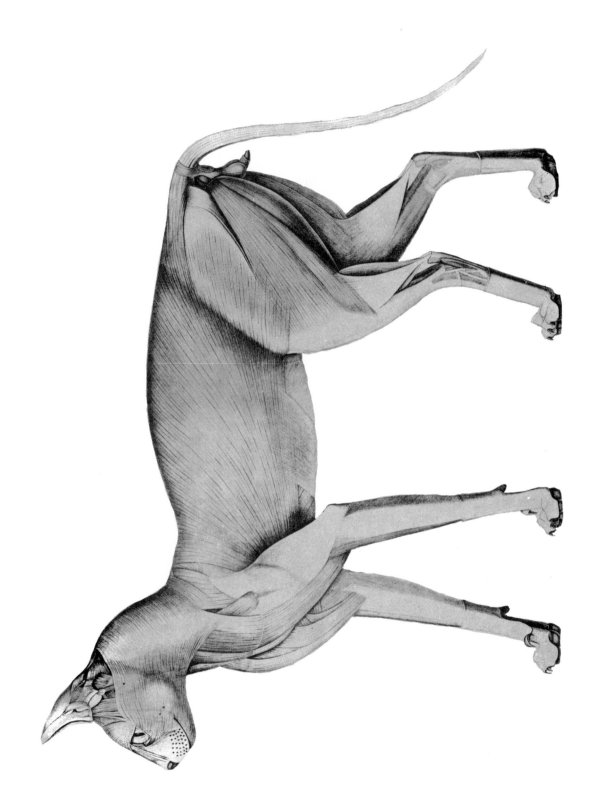

THE CAT (STRAUS-DURCKHEIM—PLATE 3)

from Straus-Durckheim, ANATOMIE DESCRIPTIVE ET COMPARATIVE DU CHAT

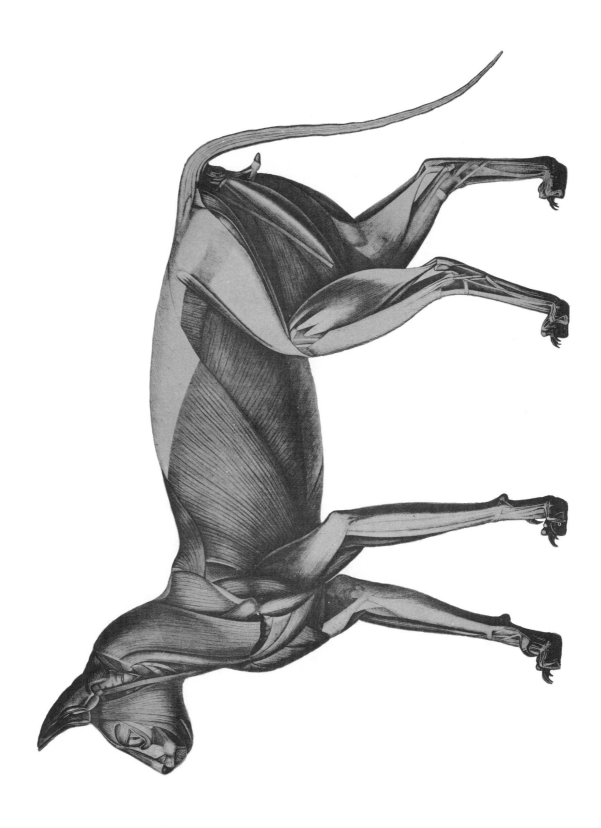

THE CAT (STRAUS-DURCKHEIM—PLATE 4)

from Straus-Durckheim, ANATOMIE DESCRIPTIVE ET COMPARATIVE DU CHAT

THE MONKEY, SEAL, HARE, RAT KANGAROO, FLYING SQUIRREL, AND BAT (CUVIER)

IDENTIFYING SYMBOLS USED IN THE FOLLOWING CUVIER PLATES

MUSCLES OF THE HEAD

ℓ —temporal
α —orbicularis oculi
ι —dilatator naris lateralis
ϕ —zygomaticus minor
ι —zygomaticus
j —masseter
f —buccinator
ℓ —orbicularis oris
q —digastricus
r —parotido-auricularis
r^2 —scutulo-auricularis superioris
\oplus —scutulo-auricularis inferioris
$\tau\tau$ —scutularis
\mathcal{H} —auditory passage

MUSCLES OF THE NECK AND SHOULDER

a—trapezius (in monkey); brachiocephalicus
 cleido-cervicalis and cleido-
 mastoideus (in seal)
a^1, a^2 —trapezius
b—sterno-mastoideus sterno-cephalicus
b^1 —sterno-mandibularis sterno-cephalicus
e—omo-hyoideus
d—omo
k^1 —deltoid
g—mylo-hyoideus
x—sterno-thyro-hyoideus
L, L^1 —complexus

MUSCLES OF THE BODY

5a —cutaneus maximus, scapular portion (skin
 muscle)
5b cutaneus maximus, dorsal portion (skin
 muscle)
5c —cutaneus maximus, lateral portion (skin
 muscle)
5d —cutaneus maximus, ventral portion (skin
 muscle)
7—external intercostal
8—internal intercostal
10, 11—small denticulated muscle
13, 13^2 —obliquus abdominis externus
14—transversus abdominis
15—rectus abdominis
a—gluteus maximus
a^1 —gluteus medius
c^2 —rhomboideus
g—serratus thoracis
i—latissimus dorsi
j—superficial pectoral
j^1 —posterior deep pectoral
j^2 —anterior pectoral
k—deltoid
n—subscapularis
o—infraspinatus
r—supraspinatus
\mathcal{N} —testicle
6—scalenus, exterior portion
6a —scalenus, middle portion
6b —scalenus, interior portion
A—spinalis dorsi
B—longissimus dorsi
C—longissimus costarum
D—longissimus cervicis

MUSCLES OF THE FRONT LEG (OUTSIDE VIEW)

t, t^3 —triceps (long head)
t^2 —triceps (lateral head)
v—long supinator
v^1 —short supinator
δ —exterior corpi radialis
ε —common digital extensor
ε —extensor of little finger
σ —ulnaris lateralis
δ' —flexor carpi ulnaris
ζ —long extensor of thumb
μ^2 —deep flexor
ι —long common flexor

MUSCLES OF THE FRONT LEG (MEDIAL VIEW)

i—long abductor of the thumb
j—pectoral
L—long common flexor
m—short abductor of the thumb
n—subscapularis

o—*teres major*
r—*biceps*
t, t³—*triceps (long head)*
t²—*triceps (lateral head)*
u—*extensor of forearm*
v—*brachialis*

MUSCLES OF THE HAND

ρ —*adductor of thumb*
ν^1—*interosseus dorsalis*
ε'—*extensor indicis*
$\mathbf{3}$ —*extensor pollicis brevi*
6 —*abductor digiti quinti*

MUSCLES OF THE BACK LEG
(SUPERFICIAL)

a¹—*gluteus medius*
a—*gluteus maximus*

q¹, q²—*biceps femoris*
r—*semi-tendinosis*
s—*semi-membranosis*
x—*fascia lata*
\oslash—*sphincter ani externus*
m—*vastus lateralis*
p—*rectus femoris*

MUSCLES OF THE BACK LEG
(MEDIAL VIEW)

α —*gastrocnemius*
ι —*iliopsoas*
ρ —*rectus femoris*
n —*vastus medialis*
s—*semi-membranosis*
$\{$ —*adductor brevis*
u—*gracilis*
$\mathbf{3}$ —*extensor digitorum longi*

MUSCLES OF THE BACK LEG (DEEPER)

ε —*peroneus longus*
ε^1—*peroneus tertius*
ε^2—*peroneus brevis*
ζ —*long common extensor*
ζ_2—*long digital extensor*
\mathcal{Q}—*short common extensor*

MUSCLES OF THE FOOT

α —*gastrocnemius*
ε, ε^1-*peroneus longus*
ε^2-*peroneus brevis*
η —*interossei dorsales*
ν —*adductor obliquus*
ν^1—*adductor transversus*
μ —*extensor hallucis brevis*
$\mathbf{3}$ —*extensor digitorum longi*

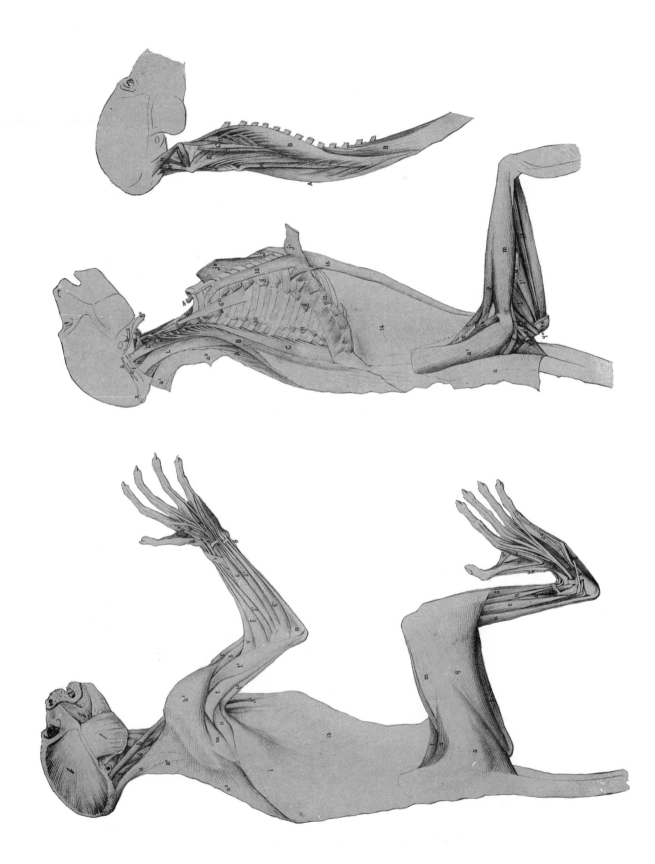

THE MONKEY (CUVIER)

from Cuvier, Laurrillard, ANATOMIE COMPARÉE

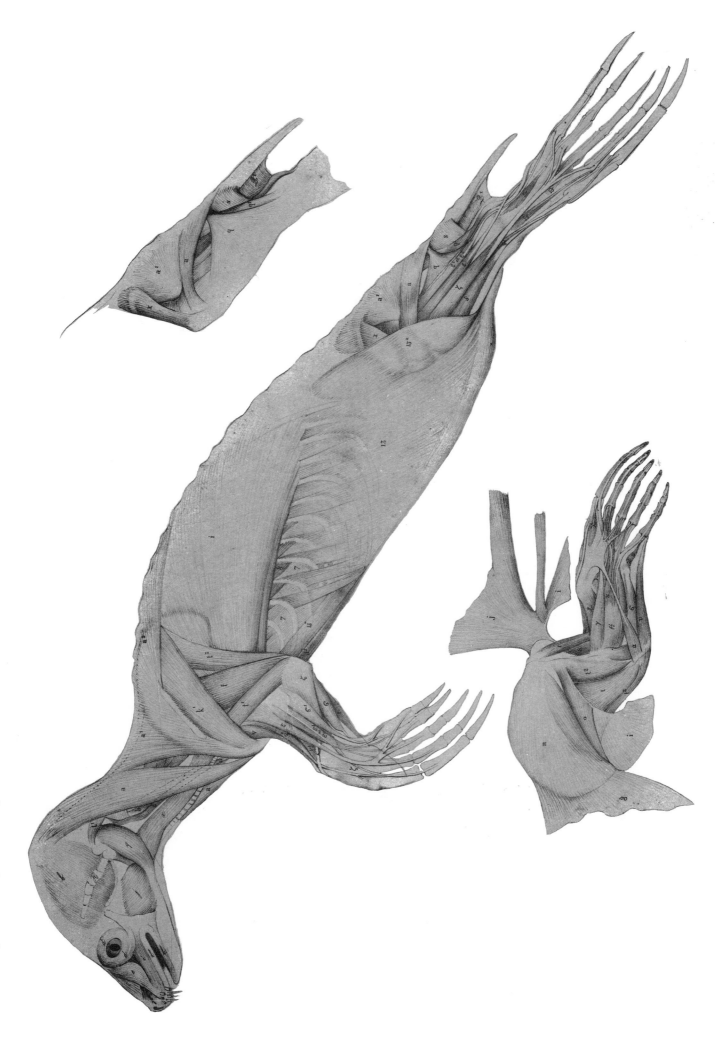

THE SEAL (CUVIER)

from Cuvier, Laurillard, ANATOMIE COMPARÉE

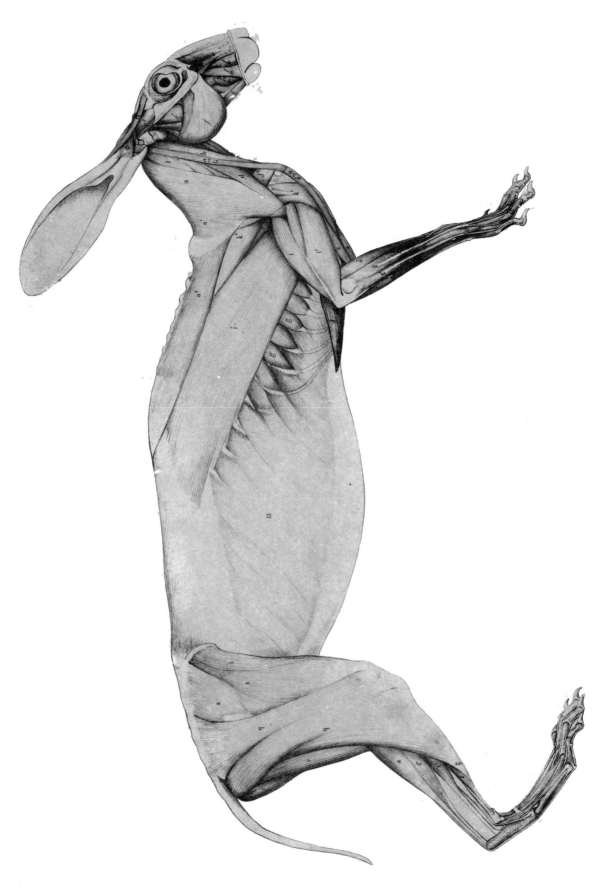

THE HARE (CUVIER)

from Cuvier, Laurrillard, ANATOMIE COMPARÉE

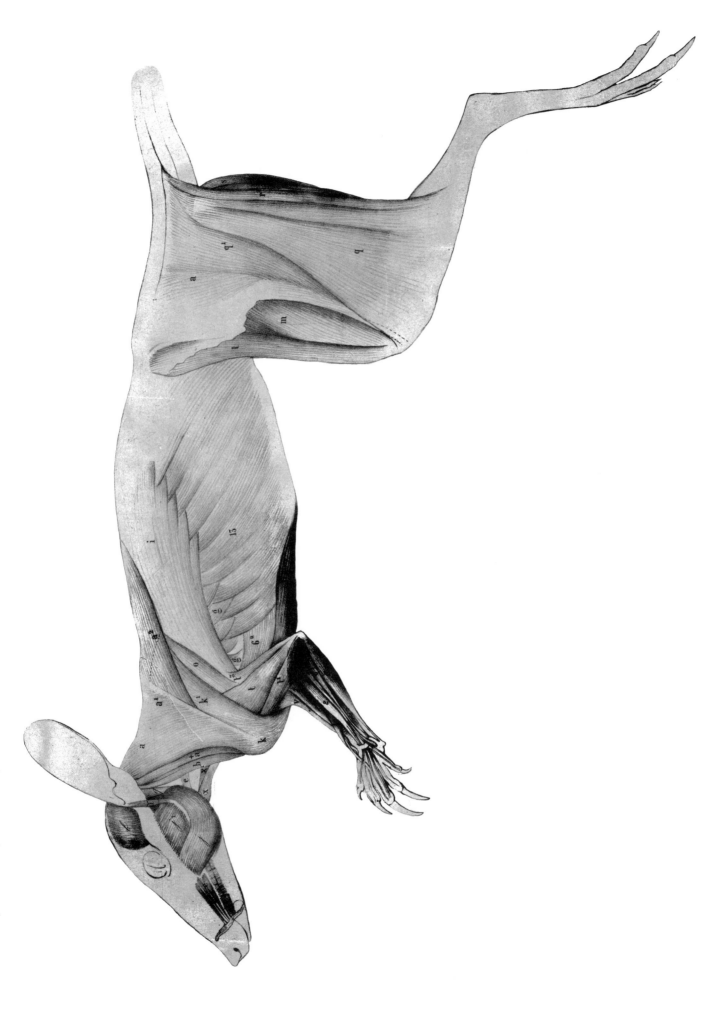

THE RAT KANGAROO (CUVIER)

from Cuvier, Laurrillard, ANATOMIE COMPARÉE

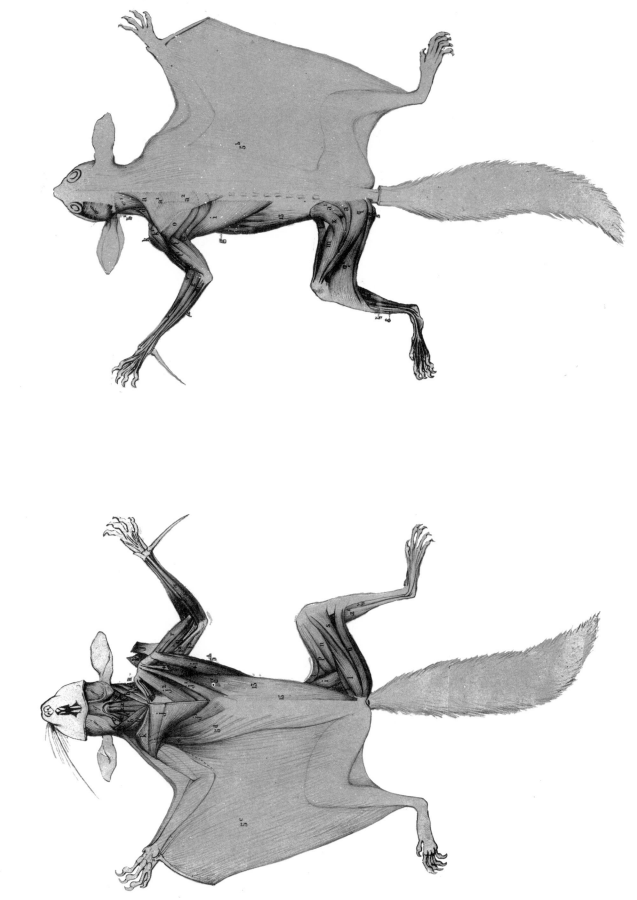

THE FLYING SQUIRREL (CUVIER)

from Cuvier, Laurrillard, ANATOMIE COMPARÉE

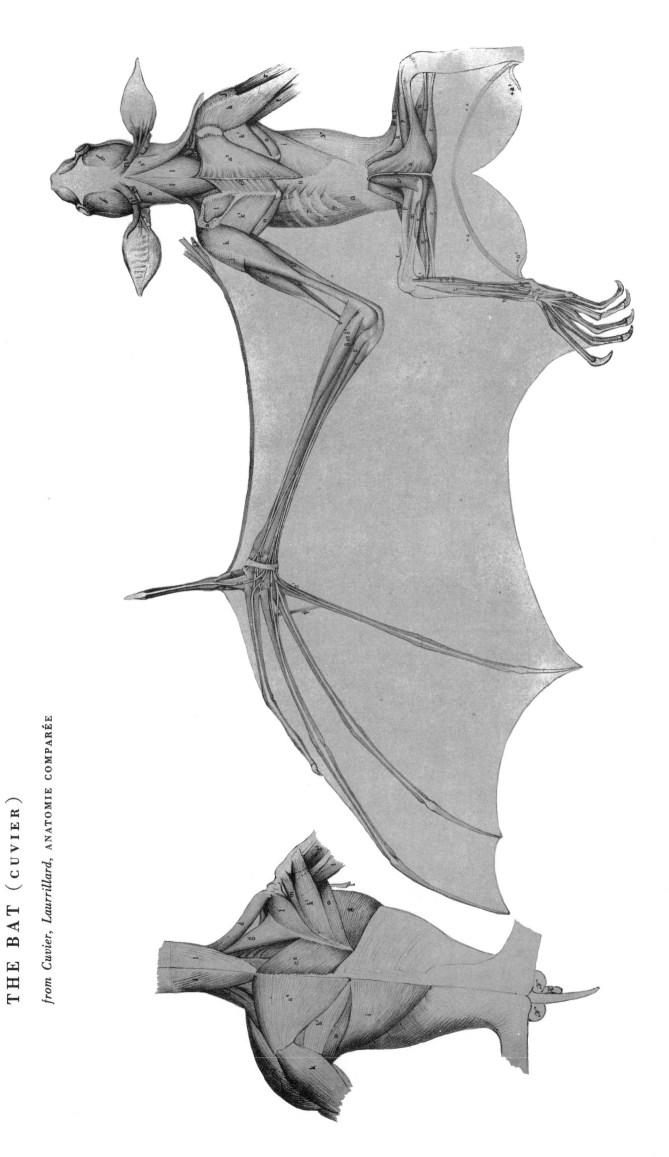

THE BAT (CUVIER)

from Cuvier, Laurrillard, ANATOMIE COMPARÉE

Bibliography

For those who wish to go beyond the necessarily limited scope of this book, this annotated list of books is included. Unfortunately, some of the better anatomical works are not easily accessible. Some are out of print, and many are in foreign languages. The volumes selected are those which have, for one reason or another, appealed to me. Most of the works are non-technical or so well illustrated that a large part of them can be grasped by the artist visually.

ANATOMY

Baum, Hermann; Zietzchmann, Otto. HANDBUCH DER ANATOMIE DES HUNDES. Berlin, 1936.
> Very good material on the dog.

Boas, J. E. V.; Paulli, Simon. THE ELEPHANT'S HEAD. Carlsburg Fund. Copenhagen, 1908.
> Studies in the comparative anatomy of an Indian elephant's head and those of other mammals. Very fine plates, many in full color. 2 volumes.

Bronn, H. G. KLASSEN UND ORDNUNGEN DES THIER-REICHS. Leipzig, 1876.
> A good and extensive series of comparative skeletons as well as some good muscle plates.

Brown, Lewis S. ANATOMY OF THE HORSE FOR ARTISTS. New York, 1948.
> A comparison of the human and horse forms showing structure, proportion, and action. Contains measurements for light and heavy breeds.

Camper, Pierre. DESCRIPTION ANATOMIQUE D'UN ÉLÉPHANT, MÂLE. Paris, 1802.

Cuvier, George; Laurrillard M. ANATOMIE COMPARÉE. Paris, 1849.
> Contains fine anatcmical drawings of many different animals from man to mouse, bat to elephant. One of the best comparative anatomies for artists. The volume from which the plates in this book were taken.

Ellenberger, W.; Baum, H.; Dittrich, H. HANDBOOK OF ANATOMY OF ANIMALS FOR ARTISTS. London, 1901. 5 vols.
> Text on the horse in English, French, and German; text on other animals in German. This book rightly remains the standard in the field. Source of the plates in the present volume.

Ellenberger, W.; Baum, H. HANDBUCH DER VERGLEICHENDEN ANATOMIE DER HAUSTIERE. Berlin, 1908.
> Excellent book on the anatomy of bovines.

—ANATOMIE DES HUNDES. Berlin, 1891.
>Excellent work on the anatomy of dogs.

—ANATOMIE DES PFERDES. Berlin, 1893.
>Excellent work on the anatomy of horses.

Friedenthal, H. DAS HAARKLEID DES MENSCHEN. Jena, 1908.
>Shows the hair patterns of men and animals. Many plates in color.

—BEITRÄGE ZUR NATURGESCHICHTE DES MENSCHEN. Jena, 1910.

—TIERHAARATLAS. Jena, 1911. 5 volumes.
>Good for skin and fur textures. Many color plates.

Knight, C. R. ANIMAL ANATOMY AND PSYCHOLOGY. New York, 1947.
>A good work on comparative anatomy by a master draftsman.

Leisering, A. G. T. ATLAS DER ANATOMIE DES PFERDES. Leipzig, 1861.
>Some Ellenberger anatomy plates of domestic animals; dogs, horses, pigs, cows.

Matthew, W. D.; Chubb, S. H. EVOLUTION OF THE HORSE. American Museum of Natural History, Guide Leaflet Series 36.
>One of the best brief accounts of the evolution of the horse. Contains photographs of skeletons of both early and recent horse forms found in the American Museum of Natural History. Mr. Chubb spent over 45 years at the museum on equine osteology and is one of the great authorities.

Pander, C. H. ATLAS VERGLEICHENDE OSTEOLOGIE. Bonn, 1828.
>Bone structure of many animals as shown in relation to the outer form.

Reighard, Jacob; Jennings, H. S. ANATOMY OF THE CAT. New York, 1902.

Ruge, George. DIE GESICHTSMUSKULATUR DER PRIMATEN. Leipzig, 1887.

Schmaltz, Reinhold. ATLAS DER ANATOMIE DES PFERDES. Berlin, 1927.

Schaeffer, Maximilian. TIERFORMEN (ATLAS). Berlin, 1899. 2 volumes.
>Comparative anatomy.

Sisson, S. THE ANATOMY OF THE DOMESTIC ANIMALS. Third edition revised by J. D. Grossman. Philadelphia, 1938.
>Standard work on anatomy for veterinarians. Contains many Ellenberger plates and excellent photographs. Includes the horse, cow, dog, sheep, pig, and an appendix on the chicken. The best source of information on the action of muscles.

Straus-Durckheim, Hercule. ANATOMIE DESCRIPTIVE ET COMPARATIVE DU CHAT. Paris, 1845.
>Complete and excellent work on the cat. Many plates. This is the volume from which the cat plates in this book were taken.

Stubbs, George. THE ANATOMY OF THE HORSE. London, 1776. Reprinted London, 1938.
>A monumental work on the horse. This is the volume from which the Stubbs plates in this book were taken.

Tschaggeny, Edmond. ATLAS D'ANATOMIE DE L'ESPÈCE BOVINE. Bruxelles, 1921. 2 volumes.
>Plates on domestic cattle.

Wolton, Elizah. THE CAMEL. London, 1865.
>Anatomy and proportions of the camel.

ANIMAL MOTION

Howell, A. Brazier. SPEED IN ANIMALS. Chicago, 1944.
 A very good work on the way animals move. Rather technical.

Muybridge, Eadweard. ANIMALS IN MOTION. London, 1899. Reprinted
 in 1925. *(Dover reprint)*
 The classic work for artists on animal motion and still the
 best on the subject. Most subsequent studies have been drawn
 from it.

Stillman, J. A. B. THE HORSE IN MOTION. Boston, 1882.
 Based on Muybridge observations, but Muybridge's book is
 greatly preferred.

ANIMAL PROPORTION AND MEASUREMENTS

Boone and Crocket Club. NORTH AMERICAN BIG GAME. New York,
 1939.

Chubb, S. Harstead. MAN O' WAR AND GALLANT FOX. New York, 1931.
 Museum of Natural History Publication.
 Exact measurements of two of America's greatest thoroughbred
 racehorses, taken as three year olds at racing peak.

Mochi, Ugo; Carter, T. Donald. HOOFED MAMMALS OF THE WORLD.
 New York, 1953.
 Illustrated with silhouettes of hundreds of different animals
 reproduced at exactly 1/32 life size. Text by one of world's
 authorities on mammals.

Seton, Ernest Thomson. ART ANATOMY OF ANIMALS. London, 1896.
 This is listed here because the best information seems to me to
 be on measurements and proportion rather than on general
 anatomy. This was one of Seton's earliest works, and the draw-
 ings are not in all cases to be relied upon.

Ward, Roland. RECORDS OF BIG GAME. London, 1928.
 The most authoritative and complete work on animals for
 descriptions and exact measurements. Very useful information
 for the artist.

ANIMAL DRAWING AND PAINTING

LES ANIMAUX. *Ed. by A. Dayot, Lt. Chollet, H. Neuville and others.*
 Maison d'édition. Paris. 2 volumes.
 Animals in legend, science, work, sport, art and their utiliza-
 tion by man. Many interesting illustrations.

Brown, Paul. THE HORSE. New York, 1943.
 A good book of sketches of the horse showing gaits and con-
 formation by one of America's best horse artists. Many other
 books on horses written and illustrated by Mr. Brown are both
 easily available and excellent.

Dayot, Armand. ANIMAUX DESCRIPTIFS. Paris, 1930. 4 volumes.
 Excellent paintings, drawings, and sculpture both realistic and
 simplifies.

Keller, Otto. DIE ANTIKE TIERWELT. Leipzig, 1909. 2 volumes.
 Animals as represented in art through the ages.

[149]

Kley, Heinrich. THE DRAWINGS OF HEINRICH KLEY. Los Angeles, 1941. 2 volumes. *(Dover reprint)*
 > Beautiful drawings by one of the great draftsmen of both people and animals.

Knight, Charles R. LIFE THROUGH THE AGES. New York, 1946.
 > One of America's great animal artists. His paintings and sculpture enrich many natural history museums.

Kuhnert, Wilhelm. FARBIGE TIERBILDER. Berlin. n.d.
 > Many good reproductions in color.

Lydekker, Richard. ANIMAL PORTRAITURE. London. n.d.
 > Fifty studies of birds and animals in full color.

Méheut, M. ÉTUDES D'ANIMAUX. Paris, 1911. 2 volumes.
 > Very good animal drawings.

Morris, George Ford. PORTRAITURES OF HORSES. Shrewbury, N. J. 1953.
 > A leading American portrait painter of horses.

Munnings, Alfred. AUTOBIOGRAPHY. London, 1950. 3 volumes.
 > The work of England's best present-day painter of the horse.

New York Zoological Society. GALLERY OF WILD ANIMAL PAINTINGS IN THE ZOOLOGICAL PARK. New York, 1930.
 > Paintings by Carl Rungius, Charles R. Knight, and others.

Schaldach, William J. CARL RUNGIUS, A BIG GAME PAINTER. West Hartford, 1945.
 > A beautiful volume of Rungius' animal paintings. An animal painter of the first rank.

GOOD PUBLICATIONS ON MAMMALS

THE BOOK OF THE DOG. Edited by Brian Vesey-Fitzgerald. Los Angeles, 1948.

DISCOVERY REPORTS ON WHALES. Discovery Committee, Colonial Office, London. Cambridge University Press. 1929.
 > A treatise on elephant seals and whales. Well illustrated.

Encyclopedia Britannica. MAMMALS AND BIRDS. Britannica booklet No. 3. New York, 1933.
 > A selection of articles from the 14th edition of the Encyclopedia Britannica. Profusely and well illustrated.

National Geographic Society. WILD ANIMALS OF NORTH AMERICA. Edward W. Nelson. Washington, D. C., 1918.
 > Paintings by Louis Agassig-Fuertes.

—BOOK OF FISHES. Ed. by John Oliver La Gorce.

—BOOK OF DOGS. Ernest Harold Baynes.
 > Illustrated in color by Louis Agassig-Fuertes and Hashime Murayuma.

—CATTLE OF THE WORLD. Alvin H. Sanders.
 > Full color paintings by Edward Herbert Miner.

Seton, Ernest Thompson. LIVES OF GAME ANIMALS. New York, 1927. 4 volumes.
 > Illustrated largely with the author's drawings. Good reference on animal tracks among a lot of other things.

SMITHSONIAN SCIENTIFIC SERIES. Charles Greenley Abbott, editor.

THE HORSE

Brown, W. R. HORSE OF THE DESERT. New York, 1929. Reprinted New York, 1947.

 A much cited book on the Arabian horse. Well illustrated.

Carter, W. H. HORSES OF THE WORLD. Washington, D. C., 1923.

 Originally appeared as "The Story of the Horse" in the National Geographic Magazine, volume 44, 1923. Well illustrated in black and white and color.

Davenport, Homer. MY QUEST OF THE ARAB HORSE. New York, 1909.

Derhardt, R. M. THE HORSE OF THE AMERICAS. Norman, Oklahoma, 1947.

Harper, M. W. MANAGEMENT AND BREEDING OF HORSES. New York, 1913.

 A book I have found very useful for general information on all breeds.

Hervey, John. THE AMERICAN TROTTER. Toronto, 1947.

 An excellent reference book on the standard-bred.

—RACING IN AMERICA. New York, 1944.

Lamb, A. J. R. HORSE FACTS. Chicago, 1948.

Simpson, George Gaylord HORSES. New York, 1951.

 The story of the horse family in the modern world and through sixty million years of history. Doctor Simpson heads the Department of Paleontology at the American Museum of Natural History. Written to be readily understood by the layman. No other book covers the subject so fully or authentically.

Sporting Life and Biographical Press. BRITISH HUNTS AND HUNTSMEN. London, 1909. 4 volumes.

 A vast collection of photographs of British horses, hounds and huntsmen.

Vesey-Fitzgerald, Brian, editor. THE BOOK OF THE HORSE. London, 1946.

 Text in places is at variance with accepted fact, but beautifully illustrated.

Most horse breeding societies publish periodicals and pamphlets on their breeds, and such magazines as the *Thoroughbred Record,* the *Harness Horse, Horse World,* to mention a few, are good. The departments of agriculture, state and federal, also publish material. Information can be obtained from the Horse and Mule Association of America.